The Photographer's
MASTER PRINTING COURSE

The Photographer's
MASTER PRINTING
COURSE

Tim Rudman

Mitchell Beazley

To Ingrid, Natalie and Chris

For their constant encouragement and enthusiasm
— and their many hours on the word processor.

ACKNOWLEDGEMENTS

The author wishes to express his thanks to:

Agfa-Gevaert Ltd, Fotospeed, Ilford Ltd, Kentmere Limited, Kodak Ltd, Paulstone Ltd, Process Supplies (London) Ltd, Rayco Chemical Company, Speedibrews and Tetenal Ltd for their generosity.

Ag+ photographic for the tables on page 156.

Richard Dawes for burning the midnight oil with him.

THE PHOTOGRAPHER'S MASTER PRINTING COURSE

First published in Great Britain in 1994
by Mitchell Beazley, an imprint of
Octopus Publishing Group Ltd,
2–4 Heron Quays, London E14 4JP

© 1994 Mitchell Beazley
Text © Tim Rudman
Photographs © Tim Rudman
This edition published 2004

Editor **Richard Dawes**
Executive Art Editor **John Grain**
Designer **Geoff Fennell**
Indexer **Hilary Bird**
Executive Editor **Sarah Polden**
Production **Michelle Thomas**

A CIP catalogue record for this book is available from the British Library
ISBN 1 84000 944 6

Set in 10/12 Linotype Weiss and Monotype Gill Sans

Produced by Toppan
Printed in China

This book recommends the use of various darkroom chemicals which are toxic by ingestion or skin contact and may also be non-biodegradable. For these reasons their supply may be subject to restrictions which differ from country to country. Therefore the reader is strongly advised, before purchasing or using any of the chemicals discussed in this book, to consult the Formulary on pages 148-51 for advice on safety procedures and the hazards associated with a number of the most commonly used chemicals. In the case of chemicals which the book describes as dangerous, the reader should check the conditions of sale and use with an authorized supplier.

CONTENTS

INTRODUCTION

What is it about darkroom work that makes it so exciting, so addictive? What obscure pleasure is gained from stumbling about in a darkened room, peering in the gloom over faint images on the enlarger, waving hands over the paper in a magic ritual and mumbling the ancient incantation 'one elephant, two elephant, three elephant', all the while surrounded by dishes of evil-smelling chemicals? And is it true that you can recognize a printer by the stooped shoulders, long arms, red eyes and pallor — the so-called 'darkroom tan'?

Clearly there is something to it. Something that makes otherwise apparently sane people shut themselves away in the dark for hours, even days on end, when they could be with friends or family, or out in the sun playing tennis, windsurfing — or, yes, even taking pictures. The secret is, of course, the adventure that lies at the heart of darkroom work. It begins with the rush of adrenalin as the print detail materializes before your eyes in the developer and reaches its culmination with the wonderful sense of fulfilment in producing a unique piece of work.

For the darkroom is a place of creation, a place where fantasy can be turned into fact, the real into the surreal, day into night and winter into spring. The feelings that were present at the taking stage, but are so often lost in the straight print, can be recaptured, and even enhanced. Alternatively, brand new images, previously only fleeting presences in the imagination, can become real as finished prints that can be enjoyed, shared, exhibited or published.

Ansel Adams referred to the negative as the score and the print as the performance — and so it is. The performance can be a heady experience: outside pressures melt away, time flies with astonishing speed. It can be strangely exciting and exhausting at the same time. And, like any creative performance, its joys and rewards are offset by occasional frustration and disappointment.

A wide range of skills is required to ensure a polished performance in the darkroom and the more these skills are practised, the better the results become. In turn, the more refined the skills, the more rewarding and addictive is the whole art of printing. But before these skills can be used they have to be learned, and this can be difficult, for the newcomer often encounters closely guarded secrets and inadequate explanations. This book seeks to remedy this situation by setting the would-be printer firmly on a road of learning that need never finish.

The straight print is usually disappointing. Not everything the eye sees is captured on film, for the medium has a limited range of tones and an individual contrast characteristic. Transferring the image onto paper results in an even more drastic loss of information. Also sacrificed are the powerful sensory experiences at the time the picture was taken: the sound and feeling of the wind, perhaps, the rain, the smells, the heat or cold. At the camera stage the imagination is already converting the scene into a mental masterpiece, yet all these qualities are subsequently absent from the straight print. It is no wonder that it falls sadly short of expectation! The miracle of the darkroom is that by the magic of suggestion it can recapture what has been lost, and even replace it with something that was never there.

The Photographer's Master Printing Course progresses step by step through the wide range of printing techniques, from the simple to the very advanced, that make this creative adventure possible. It is designed to take the reader forward from whatever level he or she is starting at.

Simple advice about setting up a darkroom is followed by a close look at the materials used and their individual characteristics, so that sound decisions in this area can be made before the first exposure is even considered. After discussion of basic print exposure and development, along with contact prints, test strips and work prints, there is an examination of the considerable impact that can be achieved by dodging and burning-in.

Contrast — the difference in tonal intensity between different areas of the image — is explained both in terms of the effect it can have on the print and the most effective ways in which it can be manipulated. Among these are the use of variable-contrast papers and pre-development bleaching, which provides a unique means of obtaining many contrast grades from a single grade of paper. Other chemicals can allow the printer to boost contrast substantially, whereas ordinary water used as a bath can provide effective and delicate control of contrast and print detail.

Also covered in detail is 'white light': how it can subtly control contrast, and, by 'flashing', expand tonal range without sacrificing the all-important midtones. Multiple printing is another area that can open up a whole new world of creative darkroom work. It can be used to create fantasy images, or to produce apparently real scenes by swapping foregrounds and backgrounds from different negatives. It is often covered too superficially to be useful, especially for the beginner who experiences early failure and gives up. Here it is covered in depth. Lith printing is renowned for its unpredictability as well as its beauty. It is likewise covered in detail here, together with suggestions for future experimentation.

Once a print is made, the post-printing techniques begin. Local bleaching with agents like potassium ferricyanide and thiocarbamide is explored, and advice given on when, how and how not to use them. Also explained are bleach baths, toners, both for achieving permanence and producing aesthetic effects such as split toning, and multiple and combination toning.

Finally the book introduces the all-important techniques used to preserve a print and present it to its best advantage: archivalling, creating borders, mounting and display.

Several of the processes described in *The Photographer's Master Printing Course* are the result of my own experimentation and are not, to the best of my knowledge, described elsewhere — and certainly not all together in one work. Whether you are new to photographic printing or are already familiar with some of its wide range of possibilities, I am confident that this book will help you to improve in many ways your performance in the darkroom.

RECAPTURING THE ORIGINAL VISION

This 'before and after' pair of photographs demonstrates how important subjective elements that have been lost in a straight print can be restored at the printing stage. I got up onto the high moor at 6.00 am for the shot. Although I recall the thunderstorm that was taking place, together with the feeling of the rain and wind, and the smell of the wet grass, no impression of this experience is conveyed to the viewer by the straight print.

The paper was pre-flashed to help control the extremes of contrast in the dark side of the backlit stones on the one hand, and, on the other, the bright areas of the sky, where the sun burst through. Despite this contrast problem, this enabled me to increase the paper grade to a nominal grade 4 and to get well-separated midtones without losing control of highlight and shadow areas.

I cropped off the empty foreground grass and rotated the picture clockwise on the easel to give a more dynamic feel to the composition. The stones were individually dodged and the rest of the picture built up by a series of thirteen extra exposures, darkening the sky and producing the 'light path' between the clouds, as well as darkening the grass in the foreground.

The shaft of light was enhanced by potassium ferricyanide solution in 'hypo', and the stones reduced in tone where necessary, in the same way. It was also used to enhance the rim lighting and remove signs of masking and dodging.

The print was washed, bleached in potassium dichromate and hydrochloric acid, and redeveloped in a high-contrast developer in daylight to intensify the blacks, and finally soaked for 15 minutes in dilute rapid selenium toner (1+20). The tonal shift achieved is unusual for multigrade in selenium, and follows dichromate intensification. This also provides a way of selenium split-toning with multigrade which is not available after normal development and fixing.

All these techniques, and many others, are fully explained in this book.

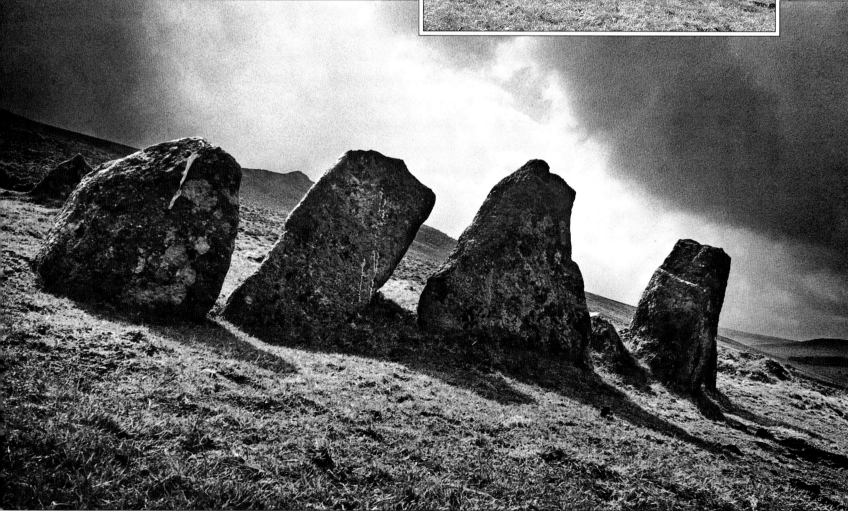

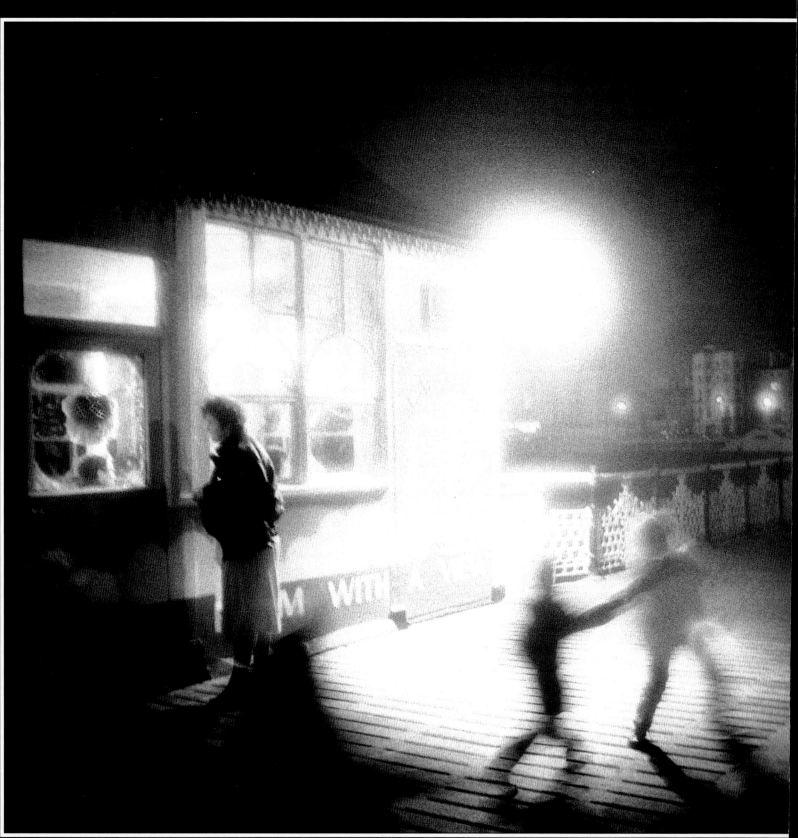

A darkroom can range from an improvised, even temporary workspace to an elaborately equipped room permanently set aside for the purpose. But whatever form the working environment takes it must be suitable for the exacting task of printing. A poorly planned darkroom will not produce the results your negatives deserve. Instead it should be inviting, comforting and above all well planned, for the fewer distractions and inconveniences there are, the more undivided attention you can give to the production of high-quality prints.

This introductory section of the book shows you how to set up and equip a darkroom, and explains how to use enlargers, papers, chemicals and negatives. In this way, if you are a beginner to darkroom work you will be properly equipped and prepared to begin printing. Those who are already familiar with the basic darkroom practices may prefer to go straight to the next section.

Parallel world *For this night-time photograph, illuminated by the pier's halogen lights, the technique of burning-in was used to emphasize the bright focus of interest and suppress the surrounding dark area. The scene was shot on infrared film with a red filter over the lens. In combination with a slow shutter speed to blur movement, this portrayed the children as ghostlike figures.*

THE DARKROOM

This book is not about how to build a darkroom; it is about how to make good black-and-white prints. However, printing cannot be divorced from the environment in which it takes place. If your darkroom is cold, cramped and chaotic, or disorganized, dusty and dysfunctional, it will adversely affect what you produce there. As far as possible, the darkroom should be inviting, comfortable and easy to work in. When you are printing, the fewer the distractions there are to be avoided or obstacles to be overcome, the more undivided attention you can give to the task and the greater your chances of success.

Of course, this does not happen by chance; a practical and comfortable darkroom is the result of careful thought and planning. Whatever your budget, plan carefully first then prioritize your spending. If possible, leave room for later expansion. You do not have to do it all at once, but what you do, you should get right.

Site and size The site is immaterial — to an extent. I know people who produce good pictures in cupboards, caravans, cellars and attics. Bear in mind, however, that as your skill and enthusiasm grow — and they will grow as you acquire the skills explained in this book — your need to store more paper, equipment and chemicals will also grow. So will the size of the paper and the dishes you use, and the room you will need for processing.

It is best if there is enough space to work unrestricted, but not so much that you get tired from walking. Maximize working surface and minimize walking surface. Spare floor space is the best place to store your largest bottles of chemicals — if these fall from a high shelf the damage can be spectacular.

Attics and sheds are often used as darkrooms since they provide cheap, already available space, and are easily blacked out. In most cases their main disadvantages are a lack of running water and extremes of temperature in winter and summer. You can easily solve the first problem by taking in large containers of hot and cold water before a session, and regularly taking finished prints into the bathroom to wash. The problem of temperature affects both personal comfort and your ability to control the temperature of working solutions. Give careful thought to the installation of ventilation

and additional insulation, for if the room is uninviting you will find reasons not to use it.

Bathroom darkroom A spare room customized for the purpose is the ideal, but if this is not possible, most bathrooms can be used as a perfectly adequate temporary darkroom. A bathroom has some form of room-temperature control, lighting, and windows which can be used for ventilation between blackout periods. It has running hot and cold water, and the bathtub can act as a large print-washing bath as well as supporting a work surface holding dishes, drum or deep tank. In some countries its main drawback will be an absence of power points. This problem is not insurmountable. The space available will usually permit the use of warm-water

PERMANENT DARKROOM TIPS

- Dry bench space is always at a premium. Always plan for more than you think you will need.
- On the wet bench, if it is possible allow enough space for four dishes of the largest size you are likely to use, rather than the usual three.
- It may be worth while to install an additional cold tap, so that you will have one free when the other is being used to wash prints.
- Never store large paper boxes upright, as this can cause the sheets to bow and stress the emulsion, which will lead to printing faults.
- A Perspex squeegee panel beside the sink is invaluable for removing excess moisture from prints.
- Add a lip to the edge of the wet bench to contain small spillages. Alternatively, but at greater cost, the whole wet bench can be incorporated in a shallow wet-bench sink.
- Different lengths of hose can be used on the taps, making it possible to take water to the dishes rather than the reverse. This also allows washing down of all areas, and of eye and skin in case of accident, and is useful for local print bleaching.
- A low-output light source such as a night light is useful for flashing and fogging. This can be connected to the timer via a switchable gang.
- Small bottles may be stored on shelves on the wet side, but large bottles should always be stored on the floor, from which they cannot fall.
- A refrigerator is useful for keeping paper fresh and away from harmful gases.
- Drop-down work surfaces allow flexible use of space in appropriate areas.
- Allocate a home to every item you use, and store it there when it is not required.
- Allow yourself some home comforts — a welcoming chair and a radio or a tape or CD player, for example — especially if you plan to spend a lot of time in the darkroom.

THE PURPOSE-BUILT DARKROOM

Whether the darkroom is purpose-built or temporary, the wet and dry sides should be well separated, to avoid contamination and electrocution. Many efficient darkrooms are much smaller than the one shown here, but thoughtful planning can achieve wonders. Large storage bottles should be kept on the lowest available level surface, which in most cases is the floor. A lock on the door stops inquisitive visitors from dropping in unannounced, and keeps children away from the chemicals.

Key

1 Dry bench
2 Paper safe
3 Focusing aid
4 Dodgers
5 Foot-switch
6 Lightproof drawer
7 Masking easel
8 Enlarger
9 Enlarger timer
10 Light box
11 Flashing/fogging light
12 Guillotine
13 Negative drying cabinet
14 Film developing tank
15 Graduates
16 Film developing reel
17 Resin-coated print drying rack
18 Tongs
19 Archival print washer
20 Perspex squeegee panel
21 Blackout material
22 Safelight
23 Extractor fan
24 Processing timer
25 Dishes
26 Dish heater
27 Large storage bottles
28 Wet bench

THE BATHROOM DARKROOM

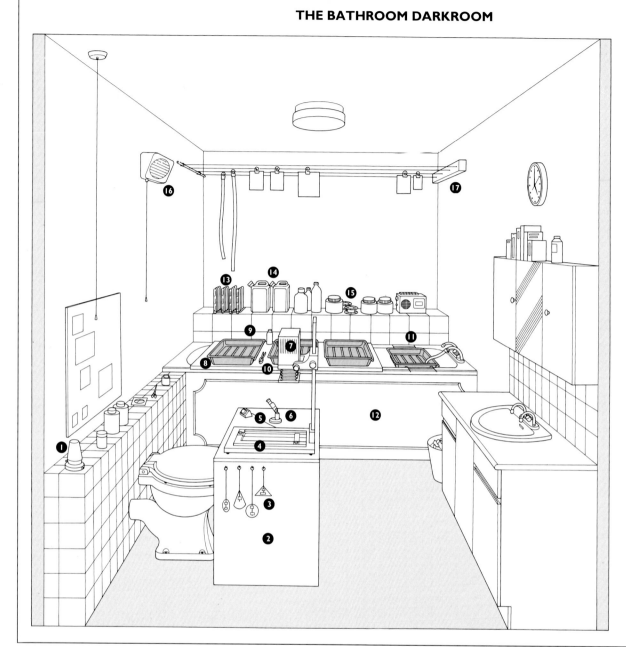

Regulations concerning the use of electricity in bathrooms vary from country to country, and you should seek professional advice on this. If you have to take cables to a power point outside the bathroom, an isolating transformer may be used outside the bathroom, between the appliances and the power point. Whether the power point is internal or external, take care not to trail cables across the floor, as this can be dangerous.

Key

1 Beehive safelight
2 Folding enlarger table
3 Dodgers
4 Masking easel
5 Enlarger timer
6 Focusing aid
7 Enlarger
8 Bathtop wet bench
9 Dishes
10 Tongs
11 Print washing tray
12 Bath
13 Resin-coated print drying rack
14 Chemicals
15 Film developing tank and reels
16 Extractor fan
17 Film and print drying line

baths to control the temperature in dishes smaller than 20in x 16in (50cm x 40cm). Mechanical timers can be used instead of electrical ones, and it may be possible legally to run safelights and the enlarger off the ceiling light. An advantage of a tiled bathroom is that it can be cleaned easily and quickly after a session.

A typical arrangement for a temporary bathroom darkroom is shown above. A serious warning is needed here: water and electricity do *not* mix. Whatever the site or layout of your darkroom, and whether it is to be temporary or permanent, you *must* address this question as a priority. If in doubt, seek advice. For the above reason, wet and dry procedures should be well separated, so

make this a fundamental design objective when planning your darkroom. A common arrangement is to have a wet bench and a dry bench on opposing walls, since as well as lessening the risk of electrocution, this set-up minimizes chemical contamination.

Floor If possible, the floor should be:
• comfortable
• even
• water-, stain- and dust-resistant
• easy to clean.
A good choice of floor covering is cushion vinyl, treated at the edges with a mastic sealant so that if you

spill a chemical it does not go through the floor. It is kind to the feet and allows a chair on castors to glide about easily. This is very important, because hours of standing can reduce the fun of picture making and adversely affect your results. Never underestimate the importance of comfort in the darkroom.

Ventilation A darkroom can easily become a stuffy, fume-filled hell-hole which can make you feel unwell. Some of the chemicals used, though not all, are actually toxic, and so it is essential to provide good ventilation. This may simply mean opening the windows periodically, or installing an extractor fan. Portable air-filtration devices may be a helpful alternative, but many small ones are inadequate for the job. They should filter both particulate matter (dust) and odours. If you are thinking about installing an extractor fan, consider where it will extract the foul air to. Filling the area adjoining your darkroom with fumes may not be appreciated by other members of the household. If you extract air from the room, you also need to have fresh air coming in to replace it. It may seem obvious, but it is often overlooked, that the ventilation must ensure that air flows across the wet bench and takes fumes with it. Bear in mind too that the incoming 'clean' air can bring with it unwelcome dust. Fitting a simple filter on the inlet — a stocking or thin sheet of sponge will do — will solve this problem.

Lightproofing The purpose of the darkroom is to enable you to work in a controlled light source that will not affect the materials adversely. Therefore it is essential to ensure that the room is completely lightproof. If an extractor fan is present, it must incorporate a light baffle. Extractors designed specifically for the darkroom usually have a built-in baffle, but they are expensive. A cheaper alternative is to construct a baffle to fix to the outlet of an ordinary extractor fan, as shown above. Although effective for lightproofing, a home-made baffle does impede the flow of air somewhat, so make sure the extractor's capacity is generous for the room, and not already marginal.

You can lightproof doors and windows quickly and inexpensively by attaching purpose-made blackout materials to them with Velcro. Note, however, that some opaque-looking materials are not truly lightproof. It is therefore wise to sit in complete darkness for a quarter of an hour to allow your eyes to adjust fully before opening film or paper containers.

Minor light leaks may be within safelight levels and invisible with the safelights on. But beware when handling film, which is more sensitive than paper and should be handled only in total darkness. Carry out the test with exterior lights on, and in hours of maximum daylight. Darkroom roller blinds are a more convenient

Not only is good ventilation necessary in the darkroom, but the system used must be lightproof. Here a simple home-made baffle is shown attached to the outside of an extractor fan. It lets air out but stops light entering. All internal surfaces of the baffle should be black.

but more expensive alternative. The walls of a darkroom need not be painted black, as some believe, for if your lightproofing is adequate, the only light to be reflected from the walls is that from the safelights, which, by definition, is safe. The one exception to this rule is the wall — and possibly the ceiling — adjacent to the enlarger, where there may be unsafe light leakage. This area is often painted black. A white darkroom has a much less claustrophobic feel to it than a black one.

Safelights The light given by a safelight is of a 'safe' wavelength, allowing you to see what you are doing without fogging the paper. Safelights are not safe for conventional (panchromatic) film and must be kept off altogether when this is being handled in the unprocessed state. Orthochromatic (litho) film may be handled in a red safelight.

Graded papers for black-and-white printing are made to be sensitive to blue light and are therefore unaffected by yellow or red safelights. Variable-contrast papers are

BATHROOM DARKROOM TIPS

• Use the bath only as a combined wet bench and washing 'tank'. Never use the bathtop work surface to hold the enlarger or any other electrical equipment.

• A folding table placed in front of the toilet to hold your enlarger, not only saves valuable space but also allows you to sit comfortably while you work! The table should be as stable and vibration-free as possible, otherwise your prints will not be sharp.

• Safelight bulbs can be used in the ceiling light. A better alternative is to use a portable, free-standing safelight of the beehive type, which will give the choice of safelight or main light, as required.

• Be aware that regulations covering the use of electricity in the bathroom differ from country to country. Ensure that you comply with these.

• If there is a window, this can be blacked out either by using a sheet of hardboard — effective but inconvenient to store — or vinyl sheeting. This is quickly attached with Velcro, and can be folded for storage. Its disadvantage is the need for permanent Velcro strips on the window frame.

• The door can easily be blacked out by hanging lightproof material from the top of the frame. It may be necessary to use a 'sausage'-type draught excluder to hold the curtain in place at ground level.

• If the bathroom is used by others, especially children, make sure that you remove all chemicals, and store them in a safe place, when it is not in use as a darkroom.

• Adequate ventilation is important because of the chemicals used in what is often a confined space. If there is no extractor fan, open the door and window periodically between prints.

TESTING SAFELIGHTS

It is obviously important to test the safety of your safelighting when setting up or changing your darkroom. It is also wise to retest regularly, because:

• Different darkroom materials have different sensitivities.

• Distance as well as safelight colour can affect safety.

• Filters may crack or fade over time, becoming unsafe.

• Printing in unsafe light will impair your work, try your patience and eventually undermine your confidence.

There are several dependable tests for safelights. The procedure outlined here is for two safelights, one near the enlarger and one at the wet bench. It can be simply modified for any number of safelights. Both safelights were deliberately made unsafe for this test, to give positive results.

Procedure Make the test using strips of your fastest (most sensitive) paper on the baseboard. Tuck one edge of each strip under the easel blade to give a strip of pure paper-base white for reference (not shown here). The numbers below refer to the strips in the order illustrated.

1 A 'flash test strip' is made to determine the paper's fogging threshold. (The procedure for this is explained on page 81.)

2 This tests for the enlarger safelight. The wet bench is kept off. The paper is fogged to light grey, using strip 1 as a guide. Ten coins are placed on the paper one at a time at one-minute intervals. The paper is developed for twice the usual development time for normal printing. This test not only shows if the safelight fogs your paper but also indicates for how many minutes your paper is safe under this light.

3 This tests for both safelights together: the procedure for strip 2 is repeated, this time with the wet bench safelight on. If this is unsafe, the background will be darker and the coin marks veiled, indicating extra fogging during development.

4 This reveals a trap in not testing safelights individually. If your wet bench safelight is very unsafe, the extra fogging here may cause the coin marks to disappear completely. This could lead you to believe that they never existed and that the enlarger safelight was therefore satisfactory, which it was not in this illustration.

5 This illustrates the importance of pre-fogging the paper. If strip 2 is repeated without doing this, the paper may be white or near white even though the enlarger safelight is unsafe. Every picture you print involves exposing the paper — pre-fogging simulates this. Remember too that exposure is cumulative — it also occurs during unpacking, repacking and trimming, for example.

6 This shows additional fogging by the wet bench safelight. Place half of strip 2 alongside half of strip 3, when any difference in tone will be immediately apparent.

Always thoroughly dry your test strips before interpreting them, as marginal fogging may not be apparent before 'dry down' (see page 44).

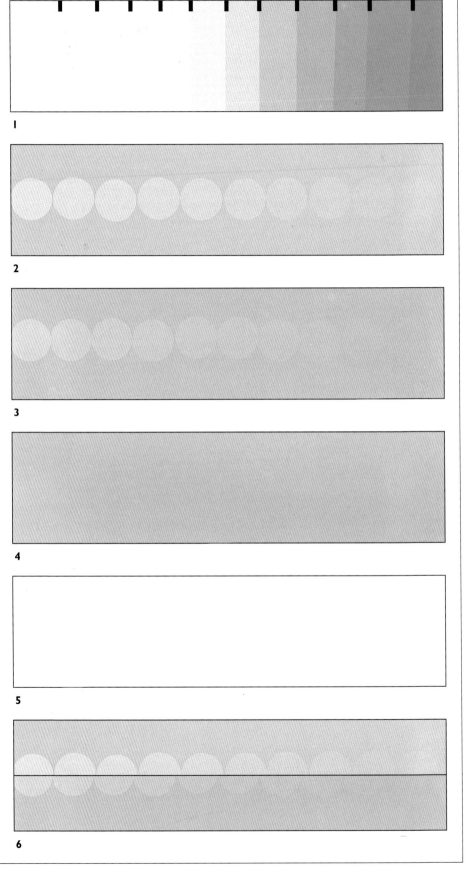

1

2

3

4

5

6

sensitive to a wider range of colours than graded papers and have different safelight specifications. While most graded papers are safe under these, not all variable-contrast papers are safe in graded-paper safelight conditions. Therefore check the paper manufacturer's specifications carefully.

Safelights take the form of either a bulb or striplight covered by a changeable filter, or rows of LEDs (light-emitting diodes), which give a fairly bright light with a very narrow wavelength. Different wavelengths for different materials (including colour paper) can be selected with a switch. LED safelights are particularly useful therefore if you print in both black and white and colour, but they are more expensive.

The number of safelights you require depends on the size of the darkroom. They should be placed where they are most useful: usually near the enlarger and over the developing area. Ideally they will be separately switchable, and the 'dry' light can be linked to the enlarger, or not, as preferred. On occasion you may be working with a negative which is dense, or is projected through a small lens aperture, so that you have only a faint image to work with. In such instances it can be helpful to switch off the safelight.

Dust Apart from unsafe light, the main enemy of the darkroom is dust, although only if it is moving around. A dust-free darkroom is a rare achievement. Concentrate therefore on keeping enlargers, lenses and negatives meticulously free of dust and do nothing to stir it up in the rest of the room. Electric fans have no place here. All that is necessary is to regularly wipe all flat surfaces with a large damp cloth. In addition, an antistatic brush and a can of compressed air are invaluable for keeping dust off the critical working surfaces — negatives and glass negative holders.

Lights If you are customizing a darkroom, consider the following points concerning lighting. Ceiling lights are better operated by a pullcord of the kind used in bathrooms, rather than by a wall switch, which can cause an electric shock if touched with wet fingers. They are usefully sited at the door and operated by a two-way switch connected to a cord near the enlarger, or a cord at the wet bench, or both. These arrangements allows the lights to be switched on when you enter or leave the darkroom, and at crucial moments when you are working. Some darkrooms have a horizontal pullcord which spans the room. The choice depends on your darkroom design. Luminous tabs, which are safe for film and paper, can be stuck on cords and switches to help you find them in the dark.

Additional illumination from desk or clip lights can be useful in various strategic positions. These lights can also be operated by a foot-switch in 'dry' areas. Blue daylight bulbs can be helpful during bleaching, spotting and colour assessment. The level of light used to assess the finished wet print deserves careful thought. Some printers prefer indirect light, others direct; some muted, others strong. The light you choose should depend on the kind of printing you do and how you intend to display your prints. You will probably want to vary it according to whether you are printing for an illuminated easel, an exhibition wall, your sitting room or for publication. Don't spend too much time on this to start with. If your prints look too dark when displayed, you will soon realize that your inspection light is too bright. However, see the reference to 'dry down' on page 44.

Paper safes and drawers Because they contribute so much to smooth, effortless working in the darkroom, I regard either a paper safe or a drawer as essential. Paper safes come in various sizes and designs. They are light-proof containers which feed you paper sheet by sheet as you need it, without your repeatedly having to open and close inner and outer packets. If you are doing a lot of printing this can become a tedious business and sooner or later you will take short cuts and unintentionally fog your stock of paper.

My preference is for a large, light-tight drawer on the underside of the working surface, located either beneath or next to the enlarger. If you have a free-standing enlarger, build the drawer underneath it with a gap above your knees so that you can sit at the easel. If you have an enlarger bench with a baseboard which you raise and lower, install the drawer next to it. If there is enough space, the drawer should be several inches bigger than the largest paper you use, and just 3-4in (8-10cm) deep.

Provided you are systematic, you can store several different papers in different parts of the drawer. This makes working so quick and easy that you will never be without one again. However, if you leave it open, you could make an expensive mistake. A further word of warning: if you are using a number of papers, repacket them at the end of a session. You may think you will remember which is which next time, but there is a good chance that you won't.

Safety Finally, a word about good darkroom practice. You should never smoke in the darkroom, and never eat or drink.when you are handling chemicals. You should label all chemicals clearly and make them inaccessible to children.

A MAKING A LIGHTPROOF PAPER DRAWER

A light-tight paper drawer is a real boon to a darkroom and it is not difficult to make..

Drawer Construct a simple drawer from ½in (1.25cm) plywood, about 3in (7.5cm) deep and several inches larger than your largest paper. I find a drawer of 20in × 24in (50cm × 60cm) ideal as it holds large sheets and several smaller sizes at the same time. Use woodfiller to fill any gaps in the joins to ensure that they are lightproof. Paint all the internal surfaces matt black.

The envelope Construct a plywood envelope, closed at the back and open at the front, just big enough to accept the drawer. Make all joins lightproof. Paint the internal surfaces matt black — this is easier before assembly. Add two or three plastic or metal glider strips to the bottom inside surface to ensure smooth running.

The drawer front: Make a supplementary plywood drawer front 1in (2.5cm) larger all round than the original front. Around the edge of this, fix four strips of ½in (1.25cm) plywood up to 1½in (4cm) wide to make a rebate. The envelope will fit snugly into this, forming a light-tight seal. Paint the inside of the rebate matt black.

The envelope seal Fix ½in (1.25cm) × 1½in (4cm) plywood strips to the outside of the envelope all around, to abut

snugly with the drawer front assembly when the drawer is closed. This completes the light seal. Instead of using a plywood strip on the envelope top, you can use a sheet of the same size as the top. This will make it easier to attach the envelope to the underside of the dry bench.

Screw the envelope under the enlarger, unless you have an enlarger table with a movable platform as described earlier. In this case fix the envelope beneath an adjacent dry bench area.

The drawer and envelope should form a snug fit. If the drawer glides too freely it may open accidentally if your knees brush it as you get up. If so, either fix a small catch at one side or stick a piece of masking tape across the join. This can be peeled back for opening and pressed down again on closing many times before it needs replacing.

Important: Before entrusting a whole packet of paper to your finished drawer, do a paper test with one sheet as follows. Fog a whole sheet to maximum flash or light grey as described for safelight testing on page 14. Cut the sheet into four quarters and label these 1, 2, 3 and 4 on the backs. Place one piece in each corner of the drawer with a coin in the centre of each. Close the drawer, put on all the lights, and go and enjoy a cup of tea. After an hour or so, develop your papers and dry them thoroughly before assessing them. Any light leak will be obvious, and you will also know which part of the drawer is at fault.

Last but not least, make sure that everybody who is likely to enter the darkroom knows the consequences of opening the drawer to see what is inside!

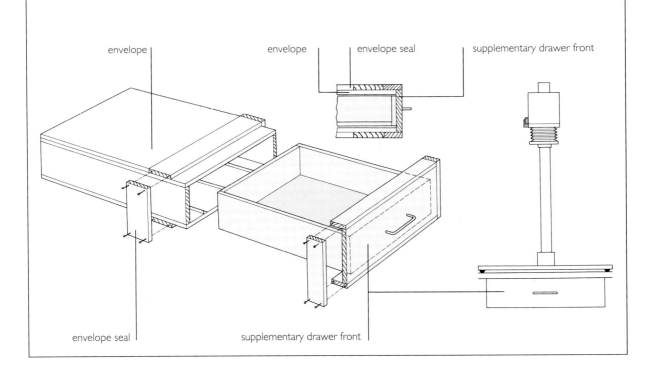

envelope envelope envelope seal supplementary drawer front

envelope seal supplementary drawer front

TOOLS AND EQUIPMENT

The most important purchases you will make for your darkroom are the enlarger and its lens. Much of the success of your endeavours will be the result of your skill, but if your enlarger is giving you images with 'hot spots' and pale corners because of uneven illumination, or poor sharpness as a result of bad alignment or vibration, no skill you can apply will change that particular sow's ear into a silk purse. So spend as much as you can afford on an enlarger that meets your own particular requirements. This by no means rules out buying a used model, for enlargers rarely wear out. Many are sold in good condition at reasonable prices for no other reason than that the owner is trading up to a better model.

Choosing an enlarger Enlargers are classified by the format(s) of film they are designed to accept and the type of illumination they provide. Consider a model which accepts a variety of formats even if initially you plan to use only 35mm film. The flexibility may be useful for darkroom manipulations even if you stick to just the one camera format. But if you really do intend to use only 35mm, and your budget is tight, make a top-quality enlarger lens your priority and buy a better enlarger later. There are three main types of enlargers: condenser, diffusion and cold cathode.

Condenser enlargers A condenser enlarger focuses the light through glass condensers into a unidirectional beam before it reaches and passes through the negative. This produces a print in which the grain is sharply emphasized. Also sharply emphasized are any scratches, flaws or dust that may be on the negative, and this in turn necessitates more time for retouching. The prints have a sharp, crisp appearance, with wide separation of highlight tones. This is due to the Callier effect (see page 66).

Diffusion enlargers In a diffusion enlarger, light travels through a mixing box and an opal diffusion screen above the negative. It passes from many directions simultaneously through the negative to the paper and consequently has a softer, gentler quality, which gives a lower-contrast print grade for grade and loses or reduces many negative flaws. The prints usually have an open look, with more evenly distributed highlights, and more closely match the tones in the negative.

The tonal differences between the prints produced by condenser and diffusion enlargers are due to the way light passes between or around the silver grains and do not occur with chromogenic black-and-white or colour films which contain dyes rather than silver. Some enlargers allow you to to switch from one type of illumination to the other by changing 'modules', or even to combine the two. In any case, a condenser enlarger can

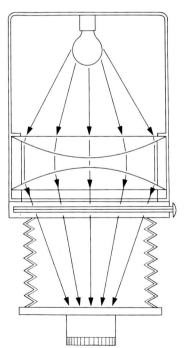
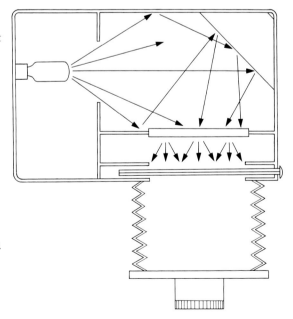

In a condenser enlarger, left, condensers focus the light so that it passes through the negative in a unidirectional beam. This emphasizes contrast, grain, dust and any imperfections in the negative. In a diffusion enlarger, right, a mixing chamber 'scrambles' the light before it reaches the diffuser. The light reaches the negative from many directions, producing a softer print than a condenser enlarger, with highlights more closely resembling those on the negative.

be converted into a diffuser by inserting diffusing materials (for example, opal, frosted glass or tissue paper) above the negative.

Cold-cathode enlargers High-quality fluorescent tubes are used in cold-cathode enlargers to give a very diffuse light which reaches its full intensity rapidly without getting hot. These tubes produce a light rich in blue or blue-green to which black and white paper is very sensitive, so that exposure times are shorter than with other types of enlarger. Special filtration may be required to make cold-cathode enlargers suitable for use with variable-contrast papers, which have a different sensitivity from single-grade papers.

Filtration If you plan to print on colour paper, or to use variable-contrast papers for black-and-white printing, the enlarger must have a filtration system to change the colour of the projected light. Older condenser enlargers may have a filter drawer for the insertion of gelatin filters. Those with no filter drawer can be fitted with an under-the-lens filter holder. Because the filters may be less optically sound than the enlarger lens, they may degrade results slightly, although this is not usually a significant problem if they are well looked after.
Many new enlargers are designed on the 'modular' system, using a dial-in filter module in the head just in front of the light source. Separate modules are available for variable-contrast paper for black-and-white printing, marked in grades, and for colour paper. Colour heads can be used for variable-contrast papers, and most manufacturers supply filtration tables for this purpose. However, better results at grade 5 can usually be obtained with a purpose-built black-and-white module. (See Filter Settings table on page 154.)

Illumination Whatever the enlarger type, its illumination must be even, with not more than ¼ stop 'fall-off' at the edges. This phenomenon, which occurs because the light has to travel a slightly greater distance to reach the edges of the image, can be measured with a light meter. If it is greater than ¼ stop, check the lens is the correct focal length for the format (about 50mm for 35mm), check the condensers and the bellows position, and finally check the type and position of the light source. This is usually only a problem with old-fashioned or cheaper enlargers, but it must be corrected if present. When you are satisfied, with no negative in the carrier expose a 'print' to a mid-grey, and then develop and inspect it. Make sure that the enlarger is focused on the edges of the negative carrier, and also that the edges are included just inside the borders of your print, otherwise any fall-off present will occur outside the boundaries of your print and you will not see it. Do this at your lens's largest, smallest and middle apertures. Any

shortcomings should be apparent, and these prints can be compared with a further set made after adjustment of the illumination.
Along with even illumination, you should always ensure that the enlarger is aligned accurately to give corner-to-corner sharpness, as described on page 30.

Enlargement range Before buying an enlarger, check that the maximum enlargement possible on the baseboard matches your requirements, allowing a reasonable margin for cropping. If, for example, you intend to produce 16in x 20in (40cm x 50cm) exhibition prints and this is the maximum size your enlarger gives on the baseboard, you will only achieve the size you want if you always print the entire negative, and this may not suit your style of photography.
Many enlargers allow you to make very big enlargements by rotating the head in order to project the image onto a wall, as on the opposite page. This may prove more difficult than it sounds, for walls are not always square, and paper prefers to lie flat horizontally. Some enlargers allow rotation of the column so that it projects down onto the floor. This arrangement takes up more valuable space, and although workable, it may be cumbersome.
If you intend to make very big enlargements it is best to use an enlarging table. This allows the baseboard to be repositioned at a number of stages between the usual position and the floor. It also allows you to position the head at a comfortable height for dodging and burning-in. The position of the hands relative to the lens and the paper is very important for both your own comfort and the result, since the edge of the shadows cast becomes sharper the closer your hands are to the paper.
The enlarging table allows you to maintain your hands at a comfortable working height, but to vary their distance from the lens and paper as required. In most cases it also allows you to avoid using the enlarger with its head at maximum extension up the column, which is the most unstable position.

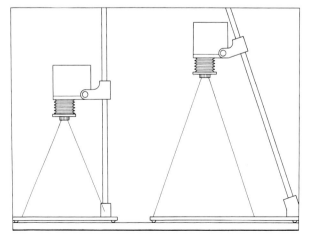

Above a certain degree of enlargement the image projected by a straight-column enlarger tends to cause the masking frame to foul the base of the column. An enlarger with a sloping column overcomes this problem. Before the image reaches the column the head will have reached its maximum height, and moving the easel, for selective cropping, should still be possible.

Enlarging lenses Along with the enlarger, the lens is the most critical piece of equipment in the darkroom. Since it dictates the level of print quality you can achieve, you should always buy the very best you can afford. Clicked aperture settings should be regarded as essential, and preferably offer half stops. The focal lengths will depend on the negative format in use, but these are the standard recommendations:

Negative size	Focal length
35mm	50mm
2 ¼in x 2 ¼in (6cm x 6cm)	80mm
6cm x 7cm	100mm/105mm
6cm x 8cm	100mm/105mm
6cm x 9cm	135mm
4in x 5in (10.5cm x 13cm)	135mm/150mm
5in x 7in (13cm x 18cm)	210mm
8in x 10in (20cm x 25cm)	350mm

Some printers prefer to use lenses with focal lengths slightly longer than average because they produce less fall-off in illumination and may make the image appear sharper at the edges. A disadvantage, however, is that they reduce the size of the projected image.

A lens with a maximum aperture of $f2.8$ will give a brighter image for composition and focusing than one of $f4$, and is well worth having for this reason alone. But I suggest you avoid exposing at this aperture unless exposure times are exceptionally long, since the optimum performance is likely to be at $f5.6$ or $f8$.

Timers A timer is essential. Mechanical timers are cheaper than electronic ones, but less accurate. I use an f-stop timer, the benefits of which are discussed in more detail on page 45. This allows me to think and work in f-stops at the printing stage just as I do at the picture-taking stage. I lighten or darken areas of a print in fractions or multiples of f-stops, which I programme into my timer. This in turn converts them into seconds for the enlarger. Each print has its own f-stop exposure map which is always reproducible no matter what the size of the print being made. If possible, connect your timer to activate the enlarger and be operated by a foot-switch, in order have both hands free during exposure.

Enlarging easels If you plan to make both large and small prints you may, depending on your enlarger, need to have enlarging easels of two sizes. The large easel may foul the base of the column if you try to use it for small prints. Make sure it is sturdy, with rigid blades which are adjustable in case they lose accurate alignment. It should be heavy enough not to move when opened for the insertion of paper, and it should hold itself open until it is closed, leaving both hands free. Wide blades are required to produce wide borders, and four-bladed easels offer more flexibility in border design but are usually more expensive.

Print washers The choice of print washers embraces inexpensive siphons which clip onto trays and very costly washing units for archival washing of fibre-based prints. Alternatively, washing the print in a purpose-made sink allows it to circulate in constantly changing water, but if it is the only sink you have you may experience a clash of uses. In addition, freshly fixed prints constantly recontaminate those in the wash, so a double

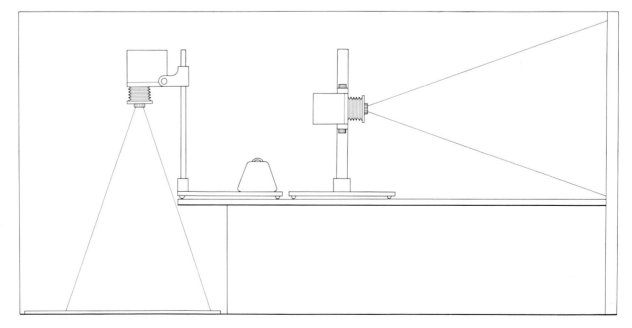

To make extra-big enlargements it is often possible to swivel the enlarger head round and project the image onto the floor. If you do this you should weight down the baseboard beforehand. Projection onto a wall is also possible, but difficult. Getting a masking frame to lie flat vertically, hold the paper flat and stay closed calls for a system of support. Commercial supports may prove difficult to find, in which case you may need to design and contruct one yourself.

washing system is useful. In this, prints are transferred after a preliminary wash into hypo clearing agent and then given a second wash in clean water.

Resin-coated prints need only short washing times and usually pose no problems, since chemicals are easily and quickly washed off their surface. However, fibre-based prints absorb chemicals deep into their structure and prolonged washing is necessary. Together with the pH (acidity/alkalinity) changes that occur during the processing cycle, this property makes their emulsion vulnerable to damage. This is especially important if the print is to be subsequently toned, because any such damage makes the toning less likely to be even.

Ideally, fibre-based prints should be washed in changing water for long periods without recontamination and without damage from other circulating prints. This is the *raison d'être* of the archival print washer, an expensive unit for serious users of fibre-based paper who tone prints or wish them to survive without deterioration for many generations to come.

Print driers Again a distinction needs to be made between resin-coated prints and fibre-based prints, and in the case of the latter, what kind of surface is preferred and whether or not toning is planned at a later date. Prints made on resin-coated paper may be dried in a warm-air drier for speed or with a hair drier. Alternatively, they can be drip-dried in racks or suspended from a line.

Fibre-based prints are usually dried either quickly in a flat-bed heat drier or slowly on mesh screens, or are hung up back to back. The last method is advisable if toning is envisaged, since it avoids trauma to the soft emulsion by the use of heat or a squeegee. Flat-bed driers vary considerably in their performance, particularly in the evenness or controllability of the heat they provide. They should be used only for fibre-based prints, and only when these are archivally washed, otherwise fixer will soak into the linen apron and be transferred to the next print.

A good heat drier is not cheap — but for that matter neither are most of the bad ones. Nor is it essential to have one, so if your budget is tight, buy a multiple-strand pull-out washing line to hang over your wet bench or in the bathroom.

Dishes and tanks As you develop your skills, you will be surprised how many more dishes you need, so it makes sense to label them individually, or colour-code them, to denote the different chemicals you use. Small dishes are quite cheap but the price rises sharply at 20in x 16in (50cm x 40cm) and larger. At such sizes it becomes important to ensure that they are of good quality, because you will be carrying harmful chemicals. Cheap large trays bend easily when laden, setting up

An enlarger table makes it possible to alter the height of the baseboard as well as that of the head. This allows you not only to carry out large-scale enlargements or crops, but also to choose the most comfortable working height for your hands during prolonged dodging and burning-in.

tidal waves in the contents. These lead to more bending and cause spillage.

Lack of space is often a problem with dishes. A row of four 20in x 16in (50cm x 40cm) dishes requires about six feet (2m) of wet bench, as well as somewhere to put the prints coming out of the last dish. An alternative is the deep tank, which is a thermostatically controlled unit providing three or four 'slots' for chemicals. These tanks are available in different paper sizes and are effectively a series of trays standing on edge. Paper is lowered into the slot from above, agitated for the required time, lifted out and slipped into the next slot, and so on until the process is complete.

Deep tanks have three main advantages. First, they save a considerable amount of space. Secondly, they are convenient because they may be left switched on to provide an instantly available processing line with no preparation, since the chemicals last one or two months without needing replacement. Finally, deep tanks are economical, especially if you are making only a few prints at a time.

There are several minor disadvantages. You cannot watch the image develop. Nor can you use your fingers to 'rub up' highlights that need encouragement. The stippled surface of the slots can leave a pattern on the prints unless agitation is constant. Sometimes this is not apparent until a print is toned, at which time it suddenly becomes evident. The number of prints you

can process at one time is more limited than with other methods. Lith printing cannot be done this way, since it is not possible to closely monitor progress, but this is a specialist technique.

Additional equipment Tongs are useful for keeping your fingers out of chemicals, particularly when you are making smaller prints. To handle larger sizes I use my fingers, since the extra size and weight of the prints makes tongs unwieldy and increases the risk of their damaging the emulsion. Tong design may seem a trivial topic, but do not be fooled, for there are some really bad tongs are on the market. A good pair will give you years of effortless, flawless use, and it is a false economy to settle for less.

Gloves are essential when handling some toxic chemicals and toners. The best to use here are cheap disposable latex gloves. They are unsuitable, however, if your skin is sensitive to developer or fixer, since they cannot be slipped on and off repeatedly. It is just as important to avoid developer contamination from gloves as it is from tongs, and here two same-handed cotton-lined household gloves are the answer. They slip off easily if pulled at the fingers with your free hand and a cloth kept by each tray.

A thermometer is essential, because temperature control is critical in many processes. Mercury thermometers react faster than the spirit type and should be long, with wide scale markings for accuracy, and have a wide column for easy visibility. Digital electronic thermometers are the easiest to read, and are very accurate.

Footnote 2004: The only ƒ-stop timers currently made are the excellent 'Stopclocks' made by RH Designs in the UK, which I can strongly recommend.

PROCESSING EQUIPMENT CHECKLIST

The first of the two checklists below shows at a glance what equipment you will need for film processing. The second covers paper processing slightly differently, showing my view of what is absolutely necessary, what is useful and what is a luxury. Use these checklists as a guide – your priorities may be different.

FILM PROCESSING
Need
Developing tanks and reels
Plastic graduates
Thermometer
Stirring rods
Plastic washing-up bowl for water bath
Storage bottles
Scissors
Luminous tabs
Film hanging clips
Squeegee or chamois leather
Chemicals
Negative storage files

PAPER PROCESSING
Need
Enlarger and lens
Safelight(s)
Trays (minimum of three)
Tongs
Masking easel(s)
Timer (clock type)

Focus device
Paper
Contact printer
Dodgers and masks
Dust-off spray
Note pad and pen
Spotting kit
Spare brushes
Chemicals

Useful
Apron
Foot-switch
Gloves
Variable-contrast filters
Trimmer
Paper towel
Diffusion filters
Hanging-up lines
Enlarger timer
Wet bench and sink
Deep tank
Adjustable lamps

Light box
Fogging light
Spotting lamp and lens
Film-drying cabinet
Steel rule
Acetate sheets
Photo-opaque paint

Luxury
Enlarger table
Paper safe or lightproof drawer
Driers
Dry-mounting press and tacking iron
Radio and/or cassette tape player
Microwave
Refrigerator
Comfortable castor chair
Calculator
Archival print washer
Lightproof extractor fan

MATERIALS

We have already discussed setting up a dark-room and the tools and equipment that are used there. In the following section of the book we shall consider the materials that are necessary for making a print.

PAPERS

Photographic papers are coated with a light-sensitive silver-halide emulsion. For this reason they must be handled in 'safelight' before and during exposure, and throughout subsequent processing until they have been 'fixed'. There are many types of printing papers, but the most basic distinction is that between fibre-based and resin-coated papers.

Resin-coated papers An emulsion is laid down on a plastic or resin base to form a resin-coated paper. All such papers have short development times, particularly those which have developer incorporated into the emulsion. In many cases the image appears in a few seconds, and is usually complete in one minute. Fixing is rapid and because no fixer is absorbed into the plastic base, washing is complete in a few minutes.

Fibre-based papers The emulsion in fibre-based papers is coated onto paper which is usually pre-coated with baryta, a barium-based substance which stops the emulsion sinking into the paper and taking on its surface characteristics. Document art papers lack this layer, and have a characteristic art-paper surface. Baryta can also be impressed with a variety of surface finishes. Finally a protective 'super coating' is applied to the paper emulsion.

Processing chemicals penetrate the fibre base of these papers, necessitating prolonged washing to remove them. Unless fixer is adequately washed out, it will in time penetrate the emulsion layer from underneath, and damage the image.

All this raises the question of which of these two papers to use, and when. Both come in a variety of types, tones, weights and contrasts and each has characteristics to recommend it. The answer is both, but for different purposes. It depends entirely on your requirements. I use resin-coated paper for contact prints, prints for reproduction, some proof printing and some experimental work where the speed is an advantage. I use fibre-based paper for exhibition and personal work, where I am happy to invest the considerable extra time for what I perceive to be the advantages.

These are as follows. Firstly, they produce better results with toning, bleaching and the various experimental techniques described in the next section of the book. Secondly, they give deeper, richer, better-separated dark shadow tones. (You would have difficulty in proving this with a sensitometer, but the difference is undeniable.) Thirdly, the results are more pleasing to view and handle. Fourthly, they make afterwork on the print easier and more effective. Finally, is still probably true that fibre-based prints are more permanent when archivally processed than resin-coated prints.

Although opinions vary as to the merits of each type of paper, very few fine art printers use resin-coated paper for finished work. The subtleties in a finished print owe a good deal to the material on which it has been made.

The other main differences between printing papers as a whole are described below. The various types are, in the majority of cases, available in both fibre-based and resin-coated versions.

Emulsion type The emulsions used in printing papers consist of silver halides (this is a generic term which embraces bromides, chlorides and fluorides, of which the first two are used in photographic emulsions). Emulsions are light-sensitive and are subsequently converted to metallic silver grains by processing.

Bromide papers have an emulsion consisting only of silver bromide, which lends a 'cold' tone — black or blue-black — to the image. Agfa Brovira is perhaps the best known of this comparatively small group of papers.

Chlorobromide papers contain a majority of silver chloride, with some bromide, and give a much warmer brownish-black tone as a result of the fine grain structure of the chloride present. They are also noted for their excellent shadow detail.

Because of these characteristics, the two types of paper described above are often referred to as 'cold' and 'warm', respectively. Bromochloride papers fall between the two in terms of the image tones they produce. They contain a smaller proportion of chloride in a bromide emulsion and give a colour closer to that of bromide papers but with a touch of warmth.

Image tone is also affected by the developer used, and this is particularly true with chlorobromide papers, which can be processed to give a considerable range of tones, from very warm — akin to a brown-toned print — to a cool tone approaching that of a bromide print. Developer additives also modify image tone, as we shall see. The tone produced by the paper and developer

combination selected has implications if subsequent toning is envisaged. Warm-toned papers react much more readily than cold-toned papers to certain toners, notably selenium and gold.

Lith paper is a specialist paper which, if overexposed and then developed in highly diluted lith developer, can reveal a combination of warm and cold tones in the same print. These tones lend themselves readily to being toned by use of the techniques described in the section on toning,

Some papers contain a cream or ivory base tint in the gelatin. Their impression of warmth makes them popular for portrait work.

Contrast Papers described as 'graded' come in packets of a single contrast grade, from 0 (soft) to 5 (hard). 'Normal' is about grade 2, but there are clear differences between the grades from different manufacturers, and even minor differences between batches from a single manufacturer. Variable-contrast papers have two emulsions and are capable of giving the whole contrast range from a single packet, or indeed on a single sheet. All that is necessary is to change the colour filtration in or under the enlarger head.

Graded and variable-contrast papers are discussed in more detail on pages 76-8.

Weight Fibre-based papers come in 'single' or 'double' weight. Although single-weight paper is cheaper, it is less in demand and therefore generally less available. Double-weight paper is more convenient to handle, process and mount. Resin-coated papers are generally available in one weight only. For standard paper sizes see page 152.

Surface Most papers produce a variety of print surfaces between glossy and matt, with a variable number of alternatives in between. Typical are glossy, stipple or lustre, pearl, semi-matt and matt, although the descriptive terms used vary between brands.

Matt surfaces take certain afterwork techniques, including hand colouring, particularly well. They are also preferred by some printers for their surface. Their low reflectivity gives an impression of lower contrast, because the blacks appear less deep and rich, as shown in the characteristic curve below.

Glossy surfaces vary according to the treatment they receive. Many prefer them for their apparent gain in detail and tonality, notably the depth of blacks. Resin-coated papers dry naturally to a high gloss which can be enhanced by hot-air drying. Glossy fibre-based papers air dry to an attractive gentle sheen. This becomes slightly more reflective if the paper is heat-dried in a flat-bed or rotary drier, and takes on a mirror-like gloss if glazed onto a glazing sheet or glass. Glazing maximizes both the detail and the tones the paper has to offer, but can make viewing difficult unless the lighting is carefully controlled.

Paper ageing and storage Photographic paper is affected by age. Although it may have a nominal shelf life of a few years, it may well have lost its 'edge' after six months, depending to some extent on how it has been stored. Ideally it is stored in a refrigerator in the darkroom. However, a freezer will keep it fresh even longer and for this method of storage it should be sealed well in plastic. After being removed from the freezer, it should be allowed to thaw for a few hours before it is used.

Another advantage of storage in a refrigerator or freezer is protection from some of the darkroom odours which can fog or age papers rapidly. Second-hand models are often available for the price of a box of paper. Bear in mind, however, that repeated large fluctuations in temperature are probably not conducive to the longevity of paper.

Large papers are best stored flat. If stored upright, half-empty boxes can allow the paper to sag and this can stress the emulsion, which will lead to uneven image quality.

Choice of paper Personal preference, fashion, the subject matter, the intended use of the print, the afterwork to be carried out and cost are all factors that legitimately govern the choice of paper The more extensive the range of paper you store, the more it costs and the more eventually gets lost as a result of ageing. It is a good idea to experiment to discover what the market has to offer and how to use it. However, it is also important to really get to know thoroughly the characteristics of any paper you choose, so that you can fully exploit it. A balance must be struck.

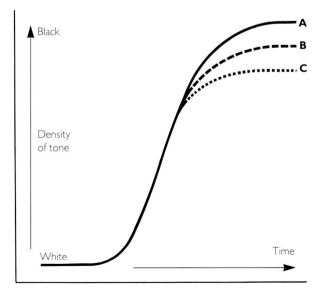

A *Glossy glazed*

B *Glossy air-dried*

C *Matt*

The following brief notes may help you to select papers to match your requirements. Prints for reproduction are usually made on glossy paper. Warm-toned prints often impart a feeling of nostalgia. Cold-toned prints may be considered more modern, particularly if used for portraiture, where warm tones were at one time the accepted norm. Warm-toned papers exhibit a greater tonal shift when particular toners are used. Fibre-based papers tend to respond better than resin-coated papers to many post-printing techniques. Resin-coated papers are particularly suitable for making contact prints, work prints and prints which are to be reproduced in newspapers, magazines and books, and all other situations where speed and ease of processing are primary considerations.

Finally, note that any print exhibited behind glass will appear to have greater contrast, unless the glass is non-reflective, in which case contrast will be perceived as lower.

CHEMICALS

Many of the chemicals used in printing will be discussed as we work through the printing section. What is given below is a brief overview of the basic processing chemicals and a few other useful chemicals.

Developer The function of developer is to convert the silver halide in the film emulsion to visible metallic silver. It is usually the first chemical bath in the processing chain and is alkaline. Developer temperature is normally kept at 20°C (68°F). Dilution varies according to brand, and can be further varied for effect.

The constituents of developer can be adjusted in manufacture to produce warm or cold tones in appropriate papers, as well as high or low contrast. Thus the warm tone of a chlorobromide paper, for example, can be enhanced or suppressed by the choice of developer, and the contrast a given paper produces can be affected, particularly with soft-working developers.

Development times vary with developer and paper. Resin-coated papers are quick: 1 minute is adequate. Fibre-based papers may take longer but with many papers modern technology is bringing down the development times. You can very easily test for the Maximum Development Time (MDT) for a paper/developer combination (see pages 42-4). Beyond this time you will achieve no further density in blacks or shadow detail, but will slowly cloud the highlight with grey.

Storage Developer oxidizes slowly in contact with the air. Therefore, never keep and use old working stock developer. (An exception to this rule is the trick of adding a little old developer to the new mixture. This has specific applications, notably in lith printing and

printing for warm tones. Likewise, developer concentrate should be stored out of contact with the air, as this too will oxidize and go brown. This can be achieved in the following ways:

1 Use a thick collapsible plastic bottle and squeeze all the air out before stoppering. 'Concertina' bottles or some manufacturers' plastic containers are suitable for this purpose.

2 Decant the developer into smaller bottles of the size required to dilute to one tray full for one session. Fill the bottles to the brim. You may be able to buy suitable glass bottles in a wide range of sizes from your local pharmacy.

3 Add glass marbles to the developer concentrate in the main storage bottle each time some is removed, in order to bring it to the brim.

4 Spray anti-oxidant gas into the container. This is available in aerosol containers from large photographic dealers. It is a heavy gas which forms a layer over the developer's surface, preventing contact with the air.

Developers, particularly metol, can cause skin rashes in some users. You should always use tongs and gloves if this happens.

Stop bath Used between the developer and the fixer, stop bath is acidic and often contains an indicator which changes colour when the solution is exhausted. Stop bath has two functions: firstly it stops development instantly by neutralizing the alkali in the developer; and secondly, it prolongs the active life of the fixer which is also usually acidic, by preventing carry-over of the alkaline developer.

Ideally, discard stop bath before exhaustion, and always discard the whole bath. Never replenish it with more concentrate, as this allows the accumulation of unwanted by-products of development.

Stop bath has a pungent smell, and this is one of the many reasons why you must ensure that there is good ventilation in the darkroom.

Fixer In most cases an acidic solution, fixer dissolves any unexposed or undeveloped silver halide in the paper by converting it to silver thiosulphate, which is soluble in water. Traditional 'hypo' fixer — sodium thiosulphate — has largely been replaced now by 'rapid' fixer — ammonium thiosulphate — which has a much shorter fixing time.

The capacity of fixer is not unlimited. As nothing visible is seen to be happening in the fixer it is all too easy to assume the fixer is doing its job adequately. This is a dangerous assumption and may lead to serious discoloration and deterioration of your prints later. The time-honoured fixer test of putting in a 'film tail' and doubling its clearance time as a test for your prints is crude and unreliable unless the fixer is fairly fresh. More

accurate testing kits are available. A guide to the fixer's capacity in terms of prints per litre or gallon is enclosed with the product. This is a useful guide, but you should always err on the side of safety rather than economy.

Fixer that is nearly exhausted may fix the prints, but unless adequate fresh fixer is present, insoluble by-products accumulate in fibre-based papers and this cannot be washed out. For this reason, many printers use a two-bath fixing regime in which prints are fixed in bath 1, then transferred to fresh fixer in bath 2 before being washed. When bath 1 approaches exhaustion, it is discarded and replaced by the old bath 2, and a fresh second bath is made up. This is an excellent system, but it does require more bench space and more discipline to avoid overfixing.

Fixer is used for both film and paper, but do not use the same batch of fixer for both. The iodine that results from film fixing significantly reduces its capacity and this may lead to inadequate paper fixing.

Occasionally alkaline fixer baths are used. They are generally unnecessary unless you are fixing very warm-toned prints with very fine grain where the more aggressive rapid acid fixers may bleach some of the more delicate tones. But if alkaline fixer baths are used, it is wise to provide a water bath after the stop bath to reduce carrying acid into the alkaline fixer.

Hardener Doing exactly what the name suggests, hardener toughens the surface of the print, which may become quite delicate with pH changes and the long washing times required for fibre-based papers. It may be added to the fixer if it is not already present, or used as a separate bath. Its advantages are its usefulness in glazing fibre-based papers, and enhancing the gloss in resin-coated papers. Its disadvantages are that subsequent toning may be less effective, and that it makes archival washing more difficult. Usually hardener is omitted unless there is a reason to include it.

Hypo clearing agents Used during the washing cycle, hypo clearing agents help remove residual fixer products from paper.

OTHER USEFUL CHEMICALS

Toners The chemicals used for toning are discussed in detail later. However, it is worth considering the use of dilute selenium toner as a routine part of your processing line, for D-max enhancement and archivalling.

Benzotriazole Two functions are performed by the developer additive benzotriazole: it is useful both for cooling down the image tone of a print and for minimizing 'fog' in old papers. Add 5ml of 1% solution per litre of developer.

Potassium bromide Like benzotriazole, potassium bromide is useful for revitalizing old papers. Add 10ml of 10% solution per litre of developer, or use as a pre-development bath at the same concentration. Unlike benzotriazole, however, it tends to warm up the image tone. It may also necessitate a longer exposure time.

Sodium carbonate Commonly known as washing soda, sodium carbonate is effective in increasing the activity of developer so as to obtain deeper blacks, especially if the developer is nearing exhaustion.

Sodium hydroxide Caustic soda, as sodium hydroxide is widely known, is used as a developer accelerator. It is useful in lith-type printing. It is also used as an additive to (thiocarbamide) sepia toner to alter the depth of brown produced.

Potassium ferricyanide An essential chemical in every black-and-white darkroom is potassium ferricyanide, also known as 'ferri' or 'liquid sunshine'. It acts as a bleach (as Farmer's Reducer) for brightening highlights and in other manipulations. 'Ferri' is also used in many toning processes and, in pre-development bleaching (see pages 74-6), to control contrast.

Acetic acid Used as a stop bath, acetic acid is also useful as a 3% solution to remove scum marks from the print surface after some toning processes.

Carbon tetrachloride Useful as a negative cleaner, carbon tetrachloride must, however, be used only with good ventilation. Do not smoke while using it.

Potassium dichromate When used with hydrochloric acid, potassium dichromate is an effective print and negative intensifier. I have found that this technique also enables some bromochloride papers to be split-toned brilliantly with selenium.

Potassium iodide Used in some intensifiers, potassium iodide is a useful bleaching agent for prints.

Sodium chloride Common salt is useful as a bath for clearing highlights and borders after blue toning.

Thiocarbamide Used as the basis for variable sepia toner, together with sodium hydroxide. Also useful for local dry bleaching.

Methanol Has several useful functions in the darkroom, including use with thiocarbamide as a 'dry' reducer for prints. Methanol is also useful for removing persistent iodine stains and for both cleaning negatives and drying them rapidly.

THE NEGATIVE

Although it is a large and important subject, the production of the negative is outside the scope of this book. However, since they have a direct bearing on the quality of the print, certain aspects of the negative should be considered, notably handling, storage and negative faults.

Negatives are very vulnerable, and a few careless seconds may lead to hours of afterwork. Handle them with respect, always by the edges, and avoid touching the emulsion. Any handling of the negative is a potential source of damage and should be kept to a minimum. By one of the cruel ironies of the darkroom, if any area of a film is damaged it always seems to occur on the frame you want to print!

Store negatives carefully in purpose-made storage sheets filed in protective ring binders or hanging files. For preference they should be kept outside the darkroom, away from chemicals and fumes, as these can cause damage and deterioration.

Insert the negative into the enlarger emulsion side down, unless you want the image reversed, and with the base of the negative image pointing away from you as the image is projected upside down onto the baseboard. Clean the negative carefully with an anti-static brush and a squirt of ozone-friendly compressed air. Glassless negative carriers are best for 35mm film, but larger formats usually require glass carriers to hold them flat. This introduces an extra four surfaces to keep spotless and dustless, as well as the possibility of Newton's rings. However much care you take in handling them, negatives do get damaged by processing faults or scratched by dirty cameras or water-borne particles. By minimizing these faults you can save hours of retouching.

Scratches The commonest problem is scratches. Those on the film base (non-emulsion side) cause white lines on the print, and can therefore be spotted out with time, effort and skill. The use of a diffusion enlarger greatly minimizes such lines and further diffusion through part of the exposure may lose them altogether but produce a softer image.

'Nose grease' is the traditional remedy here. Use your finger to take this from the side of the nose and smear it across the scratch, filling in some of the defect

without noticeably affecting the image. Scratch removers are available in the form of a varnish-like solution in which the negative is dipped and hung up to dry. My experience of these is that if great care is not taken, the sticky negative attracts dust like a flypaper attracts flies. When the 'varnish' dries, the dust becomes embedded in the surface of the negative, replacing your scratch with a mass of spots. Fortunately, scratch removers usually come with a solvent — a scratch remover remover!

Scratches on the emulsion cause black lines on the print. These are much harder to touch out than white lines, because they require local bleaching with iodine and then spotting with dye to restore the required tone. Applying a little black shoe polish to the emulsion layer across the scratch will give a white line on the print which is easier to deal with. Some printers use fine metal polishes to treat scratches, apparently with satisfactory results.

Dust If embedded in the film-base side of 35mm film, dust can usually be polished off, but be very gentle with the emulsion side. Sometimes thoroughly soaking the film for 15 minutes and gently cleaning with cotton wool will remove dust. However, bear in mind that dust spots are easier to touch out than new scratches, and if you do mess up your print when 'spotting' it, regard it as good practice and make another. If you spoil your negative you probably have lost it.

Processing and drying marks The presence of marks caused during processing or drying usually reflects bad technique, so it is important to analyse and learn from them otherwise they will keep occurring. Drying marks may disappear if you rewash the film thoroughly and then dry it carefully. Some photographers routinely soak all their films in methylated spirits after washing, to promote rapid drying and so reduce the risk of drying marks. Alternatively, bleach the negative in plain potassium ferricyanide and then redevelop it in acid amidol developer. Most other processing faults are untreatable on the negative and will usually require retouching.

Grease marks may arise from overenthusiastic use of wetting agents or soaps. They can be removed, along with smudges and fingerprints, by the use of negative cleaning solvents or methylated spirits.

'Fog' on the negative likewise indicates poor techniques or old materials, both of which are avoidable. It may be possible to overcome the problem by printing to a higher contrast or gently bleaching the negative with potassium ferricyanide.

It is worth while learning to recognize one or two 'non-standard' types of negative and knowing the best way to handle them. The printing control techniques

referred to below will be covered in greater detail later in the book.

Thin negatives It is surprising how much detail is available even in a thin negative. The tiniest variations in the thinnest of shadow tones can be captured on the print. In order to do, however, it is necessary to use high contrast grades or paper and very precise exposure times. Variable-contrast papers make this task easier, as they allow different contrast grades to be used in different areas of the print.

Flat negatives A negative with low contrast is described as flat. This effect is often accidental, although it may be deliberate. It may result from 'flat' subject matter or from underexposure and/or underdevelopment. When it is the subject itself that is lacking in contrast, printing in either low or high contrast may be appropriate for the result you require. If flatness is the result of accidental underexposure or underdevelopment, you may want to remedy it. Decide therefore if you wish to manipulate the result or not; what density of greys you want; how much shadow and/or highlight detail you want; and where to place your 'tonal window', which determines whether your print will be high key or low key.

In addition to using a 'hard' paper, you may find that the negative benefits from intensification, to further increase the contrast (see pages 71-4). If these techniques fail to give the required degree of contrast, try making a paper negative by contact printing from a single-weight print and contact printing again from that. Alternatively, use one of the other methods described in the section on contrast.

Contrasty negatives Dark (thin) shadows and bright (dense) highlights characterize the contrasty negative. Unless you want to produce a graphic, high-contrast print, you will need to use low-contrast techniques. Again exposure is critical: if you give too much exposure to low-contrast paper it will turn the highlights grey, while too little will make the shadows grey (below maximum black).

Start with a low-contrast version to see what detail is available and gradually raise the contrast to get more separation of tones where you want them — probably the midtones and shadow tones. The critical exposure for these two may not be compatible. In this case, try flashing and, if necessary, *raising* contrast further for the midtones. Flashing will enhance both highlight and shadow detail, whereas increasing contrast alone will reduce it. Other techniques which may be helpful are water bathing, two-bath development and selective development or even a contrast-reduction mask.

THE PROCESS IN OUTLINE

If you are new to printing, by now you will have a good idea of the materials and equipment required. More experienced printers will probably have skipped straight to the section on printing. Before following them, make sure you are familiar with the process and the times typically involved, with both fibre-based and resin-coated materials.

	Fibre-based paper	Resin-coated paper
Developer	2 min (varies)	I min
Stop	½ min	¼ min
Fixer	2-10 min (according to type)	1-2 min
Wash	60 min (may be 30-40 min with a hypo clearant)	2-5 min
Selenium tone* (for D-max)	10 min (varies)	—
+/- 3% acetic acid	2-3 min	—
Wash	(30-) 60 min	—
TOTAL	1½ -2 hours	5-8 min

Certain short cuts can be taken, and of course not every print will be selenium-toned, although I do recommend it for your finest work. Conversely, bleaching, redevelopment and multiple toning will significantly lengthen the process outlined above.

It should now be obvious why resin-coated paper is the favourite for contact and work prints and some other categories of print.

* May be omitted if other toning is planned. Note that shorter sequences combining hypo clearant and selenium are sometimes recommended, but these have been shown to be less effective.

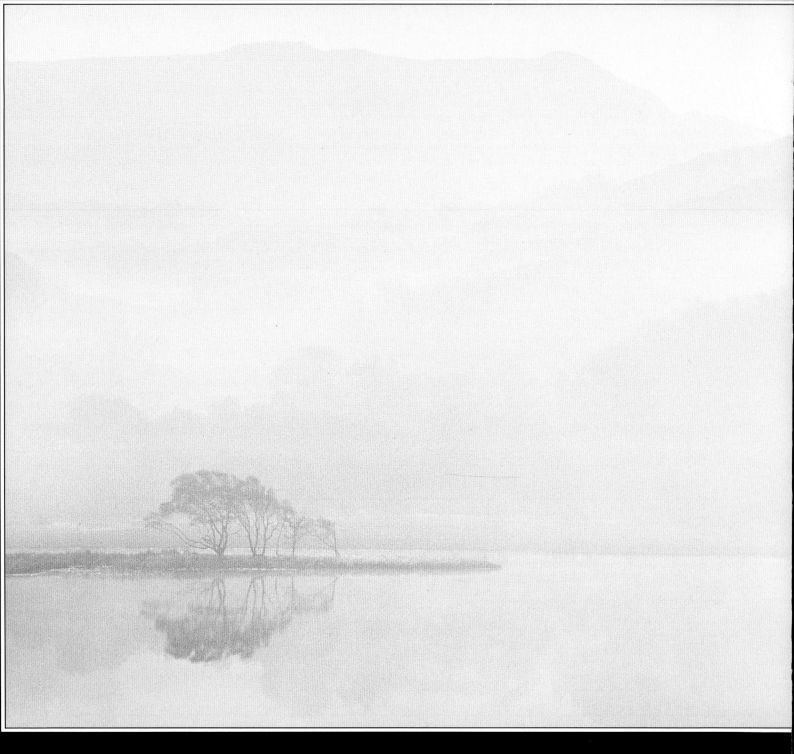

In photographic printing, art and craft combine to express ideas and emotions through chemistry and the manipulation of light. The end-product may be artistic or documentary, representing either fantasy or reality, but it should always carry the conviction of its maker.

The many printing procedures discussed in this section of the book are not just technical exercises with which to impress. They are a means to an end, and that end is visual fluency, or, as Ansel Adams put it, your 'performance' of the 'score' that is the negative. Some of these techniques are subtle, while others alter the picture radically or even create scenes that never existed. Whatever type of images you are drawn to, there is immense satisfaction in being in control of, rather than limited by, the techniques of printing.

Llyn Dinas *This early-morning scene lent itself to interpretation in many ways, and several different versions have resulted, both low-key and, as here, high-key. In this case the print was made on a brand of chlorobromide paper which I find particularly sensitive to soft tones. Flashing the paper and careful control of development produced the required tonal range and contrast. The finished print was delicately gold-toned to give a hint of blue-grey in keeping with the misty atmosphere.*

ON THE BASEBOARD

This section of the book covers the following pre-exposure techniques, all of which can be used to give additional creative control in printmaking: focusing, cropping, correcting and creating distortion, and enlargement and reduction.

FOCUSING

Critical focusing is an essential component of a successful picture. Or is it? Generally speaking, this is true, but as with most rules, there are exceptions. Most professional printers expect to see the grain razor-sharp from corner to corner, or reject the print as unsatisfactory. However, printers with a creative or pictorial approach sometimes choose to break this rule for artistic effect. But before doing likewise you must know how to obey it, and this means checking that the projected film grain is absolutely sharp all over the intended print.

Corner-to-corner sharpness Adjusting focus until it looks right to the naked eye will not do. Neither will just checking the centre of the projected image. It is all too common for enlargers to be poorly aligned, even when new, so that they cannot give corner-to-corner sharpness. So focusing on the centre of the image offers no guarantee that any of the edges or corners will be sharp. The first jobs on setting up an enlarger are checking evenness of illumination and overall focusability. If any edge or corner is less sharp than the others when you are using a focusing negative at maximum lens aperture and a corner-reaching grain magnifier, then this must be corrected before printing.

Adjustments may be possible at the head and/or the bellows or lens plate. This is usually only available in a sideways direction. Front-to-back correction may also be necessary and may require the insertion of tiny wedges or 'shims' of thin card or aluminium foil at the attachment of the lens plate to the bellows. Expect to have to do this. It can be very time-consuming, but is well worth while and then can usually be forgotten.

Focusing aids Although they all work on the same principle, focusing aids offer varying degrees of sophistication. The standard type is inexpensive and works perfectly well within its limits. Its drawback is that it

works only about halfway out from the centre and cannot 'see' into the corners or edges, which is where any focus fall-off will be greatest. Once your enlarger is critically adjusted, an inexpensive standard focusing aid is usually sufficient — until you need to alter the adjustment, for example to correct or create distortion.

A mirror reflects a small portion of the projected image up through a magnifying eyepiece to present the printer with a magnified view of the film grain. It is customary to stand this on a spare sheet of printing paper to ensure accuracy. I believe this makes no detectable difference, although I usually have a sheet in place to aid visually since some of my easels are black.

Tall focus aids are available for use when making extra big enlargements. Above a certain magnification it may be impossible to keep your eye to the eyepiece and simultaneously reach the focusing knob. If your enlarger is not designed to focus remotely, a tall focusing aid may avoid the need for an assistant.

'Corner-seeing' focus aids are very expensive compared with the standard type. They have a large, rectangular silvered mirror and are designed to be used right

The standard pattern of focusing aid is inexpensive but of limited value in that it works only up to about halfway out from the centre of the print, missing the corners and edges, where lack of focus will be most evident.

A tall focusing aid is helpful when you are using a non-remote-controlled enlarger at a substantial magnification that would otherwise prevent you keeping your eye at the eyepiece and reaching the focusing knob at the same time.

For some users the price of a 'corner-seeing' focusing aid, although much higher than that of the standard type, is justified by the fact that it can be used right to the edge of a print.

NEGATIVE POPPING

Heat from the enlarger can make the negative expand and suddenly bow in a glassless negative carrier. Even with 35mm film negative 'popping' can be a problem. Prints that have been carefully focused and yet look less sharp than they should, may be the result of the negative popping unnoticed part of the way through the exposure.

Cool-running diffused-illumination enlargers are less likely to cause negative popping, and fitting a heat-absorbing filter to a hot-running enlarger may solve the problem. Alternatively some printers leave the enlarger on until the negative has popped, then refocus and make their exposure by swinging the red 'safe' filter in and out of position without turning the enlarger off again. However, this has several drawbacks. Firstly it is less accurate than using a timer. Secondly touching the head, even via the filter, at the beginning of an exposure may cause the enlarger to move or vibrate and reduce print sharpness. Thirdly the red filter is not totally safe with some papers, especially at the wider apertures. Check the safelight colour recommendations for your paper.

A glass negative carrier may be necessary to keep the negative flat. This does increase the number of potential dust-bearing surfaces from two to six and will sooner or later cause Newton's rings to appear on the prints, rendering them useless unless the more expensive anti-Newton glass is used.

Relying entirely on a small lens aperture to overcome the effect of significant negative popping is unlikely to be successful. With small apertures, depth of field increases significantly on the baseboard, but less so close to and behind the lens.

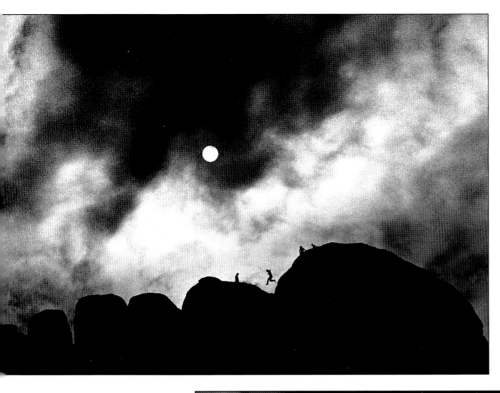

to the edge of a print. With some there is the option of a blue filter to fit over the mirror. The theory is that blue-wavelength light, to which graded papers are most sensitive, focuses at a slightly different point from the other wavelengths emitted from the enlarger bulb.

Focusing through a blue filter on the light 'seen' by the paper is therefore said to be more accurate. Tungsten bulbs produce a different wavelength (and thus colour) from halogen bulbs. Variable contrast papers require different colour light for different grades. I remain unconvinced of their value.

Choice of aperture Always focus at maximum aperture. This gives a brighter, clearer image; a shallow depth of field, allowing more decisive critical focusing; and easier detection of fall-off at edges and corners. Never print at maximum aperture if you can avoid it, since sharpness is poorest at this setting. The optimum aperture for sharpness and contrast is likely to be about ƒ5.6 or ƒ8. Depth of field increases with smaller apertures, helping to compensate for minor inaccuracies. Also, short exposure times make dodging and masking more difficult and more evident.

Printing the sky with its grain sharp seemed to render the scene static and gave the picture above far less feeling and tension than is conveyed by the version on the right, which was made with the sky negative deliberately out of focus. For me, this imparted a feeling of violent movement in a 'boiling' sky, which contrasted with the figure frozen in mid-jump.

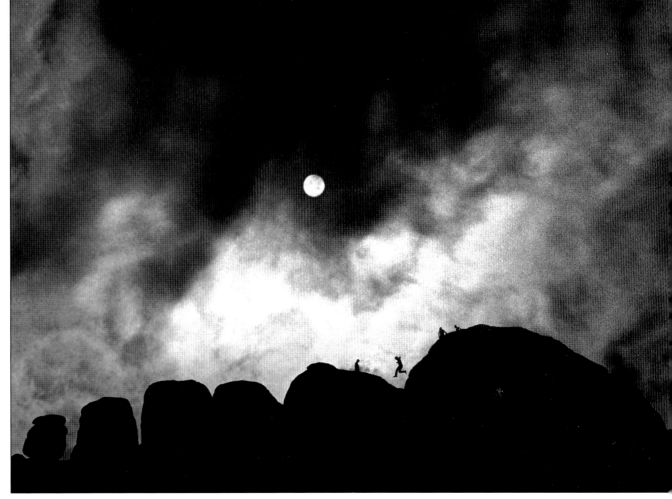

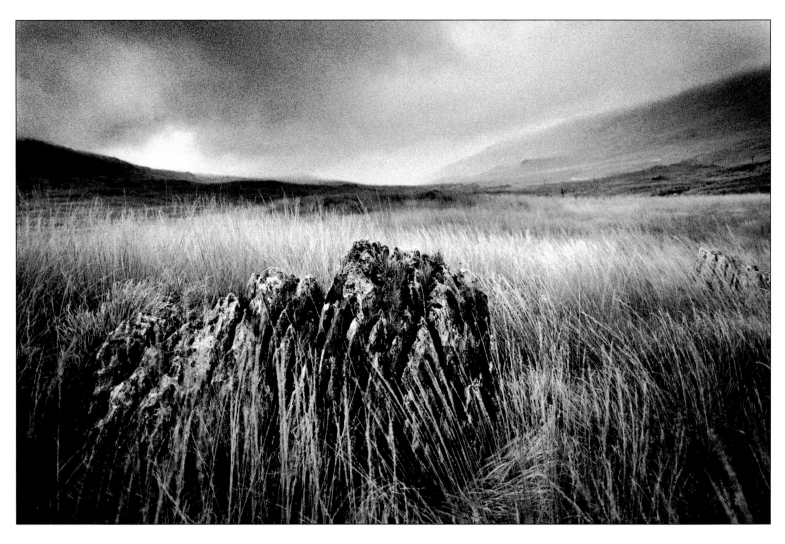

Like the larger picture on the previous page, this landscape exploits a deliberate out-of-focus effect, although much more subtly. Only one negative was used, but more than one exposure. The burning-in exposure used for the distance was given after tweaking the focus just off the critical. This softened the grain very slightly to maintain the atmosphere of dusk and reduced visibility. Grain can work for or against you, and like all other aspects of the image, you can control it if you feel it is appropriate to do so.

Soft focus An image that has soft focus should never be confused with one that is out of focus. A print made with a soft-focus device should still be in focus, unless an out-of-focus effect is specifically required. Occasionally the distortion seen in a significantly out-of-focus image is exploited for its own sake, although this is better done with the camera at the taking stage. More often the techniques are more subtle, as in the photograph above and the lower picture on the previous page.

CROPPING

There are two schools of thought about cropping — that is, removing part of the image for compositional reasons. One states that there must be no cropping on the baseboard and that the print must show everything that is on the negative. Practitioners of this approach often file back the edges of the negative carrier in order to print the borders of the negative to demonstrate this. Cropping does take place in the camera, however, and it is the skill to do this that is on display here. The alternative view is that each image is unique and has

unique requirements in terms of its design, format and dimensions. I subscribe unreservedly to this view as I can see nothing sacrosanct about any of the film formats, which were devised for various pragmatic reasons rather than because they were the optimum shape for the next photograph you or I will take.

Neither do I believe that film borders, including identification notches and other information, enhance any picture. There is, after all, only so much which can be achieved in the camera, and some prints need to be square while others require a conventional rectangle or perhaps a letterbox format. And who is to say that a print need conform to any of these shapes even?

For me, cropping is a matter of major importance in the earliest stages of every print. Sometimes the decision is easy and almost automatic. At other times it seems impossibly difficult, either because a number of pleasing alternatives are available or because getting the print to feel 'right' can be an elusive quest. In many cases tiny changes can make a big difference to the feel of a print. Prints to which this applies are usually those that have an artistic aim rather than those taken for

CROPPING TOOL

Determining the most effective crop for a photograph is easily done with a pair of L-shaped pieces of cardboard, black on one side and white on the other, as shown below. The cards should be larger than the prints you make and about 2-3in (5-7.5cm) wide for 8in × 10in (20cm × 25cm) prints and 4-6in (10cm × 15cm) wide for large 20in × 16in (50cm × 40cm) prints, although you will probably have already made the decisions on a smaller work print. You can move and rotate the cards independently on the print to find the best possible crop, and this is initially easier than assessing a negative image on the baseboard. Masking the surrounding extraneous areas makes it much easier to appreciate the weight and balance of the revealed image between the cards. It also gives you some idea of the border or mount you will prefer. Some prints have a very different feeling with a black border than with a white one, and may even require a different crop, depending on which you choose.

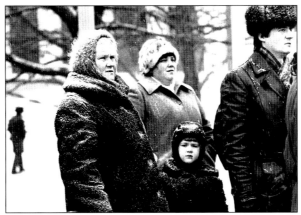

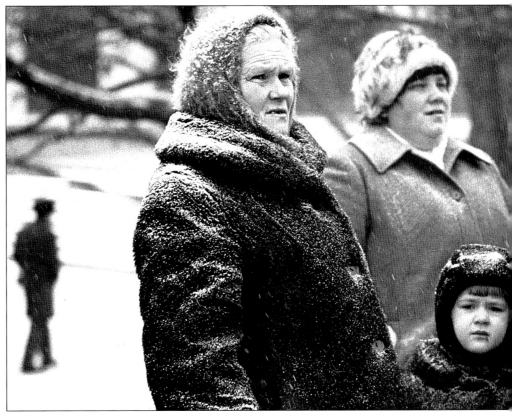

In the first version of this wintry Russian scene the subjects fill the frame and seem very solid. The child is flanked by substantial figures, in a tonal distribution of alternating dark and light. The first crop virtually removes the half figure on the right but includes a small, shadowy, out-of-focus form on the left. This figure balances the mass of the others surprisingly well, given its lack of size and density. The very small crop from the bottom makes the dark-coated lady look much squatter. The second crop comes in much tighter on the central figure's head. Now the tension between the two ladies and the man walking away is stronger. Paradoxically, the boy's position is emphasized now that he is in the corner.

documentary reasons or as candid studies.

There are no rigid rules or formulae to follow here. Attempts to operate by such rules tend to produce 'formula' prints rather than pictures which convey the author's personality or vision. On these pages I give a list of the main reasons why I crop, along with some examples of effective cropping, but the most important advice must be to be open-minded and to experiment boldly to find what feels right for you. Be prepared always to listen to advice, and then weigh it carefully. In personal work, never follow blindly and *never* print just what you think others will like unless it carries your own convictions.

I crop pictures for a variety of reasons, of which the main ones are:
• To change the format of the print.
• To alter the balance or emphasis of selected picture elements, such as relative size, density, weight and

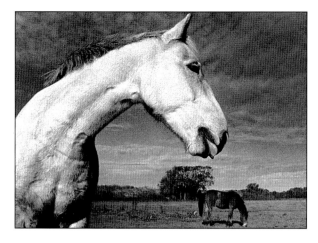

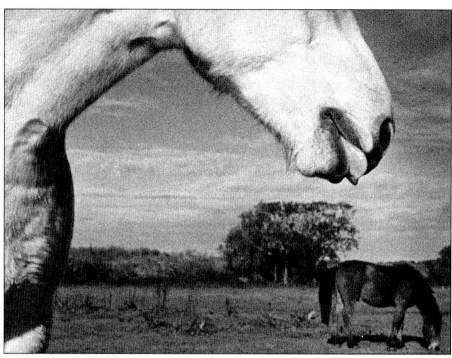

The first print shows almost the whole negative. In the original there was a little more empty space above the horse's ear and on the right , and in this first version I kept the latter space because I liked the asymmetry

The second crop, which is a more dramatic close-up, produces a quite different effect, transferring the emphasis away from the sweeping curvature of the horse's neck to the tongue.

As I only had time to catch the figure and centralize the three distant windows, the straight print, above, contains areas superfluous to the image I wanted.

Cropping is vital to the effect of the second version, right, which, by cutting out the foreground, distils the scene down to its essentially geometric components — a starkly contrasting dark portion and light portion.

empty black, white or grey areas.
- To exclude unwanted material — either objects or just unsuitable light or dark areas.
- To correct a bad camera-holding fault.
- To rotate the image for dynamic effect (as for the picture of four standing stones on page 54).
- To alter the message of a photograph. This is sometimes dangerous in that it can distort the facts. I have a print, taken after a revolution, of a figure against a wall bearing a political symbol followed by 'No.1'.

Tightening the crop in the corner shows the symbol with the word 'No'! Unfortunately press and propaganda photography is littered with misrepresentations achieved simply by careful selection of parts of images.
- To produce a sense of greater intimacy.
- To take advantage of the fact that some pictures work only one way round. Others 'flow' comfortably with a feeling of harmony from left to right, and a feeling of tension right to left.
- To generally improve the composition.

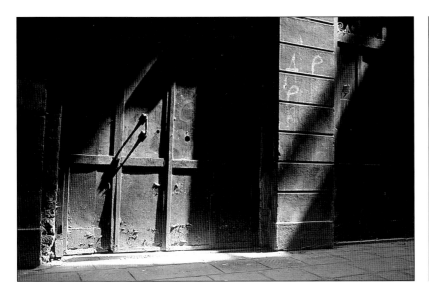

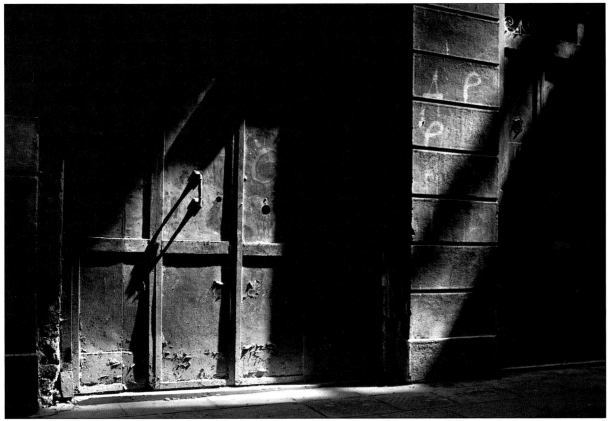

With the first version of the print, above left, I had to decide whether to keep the section of wall dividing the doors well within the print or to move it to the edge, making the main door more central.

Moving the wall to the edge destroys much of the picture's atmosphere. The highlights in the top-right corner of the first version are so important that the second, above right, dies without them. They also explain the shadows on the wall, which lack continuity in the cropped version.

For the final version, I tilted the baseboard to correct the leaning vertical on the left and made a small crop to remove much of the pavement, which contributed nothing. This small change seems to bring the door much closer, heightening the intimacy of this shadowy, mysterious place. I added a slanting, soft-edged shadow to the top of the wall at grade 3. After potassium dichromate intensification, the print was split-toned in selenium.

• To correct distortion.

The two pictures of the horse's head on the opposite page show two very different ways of cropping a subject that is large in the frame. I grabbed the first picture, capturing the dramatic arc of the animal's neck as it wheeled round above me to kick me into the river! I managed, instinctively, to keep the horizon level. The other crop produces a composition that is almost surreal — like a huge horse about to devour a tiny one.

What attracted me to shoot the Venetian alley on the previous page was the rough wall, the grilled window and the dark passage — each so characteristic of that city. I was fascinated by the combination of shadows and textures as the sun cut obliquely across surfaces, reaching deep into the confined spaces. I took the picture quickly so as to capture the figure, who might at any moment have disappeared from view, and for this reason included unnecessary detail which could be eliminated later. My other priorities were to line up the three windows and include the grilled window.

The second version was cropped to produce a composition which is strongly divided into light and dark areas, each of which contains a rectangle containing interesting visual material. The large and small windows provide a sense of scale and depth. Split toning with thiocarbamide adds a warmth to the stonework but, more importantly, emphasizes the difference between the two sections while at the same time providing a link between the near and distant walls.

The Venetian doorway on the previous page also had to captured rapidly — this time because there were passers-by and because the long, low light was penetrating the alley so obliquely that I could see the shadows closing down even as I searched for a composition in the viewfinder. After three frames the particular quality of light — and with it the picture — was gone.

CORRECTING AND CREATING DISTORTION

One of the first lessons of handling a camera is to keep the film plane parallel to the subject. This is of paramount importance with wide-angle lenses in order to minimize the distortion of verticals that they characteristically produce. Like most rules, this one can be broken to great effect, to create deliberate distortion for visual impact. All too often, however, it is broken reluctantly, for the simple reason that there is no other way of taking the picture.

Converging verticals Buildings photographed from ground level usually require an upward tilt of the camera to get them into the picture, unless they are shot from a distance with a telephoto lens. The further a subject is from the camera, the smaller it will be on the negative. Therefore the top of a building photographed from below will appear smaller than the bottom. Its vertical lines converge and it appears to be falling over backwards. Church interiors look awful with pillars leaning towards each other, and tall monuments lurch precariously to one side. While this may be impressive in a shot of the Tower of Pisa, elsewhere it is nearly always undesirable. Similarly, horizontal distortion produces odd-shaped windows and other extreme distortions, as in the shot of the Doges' Palace in Venice.

These distortions can be avoided at the picture-taking stage by using shift lenses or view cameras. However, the vast majority of photographers do not possess these expensive items. Even so, they can easily rectify the problem by producing a reverse distortion under the enlarger. Once again the remedy relies on the object-to-lens distance, although this time in reverse: the farther the (projected) image is from the enlarger lens, the larger it becomes. If the bottom of a building is too large in relation to the top, it is possible to make it smaller by lifting the end of the baseboard easel closer to the enlarger.

The good news about converging verticals is that the problem has a solution. The bad news is that the solution itself brings a number of further problems. Fortunately they are all surmountable.

Focus The first problem is focus. As one edge of the printing paper is higher than the other, something will be out of focus. Focusing just above the centre and stopping the lens down to minimum aperture will overcome this difficulty if the difference in height is not too great. Lens performance is never best at minimum aperture, however, and so you should rely on this remedy only as a last resort.

Most modern enlargers, apart from the most rudimentary, allow either tilting of the enlarger head (containing the negative) or the lens panel, or in some cases both. This allows you to correct distortion with the whole image in focus by applying the Scheimpflug principle, illustrated below and on page 38.

Keystoning Since one end of the image is magnified more than the other, it will no longer be square or rectangular, as shown in the series of pictures of a glass-walled office building. To obtain a 'squared' image some

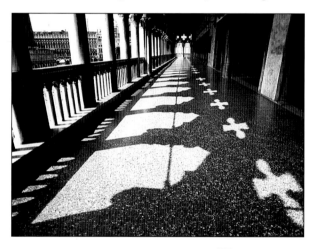

This photograph of the Doges' Palace in Venice, taken with a 20mm lens, is a dramatic example of diverging verticals.

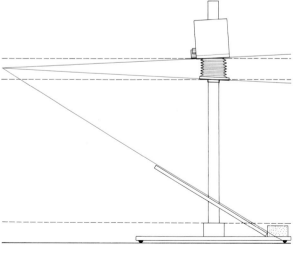

According to the Scheimpflug principle, when adjustments to the negative plane, lens panel and baseboard easel are made so that imaginary lines through them intersect at one point, the whole image will be in focus. However, in practice you are likely to find that movement of the lens panel is very limited unless the bellows are more extended than is normally the case for medium-sized prints.

areas of the wide end will have to be lost by recomposing and cropping. This can be anticipated at the picture-taking stage and extra space included in the photograph so that only unwanted picture areas are lost during darkroom corrections.

Exposure Clearly, because one end of the paper is closer to the enlarger there will be greater exposure at that end and graduated dodging may be required. This is very easy to do. A test strip at each end would give two optimum exposures of, say, 12 seconds at the 'high' end and 16 seconds at the 'low' end. Give an 11-second exposure followed by a 5-second exposure during which a card is drawn slowly across the paper, covering it from the high end to the low end. The 'missing' second at the high end will be replaced at the beginning of this manoeuvre. I would recommend making a straight test print first, however, to check if this is necessary and if other corrections are needed in addition.

Horizontal format It is no coincidence that pictures used to illustrate correction of converging verticals are usually made from vertical-format negatives. This is partly because most shots of tall buildings are in this format. I rarely use the vertical format, and often use wide-angle lenses. Often these horizontal-format negatives need correction where shooting restrictions necessitate either incurring distortion or losing the picture.

The problem of unsightly converging verticals is clearly visible in this photograph of reflections in a glass office building.

In this picture the converging verticals have been corrected on the baseboard by making the vertical edges diverge. This effect is known as keystoning.

Masking the edges of the picture with the easel blades has restored right-angled corners. The vertical lines are now parallel. Graduated burning-in and dodging have balanced the tones.

When you come to make such a correction you will discover the other reason why all such illustrations are vertical: adjustment of the enlarger head and lens panel is usually only from side to side, not front to back.

There are four solutions to this problem:

1 Some enlargers have a rotating negative carrier (although most do not).

2 Cut out the single negative and insert it into either a slide mount or a larger glass negative carrier. Slide mount carriers have a square 'well' to accept the slide (for positive colour printing) and since they are square, slides can be inserted either way round. However, singly cut negatives are best avoided if possible.

3 If you have a larger-format option, you may be able to insert the negative strip front to back in a medium or large-format glass holder without cutting it. Masking around the negative will be necessary.

4 Try to correct distortion using the easel alone and a small aperture.

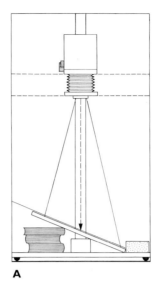 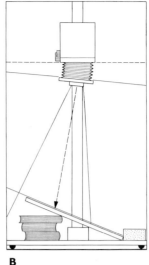 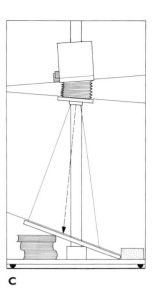

A **B** **C**

Step-by-step procedure To correct vertical distortion, the following items are needed in addition to the enlarger:

• A heavy block — a brick is ideal.

• A black inner bag from a box of printing paper. This contains your brick, preventing scratches to your baseboard and reflections back on to the paper.

• A square grid ruled in bold black marker pen.

• Books or cassette boxes to prop up the easel to the required degree (or an easel with a locking tilt facility).

• A sheet of cardboard on which to build the construction. This allows the whole set-up to be easily moved about for compositional adjustment.

Now follow these steps carefully:

1 Insert the negative, open the lens to full aperture, compose and focus.

2 Insert the paper grid.

3 Determine which end of the easel to lift. Remember: structures appear smaller on the easel as you raise them.

4 Experiment to achieve correction using the grid to line up projected verticals.

5 Prop up the easel as required, making sure that it is stable. Place the brick against the lower end to prevent it slipping (see fig A). If this prevents the easel opening without moving, place a wooden batten or thick ruler between the easel and the brick to prevent the easel's hinged edge fouling the brick.

6 Raise the enlarger head to compose the narrow end to the edges of the easel, and adjust focus to the centre of the easel. Both ends will be out of focus.

7 The wide end will spill over the frame. Slide the base card to readjust the position of the easel, supports and brick as required.

8 Tilt the lens panel in the same direction as the easel (see fig B). The image will slowly come into focus. It will also move partially off the easel, but ignore this for the moment.

9 Rotate the enlarger head with the negative carrier in the opposite direction to the easel, if your enlarger permits this. The image will move back again (see fig C). If no head adjustment is available, slide the easel to the new projected image position.

10 Make final adjustments, remembering the intersecting planes in the Scheimpflug principle, to height, head, lens panel, focus and easel (by adjusting the underlying card) to get an overall sharp, vertically aligned recomposed image.

11 Close the lens to its optimum performance aperture.

12 Make a test print and examine it for sharpness and

The possibilities for 'wide-angle' distortion of the negative on the baseboard were exploited to produce this half-menacing, half-comic study of a camel.

for decisions regarding dodging and burning-in. NB: If a single test strip is necessary at this point make sure that it goes across the print, not from the lower to the higher edge.

13 Make your print and some spares to avoid having to repeat the whole procedure more often than necessary.

14 Finally, remember to return everything you have adjusted to its usual position and check for corner-to-corner sharpness before your next 'flat' print.

Creative distortion Since the technique described above can correct distorted images, it can also be used to deliberately distort correct images. This can be subtle and tasteful — or just the opposite, as in the picture of the camel on the opposite page. In portraits, emphasis can be shifted, without obvious distortion, to give more or less importance to the chin or forehead in the same way as is achieved by changing the camera angle. Figures can be made fatter and shorter or thinner and taller. To give more obvious distortion, the paper can be curved either way rather than slanted .

ENLARGING AND REDUCING

There are two ways to make vertical enlargements: by raising the enlarger head and/or by lowering the baseboard. Which you choose depends on your darkroom arrangements, but there are several advantages to being able to lower the baseboard as well as raise the enlarger head:

• It allows you to make extra-big enlargements easily and conveniently.

• It overcomes the problems of the baseboard easel

fouling the bottom of the enlarger column. This can be a major problem with some crops done for compositional reasons, and some makes of easel compound the problem with their design.

• It allows you to choose the height at which you use your hands when burning-in and dodging, by altering head and baseboard together. If you are printing long exposures and working long hours this can be a boon.

Exposure The further the enlarger head is from the paper, the larger the print and the greater the required exposure. The extra exposure is determined by the Inverse Square Law. There is a simple formula to work out the new exposure when you are altering print size. This saves time and paper since further test strips are not required, *provided* the paper is of the same batch and used in the same chemicals. If you use a different packet of large paper (and certainly if it is a different type or make) in new chemicals made up to fill the larger dishes required, you can expect inconsistencies. The formula nevertheless provides a good starting point:

$$T2 = (L2/L1)^2 \times T1$$

where:

T2 is the time for the new size

L2 is the length of the new image size

T1 is the time of the old size

L1 is the length of the old image size

For the table below I have worked out $(L2/L1)^2$ for a range of paper sizes, so simply multiply the appropriate one by the old exposure time and you have your new time. Photocopy the table and fix it to the wall.

The beauty of using an f-stop timer is that when changing enlargements, you simply enter the new exposure time, and carry on as with the last — smaller (or larger) — print. The instructions for all dodging and burning-in modifications do not change since they are expressed in f-stops rather than real time.

Contrast It is a fallacy that contrast must be increased for larger prints, although it is certainly true that contrast may vary from one batch of paper to another. It is also true that many papers lose contrast as they get older, so if you use 20in x 16in (50cm x 40cm) paper only rarely, but get through several batches of 10in x 8in (25cm x 20cm) paper, you may in time notice a difference when making enlargements, and feel the need to increase contrast. This is a different matter, and there are ways to liven up old paper (see Developer additives on page 149). Different enlargements made from the same batch should be printed on at the same contrast and should appear to be of the same contrast when viewed side by side.

**ENLARGING/REDUCING
(FOR STANDARD PAPER SIZES IN INCHES)**

If enlarging from	Multiply T1* by	If reducing to	Multiply T1 by
8 x 10 to 10 x 12	1.44	8 x 10 from 10 x 12	0.69
8 x 10 to 12 x 16	2.56	8 x 10 from 12 x 16	0.39
8 x 10 to 16 x 20	4.0	8 x 10 from 16 x 20	0.25
8 x 10 to 20 x 24	5.76	8 x 10 from 20 x 24	0.17
10 x 12 to 12 x 16	1.78	10 x 12 from 12 x 16	0.56
10 x 12 to 16 x 20	2.78	10 x 12 from 16 x 20	0.36
10 x 12 to 20 x 24	4.0	10 x 12 from 20 x 24	0.25
12 x 16 to 16 x 20	1.56	12 x 16 from 16 x 20	0.64
12 x 16 to 20 x 24	2.25	12 x 16 from 20 x 24	0.44
16 x 20 to 20 x 24	1.44	16 x 20 from 20 x 24	0.69

* T1 = Exposure time for first print.

STARTING TO PRINT

This sheet was printed on low-contrast paper to obtain a wide range of tones. Strip 3 is reversed. You always have the option of reversing negatives at this stage.

In this section of the book we examine in detail the procedures involved in printing, progressing from the all-important basics to advanced techniques. This will enable you to build up your skills, so as to produce prints that realize the full potential of your negatives.

CONTACT PRINTING

It is very often on the basis of contact prints that negatives are selected for printing. An experienced printer can see exactly what is on a negative, but most people find contact prints easier to read. Also, when filed systematically, contacts provide an invaluable guide to what negatives you hold.

Contact prints are made by placing the negative, emulsion side down, against a piece of photographic paper and exposing this 'sandwich' to light. A sheet of clean glass is used to hold the negatives flat on the paper. Doing this manually is awkward and it makes sense to invest instead in a reliable contact printer.

Tonal information Because they are simply tiny straight prints, contacts may give only partial information about shadow or highlight detail in the negative. This is particularly true of landscapes, where skies may appear devoid of interest if the ground is correctly exposed. Some printers therefore print their contacts on very low contrast paper to capture a wider range of tones. However, you may find it difficult to get excited about these small, flat-looking prints, which can be hard to imagine in higher contrast.

Printing paper The best paper to use for contact printing is quick-drying, glossy resin-coated paper. I print contact sheets on grade 2 or 3 paper (according to the negatives) in pairs — one exposed for shadows and one exposed for highlights (for example, skies). This method is very useful when I want to visualize a heavy, oppressive sky effect. In such cases I often make a third, much darker version, in which the land mass is likely to be totally black but I can see the sky's full potential. This takes only a few extra moments and gives a wealth of additional information. If I think it will be useful, for example when the film was shot in mist or fog, I make high-contrast versions or 'flashed' versions. (Flashing

Low-contrast paper was again used, but it was flashed. The effect remains flat, but more tones are visible in the highlights here. Note the sky detail in negatives 23-6.

Normal contrast and exposure were used for this sheet. Detail can be seen in the shadows and the midtones.

the paper is explained on pages 80-2.) Using one or two extra sheets of paper at this stage may seem wasteful, but it can save both time and paper later.

THE WORK PRINT

Before manipulating a print to maximize its potential, it helps to know exactly what you are starting with. This is the purpose of the work print. The term describes the best straight print you can make from the negative with no darkroom jiggery-pokery — that comes later! From

Again contrast and exposure were normal, but the sheet was flashed. Much more highlight detail is available, as on sheet B but not as flat.

This sheet was overexposed to indicate what is in the highlights and available for burning-in. Even flashing did not reveal much detail in negatives 19 (strip reversed) to 22, and 34. For most films I find a light and dark pair of negatives sufficient.

CONTACT-PRINTING TIPS

1 Make sure that your negative strips are inserted with the frame edges lined up one under the other. When making your test strip, ensure that each strip falls midway across each negative frame, and not in line with the borders, otherwise you may not see where they are on the final test strip.

2 When you have made your contact prints, check the height of the enlarger head and the lens aperture, and put a note on the wall as a guide for next time. If your negative exposure and development are consistent, it will be a good starting point, if you use the same paper and developer.

3 Study each frame on the sheet carefully with a good magnifying glass, marking possible enlargements and making notes of any early ideas.

4 It may be worth reversing some negatives on a contact strip if you feel they do not work the right way round.

5 Always punch and store contact strips along with the negatives in a ring binder.

this you can start to formulate ideas and plans to achieve your ideal print. You may already have very firm ideas of what this will look like from the picture-taking stage, or you may develop your approach by experimentation as you go.

If you are new to printing, the golden rule is to keep things simple. The more variables you have, the harder it will be to predict outcomes and assess results. Alter only one factor at a time, keeping everything else consistent - and keep written notes! If your second print is made on a different paper type, in a different contrast grade, with an exposure adjustment and a change in development time, how can you expect to know which factor is responsible for what you get? In time you may want to explore the effect of different paper characteristics, emulsion types, base tones and surface textures on your subject and on any intended after-treatment. But first you should become thoroughly acquainted with a small range of materials.

Developing a print Before we look at test strips and work prints, I must stress the importance of consistent development. For the experienced printer, altering the development is a useful means of achieving particular

effects. But at this stage it pays to keep it consistent and to follow these crucial guidelines:

• Always develop fully.

• Never overdevelop (see testing for maximum development below).

• Never 'snatch' a print from the developer early.

• If a print turns out too dark, alter the exposure time and start again.

There are three ways of determining how long to develop a print: following the instructions on the packet, or using either the factor method or what I call the 'optimum development window' method — or both.

Bending the rules can sometimes be useful, but that comes later. So, as a rule of thumb for the beginner, I suggest using the manufacturer's maximum recommended time for fresh paper and the minimum recommended time for older paper. The reason for this is that the older stock will be more prone to chemical fogging.

The factor method Each print you make partially exhausts the developer. If you make a few prints in a large volume of developer, this gradual exhaustion will remain undetectable. However, many novices reduce costs by using small quantities of chemicals, and they also need to make more 'trial and error' prints. This gradual exhaustion means that each print may need a little longer in the developer than the last. If a print is not fully developed, highlight detail will be lost, because dark (heavily exposed) areas develop more quickly than light (slightly exposed) areas. This problem is exacerbated if the developer temperature is allowed to fall slowly as printing continues. However, factorial development overcomes these problems and

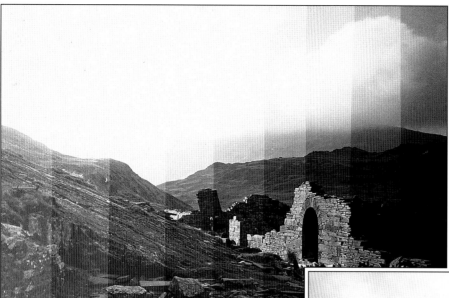

The test-strip print allows a choice to be made of the most appropriate exposure to produce the work print. Exposure should be based on the tonal range that forms the most important part of the print. In this example the exposure chosen was that used for the third strip from the right.

helps to produce consistent results. It works as follows.

Expose a print and place it in the developer at the beginning of the session with fresh developer at the correct temperature. Precisely measure and note the time it takes for the first tone to appear. This is development time (D1) for the paper/development combination in use. The other variable (D2) is the time it takes for the print to be fully developed. If, say, D2 was 120 sec and D1 was 24 sec, the development factor (F) = $D2/D1 = 120/24 = 5$.

Thereafter carefully time D1 for every new print and multiply it by F (in this example, 5) to get the full development time. As D1 slowly gets longer, so should your overall development time (D2). For example, if later in the printing session the first tone on a print appears after 30 sec, D2 for that print should be $5 \times 30 = 150$ sec to get consistent results.

Note, however, that papers are 'fast' or 'slow' and different paper/developer combinations can have radically different development factors, as, to a lesser extent, can different batches of the same paper.

Optimum development window Every paper/developer combination has a maximum development time (MDT) beyond which not only is there no further improvement but a deterioration occurs as the dark tones are already well and truly fully developed and are incapable of improvement, while the light tones will darken and eventually highlights will 'veil'.

Whatever method you use to establish 'full' development and whatever developer/exposure manipulations you may subsequently employ to fine-tune contrast, you must not exceed MDT unless you want a fogged print. To determine MDT, cut a sheet of paper into five

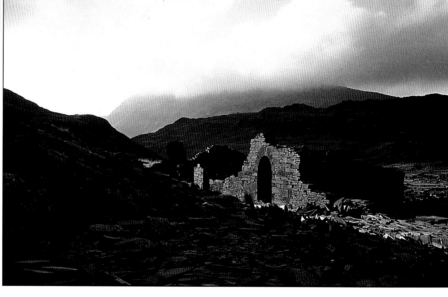

The work print gives as full a range of tones as can be obtained from a straight exposure. It allows informed decisions to be made about composition, tonal density, contrast and printing manipulations such as dodging and burning-in.

OPTIMUM DEVELOPMENT

It *looks* white — but do you *know* it is?

It *looks* black — but is it *maximum* black?

Your Optimum Development Window should ensure you get them both. But read the section on Contrast too (see pages 62-79).

It was difficult to burn-in the left side of the sky for the final print, so the paper was pre-flashed just in this area. Initial exposure was made at grade 3½, dodging the face of the ruin for ½ stop and the dark walls by ¼ stop each, to preserve the shadow detail. The brow of the left hill was held back by 1 stop to allow subsequent 'overspill' when burning-in the sky, which was done very heavily here. This burning-in exploited the different grades of contrast offered by variable-contrast paper.

strips and mark them 1-5 on the reverse with a waterproof marker. Put strip 1 straight into the fixer unexposed. Develop the others, also unexposed, for 2, 3, 4 and 5 minutes respectively. Fix, wash and dry all the strips. You should do this before proceeding, because of 'dry down', which is explained on the next page.

In good light, compare all the developed strips with strip 1. The first strip to show a discernible tone is fogged chemically and has exceeded MDT, which lies somewhere between the time given to this strip and that given to the previous one. Further testing along the same lines in quarter or half-minute steps will pinpoint MDT more accurately, if necessary. Similarly, if none of the strips exhibits a tone, the test can be extended to 6, 7 or 8 minutes. (If you use a number of papers and developers, you will need to do this for each combina-

tion, if for any reason you develop to approach maximum development times.)

If there is a point of maximum permitted development, it follows that there must also be a point of minimum permitted development. This is the point below which the paper has not yielded its maximum black. It may look black on its own, but compared to the true maximum black it lacks depth and as a result the print will be of poorer quality. The test for this 'maximum black development time' (MBDT) is simple, along the same lines as the above but using a sheet of fibre-based paper exposed beyond maximum black exposure time as determined by a test strip. This is cut into quarters, labelled 1, 2, 3 and 4, and developed for 1, 2, 3 and 4 minutes respectively and fixed. The blacks are compared side by side, where any loss of depth can now be

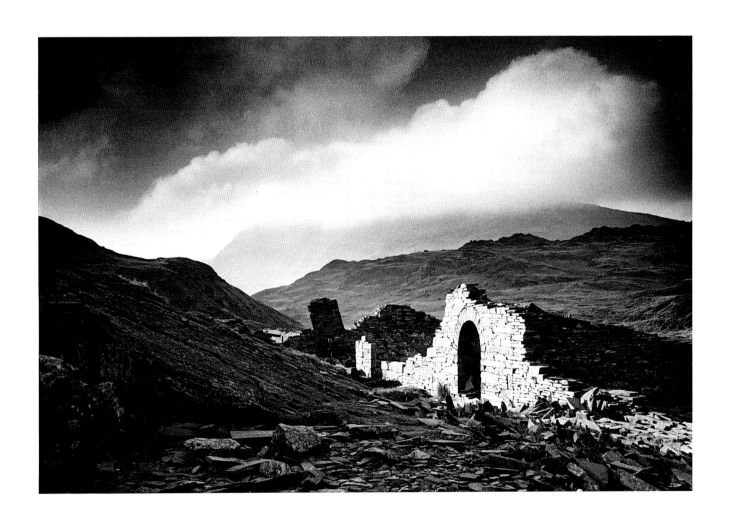

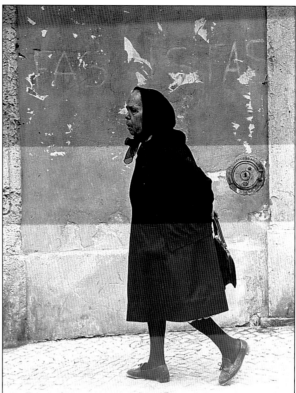

seen. Some fresh modern fibre-based papers may show no difference if maximum black development has been reached in one minute, but a difference is often detectable. The point at which no difference is seen represents MBDT.

(Note that, whereas assessing highlights must be done dry, subtle differences in blacks may be easier to spot when the paper is wet. Note also that when the paper gets older and is past its best, both MDT and

MBDT will alter as it becomes more prone to fogging.)

It follows from the above that the 'optimum development window' is the time between MBDT (for best blacks) and MDT (for best whites).

Test strips I always make test strips when starting a new print. Like contact prints, test strips are often undervalued. They give information not only on the correct exposure but also on the effect of over and

f-STOP CALCULATIONS

Sec	+¼ stop	+½ stop	+¾ stop	+1 stop
2	2.4	2.8	3.4	4.0
3	3.6	4.2	5.0	6.0
4	4.8	5.6	6.7	8.0
5	5.9	7.1	8.4	10.0
6	7.1	8.5	10.1	12.0
7	8.3	9.9	11.8	14.0
8	9.5	11.3	13.4	16.
9	10.7	12.7	15.1	18.0
10	11.9	14.1	16.8	20.0
12	14.3	16.9	20.2	24.0
14	16.7	19.7	23.5	28.0
16	19.0	22.6	26.9	32.0
18	21.4	25.4	30.2	36.0
20	23.8	28.2	33.6	40.0
24	28.6	33.8	40.3	48.0
32	38.1	45.1	53.8	64.0
40	47.6	56.4	67.2	80.0
48	57.1	67.7	80.6	96.0

DRY DOWN

Whether exposing for test strips or work prints, always base exposure calculations on dry prints. This is because prints, especially on fibre-based paper, darken as they dry — the so-called 'dry down' effect. If you base exposure on a wet test strip your next print will look fine — in the wash! This is especially noticeable when delicate light tones are involved, since these may be invisible on a wet print and appear only on drying.

Resin-coated prints dry quickly with the help of a hair-drier and fibre-based prints dry quickly in a microwave! When using the second, blot off the excess water, place on two sheets of household paper and cook initially for 1–2 minutes, according to taste, but more if required.

Do not dry fibre-based prints on a flatbed drier unless they have been washed for 30–60 minutes, otherwise fixer may contaminate the apron and be transferred to subsequent prints. This method is therefore not generally suitable for test strips, which need to be assessed quickly.

If you must work from a wet print for purposes of exposure calculation, reduce exposure by about 10 percent to allow for dry down. Note, however, that this figure varies from paper to paper.

Apart from test strip evaluation, it is essential that 'dry down' is taken into account when you do safelight tests, paper safe drawer tests, maximum development time tests, maximum flash tests, fogging assessment and any procedure which involves detection of very light tones, especially with fibre-based papers.

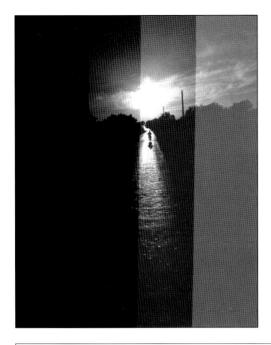 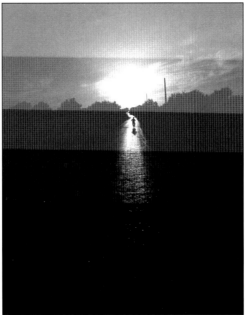 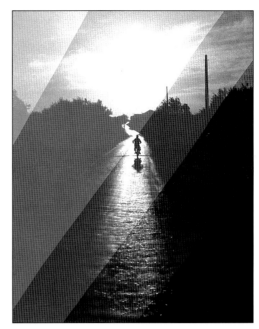

SECONDS VERSUS *f*-STOPS

Test strips are usually made using equal time increments — for example, 5, 10, 15, 20 sec. This is because most timers work in real time, and exposures based on these increments accumulate across the test strip. When using cameras, however, we always think in *f*-stops — in terms of either aperture or time, each stop doubling or halving exposure.

Microchip technology has made it possible to think, and instruct the timer, in familiar *f*-stops. The *f*-stop timer converts these into real time. Consider a test strip made with 5, 10, 15, 20, 25 and 30 seconds. Strip 2 is a whole stop more (i.e. double) than strip 1. Strip 6, however, is only ¼ of a stop more than strip 5, i.e. each exposure increment is smaller than the last. A test-strip increasing in ¼ or ½ stop increments is consistent throughout and much more useful for estimating burning-in and dodging times. The benefits of *f*-stop timing become even more become apparent when a print with significant dodging and burning-in requires enlargement or reduction. Exactly the same *f*-stop instructions are used for any size of print, the initial exposure time being all that needs changing. (A simple formula for calculating changes in the initial exposure time is shown on page 152, together with conversion factors for switching between standard paper sizes.) With a real-time timer exposure for every dodged and burned-in area must be calculated as a percentage of the initial exposure and then recalculated for the new exposure. This can be tiresome if you make versions of the print in several sizes.

If you like the idea of working in *f*-stops but cannot afford or find an *f*-stop timer — they are expensive and still not widely available — use the table on pages 152-3. Note that in real time increments are non-linear: an increase of 1 stop on 5 sec is 10 sec, but an increase of ½ stop is 7.1 sec, not 7.5. sec.

The direction in which the test strips are made on the paper is determined by the nature of the image. Here, where much of the picture is black and devoid of detail, with the interest concentrated in a specific area, conventional vertical or horizontal strips completely miss important areas and so a diagonal strip was used.

underexposing and the degree of dodging and burning-in which may be required. After processing they can be kept for preliminary trials and timings for toning and bleaching processes, retouching practice, matching spotting dyes and so on. Always store test strips with finished print copies and if you later decide to tone or otherwise alter the print, you can risk the test strip first. The test strip consists of a series of incremental exposures across the print. This initially involves guesswork, but start with the lens at *f*5.6 or *f*8, as these are likely to be the enlarging lens's best-performing apertures. The time of each step will depend on your enlarger's brightness and height and the type of paper.

The strips should be wide enough to permit adequate inspection. Too many on one sheet will be too narrow to be of much use, and it is better to use an extra sheet. I use a full sheet for small prints — up to 10in x 8in (20cm x 25cm) and ½ or ⅓ of a sheet for large prints.

Ideally the area to be test-stripped should be fairly consistent in tonal range. This may also dictate the direction in which the strips run. It can be misleading to run a strip from a light into a dark area and vice versa. Changing the direction of strips from vertical to horizontal or even diagonal might overcome this problem. When doing test strips on a contact sheet, make sure that they fall mid-frame and not between frames, or you may not be able to see them.

Examine your dry test strip and choose the strip which offers you the effect you want. (This can be between strips.) Calculate the exposure and make a fully developed print as described earlier. This is your work print. It is possible that it is already a perfect print, but it is much more likely that it can be improved — either subtly or dramatically.

DODGING AND BURNING-IN

A saying has it that 'honesty is the most important thing in life. Unless you can fake it, you'll never make it.' Whether or not this is true in life, it is certainly true in photographic printing. 'Photography' means 'drawing with light', and by using your hands and simple tools you can redistribute the light falling on the paper to produce the effects you want, ranging from subtle to dramatic. It is up to you to decide whether you want to fake honesty or be explicitly dishonest — both approaches have their place.

Reasons for dodging and burning-in Dodging and burning-in are usually the first steps in the manipulation of a black-and-white print. Also known as holding back and printing down, these techniques are used, respectively, to lighten or darken areas of the print by allowing less or more light to fall on those areas of the paper. Before looking at 'how', it helps to consider 'why' so that we have a clear idea of what we want to achieve. Earlier we saw how to make a work print. Why not leave it there?

Firstly, compared with most negatives, printing paper has a limited range of tones and the work print or contact print shows just how much detail can be lost. Extra exposure to highlight areas may be required to reproduce the highlight detail that is in the negative. Similarly, in order to preserve the shadow detail in the negative, reduced exposure to these areas may sometimes be necessary to prevent shadows filling in completely, or 'blocking up'. A single 'straight' exposure may not reconcile these two mutually exclusive objectives.

Secondly, you may not always *want* a print that shows everything the negative has to offer, but prefer to inject a personal mood or style. Shadow details may be deliberately suppressed rather than preserved. A darkened sky may add drama, while the emphasis in a face may be altered by changing the skin tone or the way the eyes are printed.

A third reason is that the overall tonal balance of a print may need to be adjusted for aesthetic and compositional reasons to produce a 'balanced' picture. The need for emphasis is another factor. The tones of certain elements within the picture may be altered to affect their importance, the statement they make or the degree to which they attract the eye. Lightening a face in a crowd may draw the eye to it. Darkening bright, unimportant parts of the print — especially near the edges — may prevent them drawing the eye away from more important areas.

The decision to emphasize perspective in a picture also calls for dodging and burning-in. Lightening and darkening objects can make them advance or recede within the print, enhancing the impression of depth.

In this high-tech age the tools you need for these techniques are delightfully simple and cheap — with the exception of your enlarger, lens and timer.

DODGING

If you want to dodge something near the edge of a print, you can easily use your hands as dodging tools. If the area to be dodged is in the middle, however, you cannot place your hand over it without your arm dodging an unwanted strip leading towards it. To avoid this, use dodgers on fine, pliable wire. These can be either precisely shaped pieces of card or simple circles, squares or triangles. By revolving the latter shapes or bending the angle at the end of the wire, you can produce a wide range of differently shaped shadows. Alternatively, Blu-tack or Plasticine is easily pressed into any shape of dodger or can be used to hold card cut-outs on to the wire.

The underside of the dodger should be dark — preferably black — never white, since this will reflect light back down on to the print and degrade it slightly. I keep all my old Agfa packets for this purpose; they make excellent dodgers and burning-in tools, being red

Dodgers can be bought ready-made or improvised with card and pliable wire. Circles, triangles and squares held at a variety of angles serve most purposes, but dodgers can be cut from card to any shape.

To decrease exposure to a selected portion of the image, interpose the dodger between the projected negative and the printing paper on the easel. The height at which the dodger is used is critical to the result.

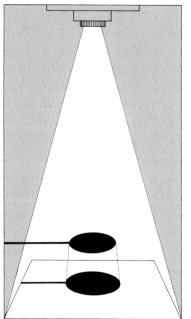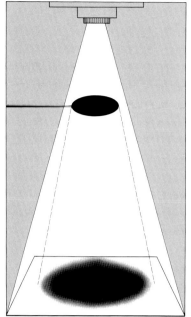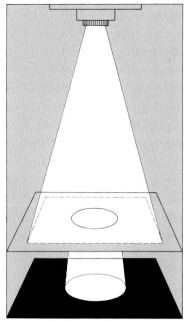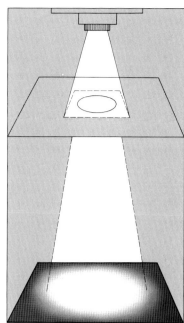

The first pair of diagrams above show how using the dodger at different heights affects the size of the area dodged and the edge sharpness. Similar considerations apply when burning-in, as shown in the second pair of diagrams.

If it is held close to the paper, the dodger's wire handle will produce a shadow and leave a distinct line on the print. Avoid this by raising the dodger or bending the wire away from the paper, as shown on the opposite page, or by moving the wire in an arc, as shown in the first diagram on the right

When shading a large area by moving a small dodger in a circular motion, as shown in the second diagram on the right, careless overlapping may cause excessive lightening at the centre. A similar thing can happen when an area of the print is darkened by burning-in through a card with a hole in it.

on one side and black on the other.

The height of the dodger from the paper is important. Precisely shaped dodgers need to be placed on the paper, as shown on the opposite page. The danger here is that a line will be visible if registration is not perfect, and so they are more difficult to use. When using this type of dodger or mask, I always bend the wire so that it is not also lying on the paper, since it would then leave a visible trail on the print.

If the dodger is raised above the paper, two things happen: the shadow cast becomes larger and the edge becomes progressively less distinct, as in the illustrations above. This is a great advantage when you do not want an edge line, but it does prevent the use of a precisely shaped mask.

You may find it helpful to use a dodger smaller than the area to be lightened, and avoid leaving tell-tale signs by moving it around the area. It is also a good idea to move it up and down the light path, so that the edge is always changing in size and sharpness, but be careful not to over-dodge the centre. If you hold the dodger too still, the effect will be too obvious. Since the wire is thin, it will not usually leave any visible sign unless you hold it too close to the paper. If this is necessary — for a precisely shaped mask you can bend the wire as shown on the opposite page, while for other masks you can rotate the wire in an arc to avoid a shadow.

BURNING-IN

Like dodging, burning-in can be done with the hands or through a hole in a piece of card About halfway up the light path is a good starting point. If using a card, do not try peering under it to see where the light is falling on to the paper. It is much easier to cover the hole from underneath, then switch on the enlarger, looking at the projected picture on your card as a guide. Move the card until the hole corresponds to the area required in the image now being projected on to your card. Raise or lower the card to make the hole the required size on this projected image. Uncover the hole for the required time, exposing the area of paper underneath, while masking the remainder. Remember to keep the card moving and to keep an eye on the edges of the card in case, as you move it across the print, you inadvertently uncover a corner or side, so giving unwanted extra

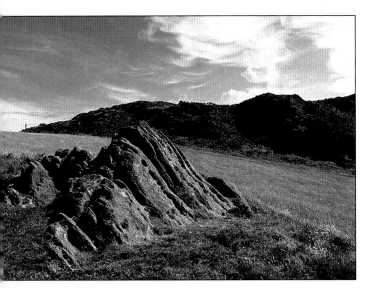

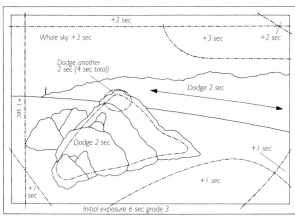

The straight print, far left, is a guide to the tonal relationships and detail on the negative. The print map, left, ensures that exposure adjustments can be repeated faithfully whenever a reprint is required of the finished print, below.

Within the print map:

+2 sec

Whole sky +3 sec

+3 sec

+2 sec

Dodge another 2 sec (4 sec total)

Dodge 2 sec

+1 sec

Dodge 2 sec

+1 sec

+1 sec

+1 sec

Initial exposure 6 sec grade 3

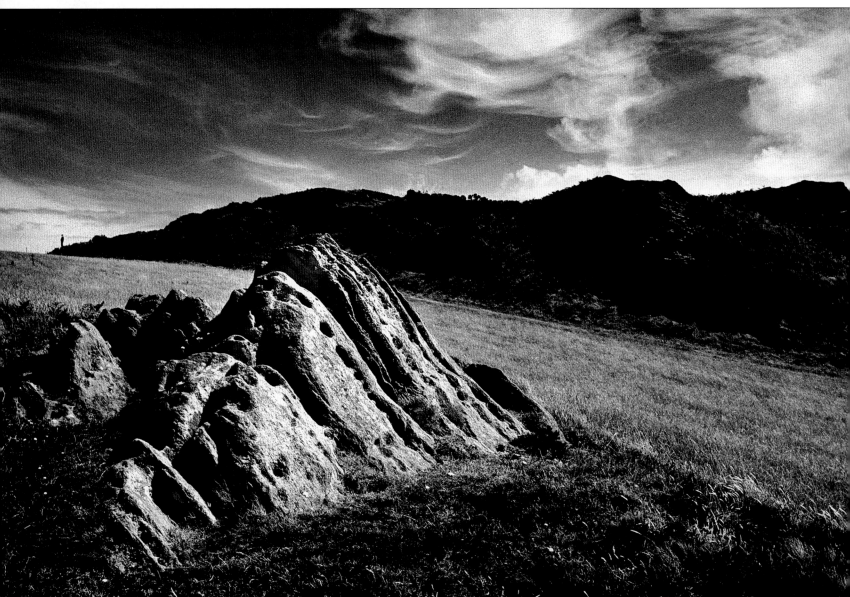

exposure in the wrong place.

I strongly recommend two other important items: a foot-switch and a large wastebin. The foot-switch operates your timer, which in turn directly operates your enlarger. For non-electric timers, connect a foot-switch directly to the enlarger, so as to keep both hands free.

If you are not filling your wastebin, you are probably not taking risks and therefore not learning. Consider reject prints not as failures but as steps to success. If you do not take these steps, you will not progress along the learning curve. Also it is necessary to analyse exactly why each failed print was imperfect and learn how to avoid the mistake in future.

Creating depth The triangular foreground rock in the main picture on the opposite page was dodged during the main exposure. This manoeuvre has achieved several things. The rock now has greater importance, since lighter objects attract the eye. It also gives the impression of directional light and 'moulding' — in short, it looks less two-dimensional. Furthermore, lightening the rock has made it advance from its darker background, increasing the illusion of depth. The sky has been 'burned-in' and the whole picture now has more impact.

Aerial perspective In the photograph on this page, simply using my hands as dodgers (a moving card would have done just as well) to hold back the top of the print for part of the exposure has lightened the tor in the background, making it appear further away. So, having told you that lightening something makes it advance, am I now telling you it makes it recede? This is not the contradiction it appears. In the foreground, and particularly when placed against a darker background, light objects do appear to jump forward.

However, the effect known as aerial perspective, and caused by natural haze, makes distant objects such as mountains, hills and horizons appear lighter the further away they are. Because a wide-angle lens was used, the scale or linear perspective suggests that this tor was much farther away than it actually was. Lightening it in the print therefore completes the illusion and also enhances the effect of the fine drizzle present at the time the picture was shot.

These two techniques were combined in one print in the photograph of the rock on the next page, bending the flat plane of the straight print to increase the impression of three dimensions. The powerful foreground position of the rock in the straight print already makes it stand forward and this effect is enhanced by two factors. The first is the vast scale difference between it and the background, and the second is the way it thrusts upwards into the picture as a result of this stark cropping, almost if it is intruding into an existing

picture but separate from it. Lightening the rock in printing by 1 stop helps to bring it forward and separate it from the background.

I used the technique of split filtration on variable-contrast paper to render the rock in a higher contrast grade than the rest of the picture, which further emphasized its spatial separation. (This procedure is discussed in more detail on page 79.)

Graduated burning-in of the sky resulted in a progressive darkening towards the top of the same picture.

Dodging the background can enhance or mimic aerial perspective, increasing the impression of distance.

DODGING AND BURNING-IN TIPS

1 If you are using a precisely shaped dodger on the paper, position it first using the red safety filter on the enlarger. But note that this may be unsafe at maximum aperture and also with variable contrast papers.

2 To avoid wire marks leading up to precisely dodged areas, bend the wire up away from the paper — or use an acetate mask.

3 To make a soft-edged but shaped hand-held mask: either raise the easel on books to the height required for the mask and draw round the projected image (without refocusing); or lower the enlarger head by the distance you want the mask to be above the easel and draw around the unfocused image on the easel, then return the enlarger to its original position. Now cut the mask. It will be the correct size when held that distance from the paper.

4 When deciding the height at which to hold your hands as dodgers, consider not only the shadow size and edge sharpness, but also your comfort and ability to work accurately at that height, especially during very long exposures. Consider installing a vertically adjustable baseboard to give you the most comfortable working height.

5 Some printers use a metronome as a timer and count the ticks. However, it is easy to lose concentration briefly with long burning-in exposures for big prints, especially with multiple exposures.

6 Print with conviction, and even try pushing your printing to extremes from time to time. At the very least this will prove instructive and it can be creative. Novice printers are often too timid.

7 Keep reject prints. You will find many uses for them as you work through this book.

8 If your sky burning-in spills over on to hill tops and other details, do not discard the print. Read the section on bleaching and you may be able to retrieve it.

9 Consider combining split filtration with dodging and burning-in, for both impact and greater control.

10 In high-key portraits, burn-in the pupils to black, one after the other, through a tiny hole in a card.

11 In low-key portraits, try dodging the eyes with two lumps of Blu-tack on a wire. Make a 'nose bridge' in the wire and rotate it in an arc during the exposure,(see diagram below) to avoid tell-tale lines between the eyes. Practise the manoeuvre several times beforehand.

12 Finally, learn to regard reject prints not as failures but as steps on the road to success.

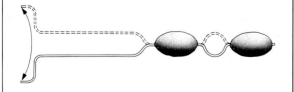

This enhances aerial perspective and creates the impression of the upper part of the sky extending forwards. Stand and look at a blue sky over a landscape and see how much deeper the blue is directly above your head than it is towards the horizon. With the middle ground printed darker, the distant hill was separated and lightened with the bleach potassium ferricyanide.

These simple examples have introduced dodging and burning-in as a way not so much of distorting reality as of enhancing it with a little honest artistic licence. However, your intentions in making any print — even landscapes — do not have to be remotely honest. Whether you are printing in, say, a realist, expressionist, symbolist or surrealist style, you should print appropriately for the image you wish to create. Some people have strong opinions about style, but there is no absolute right or wrong here — only personal tastes and fashions.

Fantasy The large picture of a circle of standing stones was printed simply by using the dodging and burning-in techniques already described to produce a

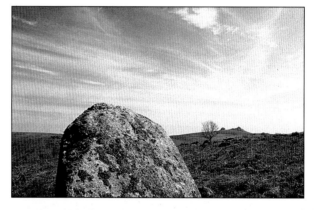

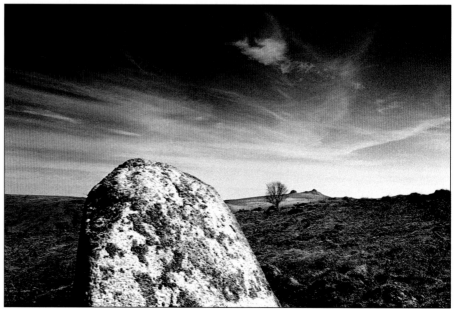

It is possible to make the plane of a photograph appear to bend, by using a combinination of the techniques explained in the previous pages. In this way the picture is made to convey the illusion of depth. In the example seen here, the background was lightened, the top of the sky was darkened and the rock in the foreground was pulled forward by dodging.

picture that in no way pretends to emulate reality, but rather to hint at the magic and mystery suggested by prehistoric stone circles. The work print, above it, lacks the atmosphere of the finished print.

After working out the basic exposure for the rocks and the central area, I burned-in the sky heavily. This was easy to do since no 'join' was required at the horizon. Instead the extra exposure was allowed to spill over the background to render the background hills black and mysterious.

I used a large elliptical dodger to hold back the stone circle while I was burning-in the edges of the print. This latter effect was enhanced by applying a graduated darkening to the sides and corners. The central 'light' was allowed to spill between the stones by the judicious use of additional potassium ferricyanide bleach to complete the illusion.

The manipulations employed in printing do not have to be 'honest'. They can be openly dishonest, for artistic effect or to create a fantasy, as in the picture below, which is a dodged and burned-in version of the straight print on the right.

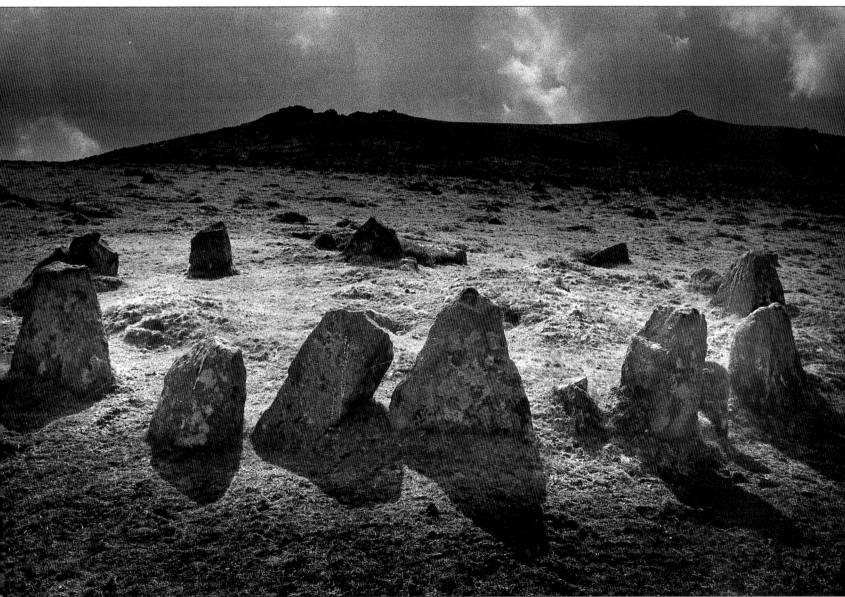

Artistic licence Over the centuries, painters have used exaggerated, unearthly light in their pictures, often to emphasize the drama of nature or to suggest the presence of divine or supernatural forces. Photographic printing likewise grants the photographer freedom from the constraints of reality. The main picture below exploits this potential, its contrived lighting designed to stimulate fantasy in the mind of the viewer.

Complex printing problems All the illustrations so far have been technically fairly simple. It will not always be so. Let us look at some of the problems amateur printers encounter with the apparently straightforward task of burning-in a sky. Depending on your negative and the horizon, this can be simplicity itself — or fraught with difficulties. If the technique is new to you, choose an uncomplicated horizon where nothing protrudes up into the skyline — with the possible exception of silhouettes.

Before long, though, you will want to burn-in an irregular skyline, as in the study of four rocks shown here. With this subject, problems arose from the fact that in order to convey the stormy atmosphere the sky needed a considerable amount of burning-in — 2 stops, or 32 seconds, on to a basic exposure of 8 seconds, with extra in some areas. At the same time I wanted the distant hill top to be a mid-grey, and not go black.

Fig A shows the straight work print. Fig B illustrates the effect of trying to darken the sky by masking off the rocks and foreground with a moving card during the extra sky exposure. (Unless you keep the card moving, you will produce an even more obvious band between sky and horizon. This is a common fault in home-made prints.) Fig C shows what happens if the mask is lowered to get rid of this fault. Another common problem occurs — the top half of the stones have gone black.

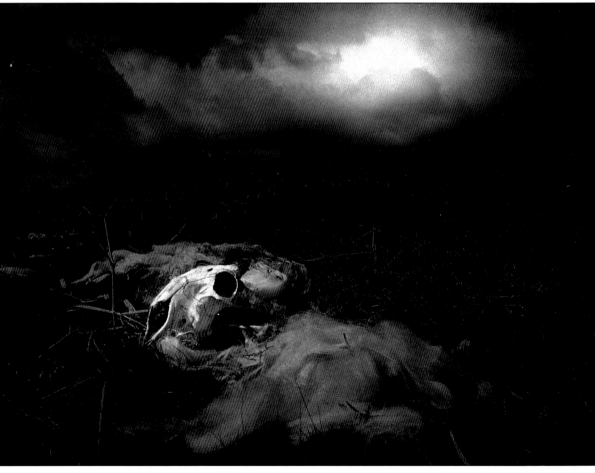

The sheep's skull lacked impact, so I used burning-in to darken unwanted detail and dodged certain areas to lighten them for emphasis. For example, the cloud was made lighter to echo the light tones of the skull and wool. This deliberate departure from a realistic interpretation lent the picture drama.

A *The straight work print without additional burning-in.*

B *This print shows the result of trying to mask off the foreground by using a moving card. An even more obvious light band will appear in the sky if the card is not kept moving.*

C *In order to remove the light band in fig B, the mask has been lowered. This, however, has caused parts of the horizon to become black.*

D *The halo effect, here deliberately exaggerated, resulted from dodging the stones during the second exposure while burning-in the sky.*

E *It is very difficult to cut a dodging card with precision, especially for a relatively small print like this. As a result, parts of the sky at the horizon are white, although careful spotting can disguise this problem when it is small. But parts of the mid-grey hill tops have gone jet black, which is less easy to rectify.*

This too is common in amateur prints, affecting trees, church spires, office blocks or any structure protruding into the sky area to be darkened.

Fig D shows the halo effect on the horizon that can result from trying to dodge such structures during the second exposure. Here the problem is deliberately exaggerated. The answer is surely to make a card cut-out exactly corresponding to the skyline shapes and just burn-in the sky with the mask in place. It sounds easy, but just try it with trees and complex skylines! Fig E shows what can happen with this technique. It is extremely difficult to cut a card with exact precision, especially on a small print such as 10in x 8in (25cm x 20cm). Parts of the sky at the horizon are white and parts of the mid-grey hill tops have gone jet-black. Similar tell-tale signs appear around the stones.

Multiple choice My solution was to think of several ways to burn-in the sky or dodge the stones — in this case six — and use a little bit of each. In this way, if each left a slight trace, it would only account for a sixth of the exposure and so not be very prominent. Furthermore all the other exposures with their tell-tale signs would help to cover each other up. I dodged the top part of each rock during the main exposure by as much as I could. I was then able to simply burn-in the sky and the tops of the rocks (as in fig C) with a straight card, which was kept moving and held well above the paper so as to avoid a visible line on the print. This returned the rocks to their correct exposure and started to darken the sky.

Then I gave another sky exposure, moving my hands to try to dodge as required. This was too short an exposure to produce the halos in fig D. I followed it with a precise cut-out contact-mask exposure, as described earlier — again too short to create the problems seen in fig E — and subdivided the exposure into four or so exposures, with minor adjustments to the mask position in each, in order to further minimize the risk.

The next exposure was given with a smaller cut-out mask on a glass sheet about a quarter of the way up the light path, thus producing out-of-focus edges. A further, smaller mask was used in the same way two-thirds up the light path. I gave a graduated sky exposure, which had little effect on the skyline but most effect at the top of the print. Finally I gave additional exposures, using hand masking either side of the light path. Other helpful techniques, such as flashing or using diffuser materials like tissue paper or exploiting the properties of variable-contrast paper, can make difficult edge control more manageable. The final version is shown on the next page.

Painting in tone If the halo effect is still presenting a problem on the horizon, the main exposures can be fol-

EXPOSURE TIME

When carrying out any of the dodging and burning-in techniques described on these pages, altering the lens aperture will give you considerable flexibility in your choice of correct exposure times. I prefer not to change the aperture part-way through making a print, but instead to chose one that will give me workable times throughout.

If you do change aperture in mid-print, do it extremely gently in order to avoid slight changes in registration or focus. Until you have acquired a degree of skill, it is easier to use a smaller aperture, as this will give you a longer exposure. If you have a two-second error in getting your dodger, mask or hands in exactly the right place in a four-second exposure, the mistake will be much more obvious than it would be if you closed down the lens by two stops, which would give you an exposure of 16 sec.

lowed by a long exposure during which a hole in a large card is run back and forth along the affected area or areas, 'painting' in a tone to exactly the required degree. Keep detailed notes of all procedures and times, since this will require trial and error. Because the hole is kept moving, very long exposure times may be required. If you are using a variable-contrast paper, it may help to select grade 0 or 1 for this final exposure.

If part of the print appears too light as it comes up in the developing dish, this area can be 'hurried up' by rubbing it with the fingers during development. If you do this, make sure that the dish bottom is smooth at this point. Do not rub along ridges, as they will subsequently show up on the print. Move the print in the dish as necessary. A larger dish makes this easier. This works much better when you are printing on fibre-based paper than on resin-coated.

A refinement of this technique can be used in which, after full development, the print is transferred to a dish

F *The final version of the print, after flashing, dodging and burning-in, rotation, cropping, local bleaching, chrome intensification and selenium toning. Rotation of the image is a part of cropping and composition. In this picture cropping removed some redundant foreground and rotation produced a much more dynamic composition. The stones are much less static than those in the original print.*

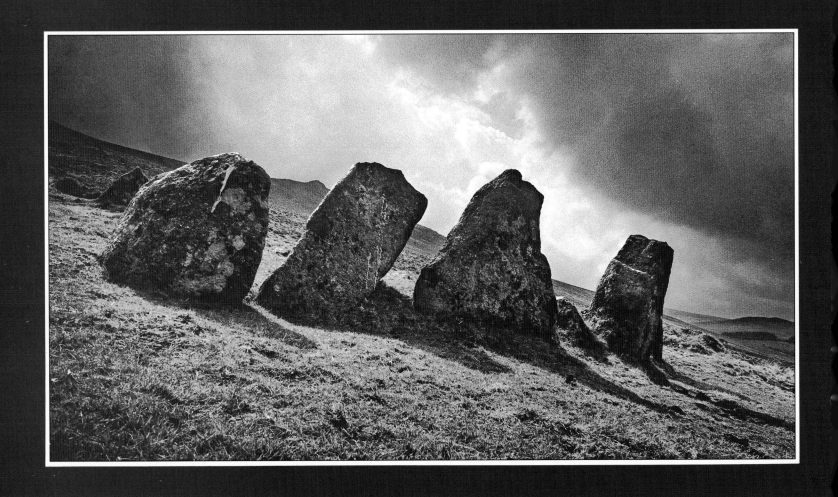

of water. It can then be lifted on to a flat surface — a piece of Formica just small enough to slide into the dish with the print still on it, is ideal — and the offending areas massaged with developer on cotton wool. Care must be taken not to leave the developer on too long without reimmersing the print in water, blotting 'dry' and repeating the process, otherwise lines will appear on the final print. Watch also for trails of developer running across the other areas of the print. Different strengths of developer can be used, from small containers kept nearby.

Fogging The prolonged exposure of your developed but unfixed paper will be a severe test of your safelights, and fogging — both light and chemical — may result. Chemical fogging can be minimized by using very fresh paper and/or adding 10ml of 10% potassium bromide or 5ml of 1% benzotriazole to 1 litre (1.8 pints) of developer, keeping development time to one minute, with an appropriate exposure time. Light fogging can be avoided by carrying out the safelight tests described earlier, taking into account extended development times.

Print mapping As you become more skilful, you will want to tackle more challenging printing tasks. It helps to have a clear mental image of what you wish to achieve. You can then build up a 'printing map' based on your straight work print, along the lines of those shown on pages 60-1. Keep these for future reference, as they will save much time and paper during subsequent reprinting sessions.

If you lack a clear vision of what you want when you begin, be bold and experiment. Your inhibitions may be holding you back. Sometimes pictures printed 'way over the top' turn out better than expected. Never discard your prints before reviewing them carefully in the cold light of the next day or two.

Working up a print You can either build up a print progressively from its lightest area, or dodge and burn-in piecemeal. The techniques are different and suit different negatives — and different printers. With the photograph below, of the satellite tracking station, *Anybody there?*, I knew at the taking stage exactly what the final print should look like. From the two straight prints it is obvious that a single exposure could not possibly give acceptable detail in both foreground and sky. Even if a correct exposure were given for the 'hole in the sky', the surrounding tones would have to be rearranged.

The critical area to get right in the initial exposure was the strip incorporating the dish, the sky behind it, which could not be too light or too dark, and the horizon. Once this exposure was established by test strips, the rest of the print was progressively built up step by

ACETATE MASKS

Dodgers can be used off the paper, or on the paper in the form of precise cut-outs. The latter can be moved slightly during exposure to reduce the edge effect, but they can be difficult to use, particularly since they have to be put in place 'blind' on a white, featureless sheet of paper and then quickly adjusted when the enlarger comes on.

With practice, acetate masks can be easier to use than precise cut-outs, especially where several precise maskings are required during a single exposure. Acetate masking allows these to be done all at once and to be placed in register simultaneously. It can also provide a practical alternative to the laborious series of exposures required for a print like that of the four standing stones on the opposite page. Clear acetate sheets suitable for use as masks can be purchased in paper sizes from suppliers of art materials.

To use an acetate mask, project the image onto the back of a print in the easel, compose and focus. Lay an acetate sheet on the paper and close the easel, making certain that the acetate is firmly butted up against the top and side registration guides of the easel. Using full aperture, for maximum brilliance, very carefully outline the required areas with a fine-point pen suitable for use on acetate. Great care must be taken to get the outline exactly right. Remove the acetate and carefully paint in the marked areas with photo-opaque paint. This must be thick enough to block light transmission. You can check this by holding the acetate up to a light.

You are now ready to print. Insert the paper as usual, but tape the edges to the easel with masking tape to ensure that

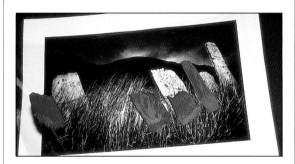

it cannot move when you put in the acetate mask later. Give the exposure needed for the masked areas. Open the easel, carefully insert the acetate, making sure that it lies against the registration guides of the easel as before. Close the easel, ensuring neither paper nor acetate moves. Give the second exposure to bring the rest of the print to the required tone.

Conventional dodging and burning-in can be used in combination with this technique, and it is particularly useful when burning-in a sky in the conventional way, as it avoids blackening any structures protruding into the sky.

Acetate masks can also be used in multiple printing with any of the other blending techniques (see pages 86-99).

step as shown on the print map. The masking was done by moving hands into the desired shape for each new exposure, which in turn was controlled by a foot pedal, so that both hands remained free.

Note that the printing map uses *f*-stops rather than seconds to indicate exposure, as explained on page 45. By using the table on pages 152-3, you can use this method without an *f*-stop timer. It is particularly useful when making enlargements of a complex print like this. But do not attempt it by actually making multiple *f*-stop changes on your enlarger lens. Simply work out a new initial exposure (T2) from the formula $T2 = T1 \times (W2/W1)^2$, where T1 and W1 are the time and width of

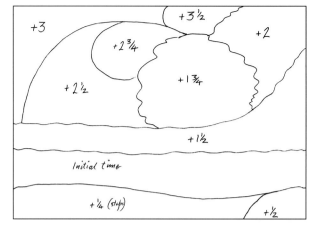

An f-stop printing plan indicates the pattern of increasing exposures used to produce the final print, below.

These two straight prints were exposed for foreground and cloud detail respectively. Considerable redistribution of tones will be necessary for the final print.

The negative was flipped to read from left to right. Galerie grade 4 paper was flashed to 'max flash'. The final print was built up step by step from the lightest exposure, just above the horizon, by using both hands as dodgers and an f-stop timer operated by a foot-switch. A short dilute selenium bath was used to cool down the image tones.

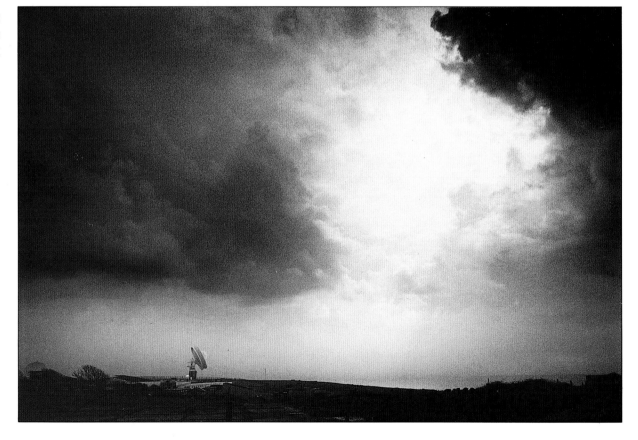

the new print. All other exposures follow automatically as the *f*-stops are already programmed into the timer.

Piecemeal printing The infrared shot of the beach huts was printed in real time. But, as the printing map below shows, it was dodged and burned-in piecemeal, with the main exposure set for the body of the print, rather than building up from the beach huts as the lightest area. The aim was both to highlight the design in the picture and to exploit the properties of infrared film so as to raise questions in the viewer's mind. Why

are the beach huts glowing? Why is the man blasted by light but the sky so holocaustically dark? Why are the picnickers unaware of this anomaly? Was this a split-second occurrence? The picture certainly evokes a 'Chernobyl-on-Sea' scenario. The straight print on Multigrade 2½ reveals a rather flat negative. An increase of one grade and selective printing together help to overcome this, as shown by the final print.

Vignetting As dodging is to burning-in, so vignetting is to edge burning. Here the edges of the print are

The straight print is seen on the right. Next to it is the real-time printing map which was used to indicate the piecemeal dodging and burning-in carried out to make the final print.

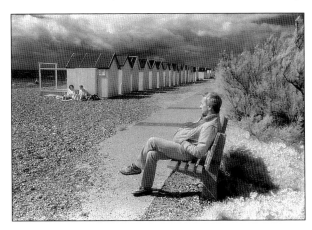

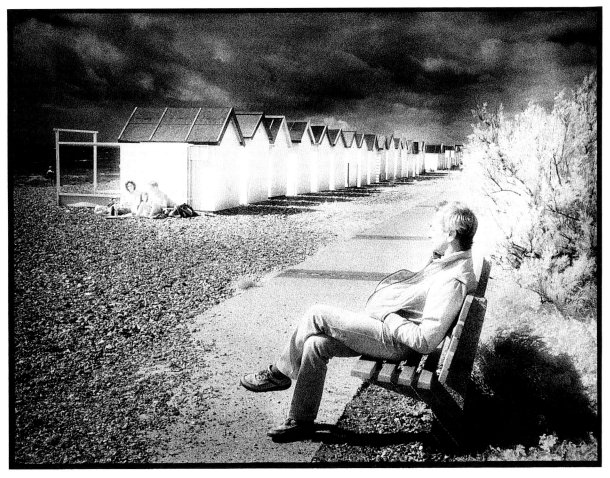

Drama and tension were imparted to the final print by using dodging and burning-in to reposition tones on the characteristic curve. This brought out the essential qualities of infrared film, allowing the huts to glow. The print was made on Ilford Multigrade grade 3½ in Ilford FF, and toning in 1 + 20 selenium toner was given to enhance D-max.

deliberately lightened to 'paper base'. Although it is possible to do this with iodine bleach after processing, it is normally done by holding back during exposure.

As shown here, high-key photographs are particularly suitable for this treatment, as their delicate tones bleed comfortably into white. Vignetting also enhances the romantic, dreamy or gentle aspect of the subject and this is often the nature of high-key shots. For pictures like those on the right, it is easy enough to use the hands to roughly shield the edges of the paper.

More formal vignetting is sometimes used in pictures with a period feel to them — usually combined with sepia toning — to mimic the fashion of the time. For this an oval window must be cut in a masking card, and this is the most difficult part of the procedure. If the window is cut to be used as a precisely shaped mask on the paper, this must be done very accurately, since any flaw will be instantly obvious on the print.

A softer edge is much more forgiving of your mistakes, and looks better. To produce this, place a piece of clean, good-quality glass about 12in (25cm) above the paper. Turn on the enlarger and focus the image on the baseboard. Place the masking card on the glass and draw the oval window around the out-of-focus image. Remove the mask and correct any imperfections in the outline. Cut with a sharp scalpel rather than scissors.

Replace the mask on the glass, compose the picture and turn off the enlarger. At this height you should be able to open the easel far enough to insert the paper. During the exposure, keep the mask gently and slightly moving. This further softens the edges and, more importantly, further disguises any flaws in your knifemanship. For a really soft edge you may need to use a mask much nearer the lens.

A dark vignette is obtained by using the oval cut-out to mask the image during a heavy burning-in exposure. The image thus produced sits on a black background. The glass sheet enables you to keep the oval dodger in place without using wires, which might leave visible traces on the print.

Edge burning Some printers use a technique known as edge burning to slightly darken the edges and/or corners of the picture. One reason for doing this is to counteract the fall-off in illumination that occurs at the edge of a projected image. However, as this fall-off will have been largely counteracted by the same phenomenon in the camera, it should not be a noticeable problem if the enlarger is set up properly.

The more usual reason for edge burning is to 'contain' the image within the picture area by darkening the edges slightly, as the darker periphery is less eye-catching. It is used as a finishing touch and may be quite obvious or almost subliminal, depending on the requirements of the image, as perceived by the printer. It may

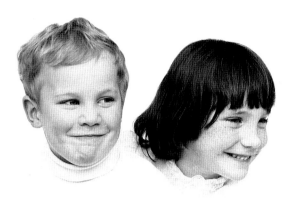

Loose vignetting by hand was used to lose unwanted detail from this high-key print.

Here formal vignetting, using a mask placed on the paper, was carried out. When this technique is used any edge irregularities will be noticeable.

Raising the mask a few inches softens the edges only slightly.

A higher mask moved gently throughout the exposure gives a softer effect, as well as hiding minor mask defects.

also be used, of course, to even up uneven sky tones resulting from flare or as a natural phenomenon.

Edge-burning techniques can be used to produce results with subtle differences:

1 A square or rectangular dodger smaller than the print but of similar proportions can be used. This is raised and lowered in the light path, allowing all sides to be equally and progressively shaded to the required degree.

2 Each side in turn can be given a graduated exposure by drawing a large dodging card back from the edge

slowly and re-covering it again. This has the effect of giving greater shading to the corners, where these exposures overlap.

3 The above method can be combined with oscillation of the dodging card to give more weighting towards the corners than at the mid point at each side.

4 Any of the above techniques can be used, but with the print placed under a weak fogging light instead of being edge-burned through the negative. Either a separate fogging light or the stopped-down enlarger with the negative removed will do. The result is a combination of darkening and lowering contrast around the edges. It is especially useful if high-contrast objects or light areas — clouds, for example — are present at the edges or corners. If used to excess, the technique may give noticeable loss of grain pattern, in which case it might be better combined with 1 or 2.

DIFFUSION

Although not strictly part of dodging and burning-in, diffusion is often applied using similar techniques and for this reason it is discussed here. It may seem ironic that now that computer-designed lenses provide sharpness once undreamt of, we should be discussing diffusing the image. Earlier I advised you to buy the best lens you can afford, so why deliberately reduce that razor-sharpness? The answer is that the techniques described collectively as diffusion offer a variety of creative effects. These range from the gross and distorting to those so subtle that the viewer may be unaware of them without a straight print for comparison. As with all darkroom skills, success depends on how and when these are used.

W. Eugene Smith, one of the greatest photographer-printers, used a piece of black wire mesh on a stick like

Raising and lowering a rectangular dodger in the light path produces a regular pattern of edge darkening in the print, as seen in the left half of the diagram below. Burning-in each edge in turn results in a build-up of additional tone in the corners, as shown in the right half. The second method is particularly useful when you want to focus the viewer's attention on the central area of the picture.

a see-through dodger to diffuse grain in areas of his prints if he felt it intruded between the viewer and the feeling in the print. He preferred to enhance the emotional pull of an image by smoothing out the tones, even though it meant sacrificing a little sharpness. Diffusion is used to:

• Suppress unwanted grain.
• Produce dreamy, soft-focus effects to enhance mood.
• Suppress wrinkles, freckles and blemishes in portraits.
• Disguise unwanted detail in less important areas of the picture.
• Soften problematic edge areas when burning-in or dodging.
• Convey a feeling of movement.
• Create a zoom effect.
• Produce deliberate distortion.
• Provide a vignetting effect.

Soft-focus effects A variety of diffusing tools can be used, some shop-bought and others improvised. Among the first are soft-focus filters, of which the square type are very effective when used with an enlarger. They come in a range of softnesses, and I keep by my enlarger a '1' and a '2'. Either can be left in place for the whole exposure or for any part of it, and when I need a particularly marked effect I combine the two.

A film exposure made with a soft-focus filter produces the familiar effect of highlights flaring into the other tones. When it is used under the enlarger, however, the shadows bleed into the highlights. Used inappropriately, this effect just looks muddy. But it can be attractive, especially where highlight areas are large enough to withstand some edge darkening without becoming veiled all over, as smaller highlights may do.

If the result is unsatisfactory, try either repeating the procedure at a different aperture (if the diffuser is close to the lens) or at a different contrast, which can have a dramatic effect on the outcome. As explained in the section which deals with contrast, the higher the contrast, the more greys will be banished from the highlights, whereas the lower the contrast, the more tones will be pulled into them.

If your result is too veiled, try a brief potassium ferricyanide bath. This is best done as a series of short immersions with intermediate washes until you achieve the desired result. If you use the filter for only a fraction of the exposure, the result may be very subtle and these additional measures will be unnecessary.

The landscape shown on the next page was taken on a tripod with a slow shutter speed to show the wind on the long grass. The nearest grasses in the bottom edge and left corner appeared too sharp and static for the rest of the picture, so I used a square soft-focus filter, moving it like a dodger just over this edge and corner to soften them during printing. (Crinkled transparent

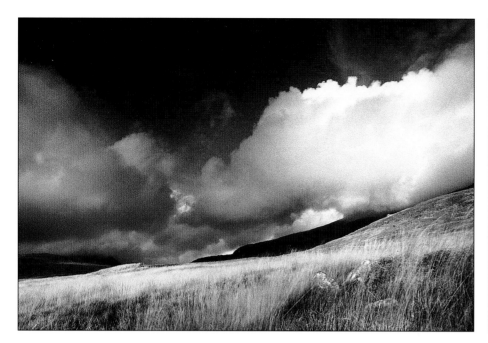

sweet wrappers also work well.)

Although sharper than those in the distance, the nearer grasses now fit more comfortably into the picture. After processing, I bleached the image in potassium dichromate and hydrochloric acid, and redeveloped it in Ilford FF. This technique, I have discovered, makes it possible to split-tone some 'unsplittable' papers with selenium (see page 119). A modest selenium tone was laid down in the deeper tones.

Variable soft focus Also available is a variable soft-focus attachment which fits on the enlarger lens. It consists of transparent diffusing diaphragm blades which can be set to produce effects ranging from razor-sharpness through soft focus to distortion. The attachment has a rotatable numbered ring with which you operate the diaphragm blade. This allows you to record settings on your exposure map for accurately repeatable results.

This soft-focus attachment can produce all the diffusion effects listed above, except that, unlike a hand-held filter, it cannot be used to treat an edge or corner alone. However, it can be used in conjunction with masks to render parts of the print sharp while others are slightly or totally diffused.

Grease diffusion Another very commonly used diffusion device is some form of grease. This is cheap, readily available and versatile. The methods of use and the effects of grease diffusion vary widely. For example, it can:
• Convey movement in fast-moving subjects such as cars, motorcycles and bicycles, and windsurfers.
• Simulate subtle movement in trees, grass or water.
• Create a sense of movement in clouds.

• Produce streaks of light or haze to create a dreamlike atmosphere.
• Blur or lose unwanted background detail.
• Create a zoom effect.
• Produce soft vignetting.

In fact, grease is more often used to distort part of the image rather than just diffuse it. To control this effect, you must apply it to glass somewhere in the light path, but far enough from the lens so that it produces the desired effect.

Grease from the outside of the nose is excellent for subtle effects when applied to a filter under the lens. It can be smeared either around the subject area, leaving a clear centre, or all over it. It can be applied sparingly (as is usually appropriate) or generously.

If used close to the printing paper, most greasy substances show finger or brush marks too clearly to be acceptable. Nose grease is thin enough to produce subtle results in precisely defined areas when used with an acetate sheet. For more pronounced diffusion, a glass sheet must be used, in a similar fashion to that described on page 92. However, it must be supported much nearer the lens: three-quarters or more of the way up the light path. This allows a working space between the lens and the glass, as well as room to open the easel underneath. It also ensures that brush marks are reasonably out of focus.

The choice of grease is important. Some are stiff and difficult to control, so that the lines become too obvious on the print. Others are too runny, so that the carefully arranged result 'melts' before or during the exposure. Among those that work best are soft margarine and Vaseline.

You can brush Vaseline on the selected areas of the

Subtle selective diffusion was applied in the picture above left, to slightly soften the grasses in the foreground during the primary exposure. Potassium dichromate intensification allowed the use of split selenium toning on Multigrade paper.

Unlike filters used on the camera, soft-focus filters used under the lens cause shadows to creep into the highlights, as in the picture above right. They work well in high-key pictures where light areas are abundant and not easily muddied. If the image is bleach-toned, as in this example, a little extra 'creeping' — produced by a slight increase in exposure or in the degree of diffusion, or both — may be needed to counteract the loss of highlights which sometimes occurs.

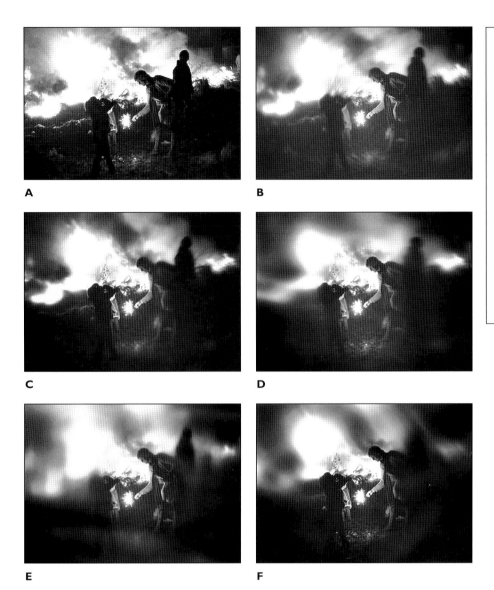

A

B

C

D

E

F

A-F *This series of pictures illustrates some of the diffusion effects that can be achieved with Vaseline or margarine on glass positioned three-quarters of the way up the light path. It is important to remember to apply the diffuser in the opposite direction to that in which you want it to work in the image. For example, to produce vertical streaks you must apply the diffuser horizontally.*

glass, watch the result on the projected baseboard image and work it around as required. Alternatively, smear the whole area and then, with an OO brush dipped in warm water but free of drips, clean off the areas you do not want to diffuse. A hair drier can be used sparingly to soften Vaseline and margarine, and to dry off unwanted water.

Although they can be difficult to get right, these results are often pleasing. It is important to remember that the direction in which you brush the diffuser is the opposite to the effect that you will see produced on the print. If you want to produce vertical streaking, apply the diffuser horizontally; if you want to achieve a zoom effect, apply it in a circular pattern; and if you require a circular effect, apply it radially, working out from the centre of the image.

Finally, you may find it easier to hold white paper on the underside of the glass than to work with the baseboard image.

CONTRAST

An area that often causes problems for amateur printers is choosing the 'right' contrast for a print. Papers come in single grades of contrast from 1 to 4 or 5, and in the variable-contrast form. With the latter, contrast grades from 0 to 5 in fractions of a grade are available from the same packet — or even on the same sheet — simply by changing the filtration used at the enlarger. Grade 2 is usually regarded as normal, grade 1 as soft and grades 3, 4 and 5 as progressively harder.

Apart from the choice of paper grades and the use of filters, there are other time-honoured ways to alter contrast, either to produce finer control or to move beyond the options offered by the paper in use. First let us look at what changing contrast means in visual terms and then consider some easy ways to remedy excessive contrast. Later we will examine ways of overcoming inadequate contrast, negative and print intensification, predevelopment bleaching and flashing with 'white light', as well as exploring the uses of variable-contrast papers.

'Correct' contrast What is the correct contrast for a print? The stock answer used to be: the contrast grade that gives a good white, a rich black and a full range of tones in between. This definition assumed that the photographer wanted such a result. However, most photographers now accept that the 'correct' version of a print is the one that the photographer intended, whether it displays a full tonal range, extremes of tone ('soot and whitewash') or a limited range of soft or dark greys. Ideally the result should have been pre-visualized and achieved on the negative by appropriate exposure and development to print correctly on to grade 2. However, with many different subjects on a 36-exposure roll of film, this is not always possible, so control is needed at the printing stage.

For a given paper, the base white and the maximum black will be the same for *all* contrast grades, provided the processing and/or the paper's surface finish do not vary. As explained below, it is the range of tones in between that varies according to the slope of the graph showing exposure versus density. Beginners sometimes believe that an increase in contrast affects only the whites and blacks, but it is often the separation in the midtones that puts 'light' into the print. Indeed clogged-up midtones can kill a print.

Contrast options When you want to change contrast the following options, and variations on them, are available. However, remember that base white and maximum black remain exactly the same at all contrast grade for a given paper.

When lowering contrast:
• Expose to keep the whites the same; allow the blacks to print as grey.
• Expose to keep the blacks the same; allow the whites to print grey.
• Expose to print the midtone the same; 'pull in' both whites and blacks towards grey.
Note: Other midtones will tend to close up.

When raising contrast:
• Expose to keep the whites the same; lose some darker greys into black.
• Expose to keep the blacks the same; lose some light grey detail as white.
• Expose the midtone the same; 'push out' both light and dark greys towards white and black.

Note: Other midtones will tend to expand.

These effects are clearly demonstrated in figs A-F, which show identical exposures on grades 0 to 5, with the exception of fig F, where the exposure was reduced just enough to hold the black, letting the remaining greys disappear into white. In effect, on a tonal scale ranging from light to dark the 'tonal window' was shifted to the left. It could also be shifted to the right, giving a different interpretation at any of the contrast grades — without yet even resorting to dodging and burning-in.

The series of pictures on page 64 repeat the exercise with a mid- to low-key subject. Although printed without any manipulation in mid key to give optimum tones throughout at grade 2-3, the print would probably have more impact if printed in low key. Despite identical exposures (using a fully corrected Ilford Multigrade dichroic head to eliminate exposure variables between grades) and identical processing, it is clear that the darker tones at grade 5 are moving towards black and producing a 'black hole' in the central dark portion which is only hinted at in the grade 0 print. This indicates that, although the exposure looks fine on grade 1, the 'exposure window' is slightly too far to the right for grade 5.

Furthermore, a modest ½-stop increase in exposure produces a barely apparent darkening at grade 0 but a substantial 'blocking up' of the shadows into black on grade 5, as seen in figs G and H on page 65.

CHARACTERISTIC CURVES
The pictures on pages 64-5 demonstrate what happens

A-F The series of pictures on the opposite page, printed in paper of grades 0-5 at the same exposure, show how, when contrast is raised, light tones gradually disappear into white (at the toe of the characteristic exposure curve) as the print tones expand. The grade 5 print (fig E) was reprinted (fig F) with exposure time reduced to the minimum necessary to retain a black in the foreground sticks, thus allowing even more light tones to disappear. The final interpretation of a print therefore depends not only on the chosen contrast but also on where the 'tonal window' is placed on the characteristic curve

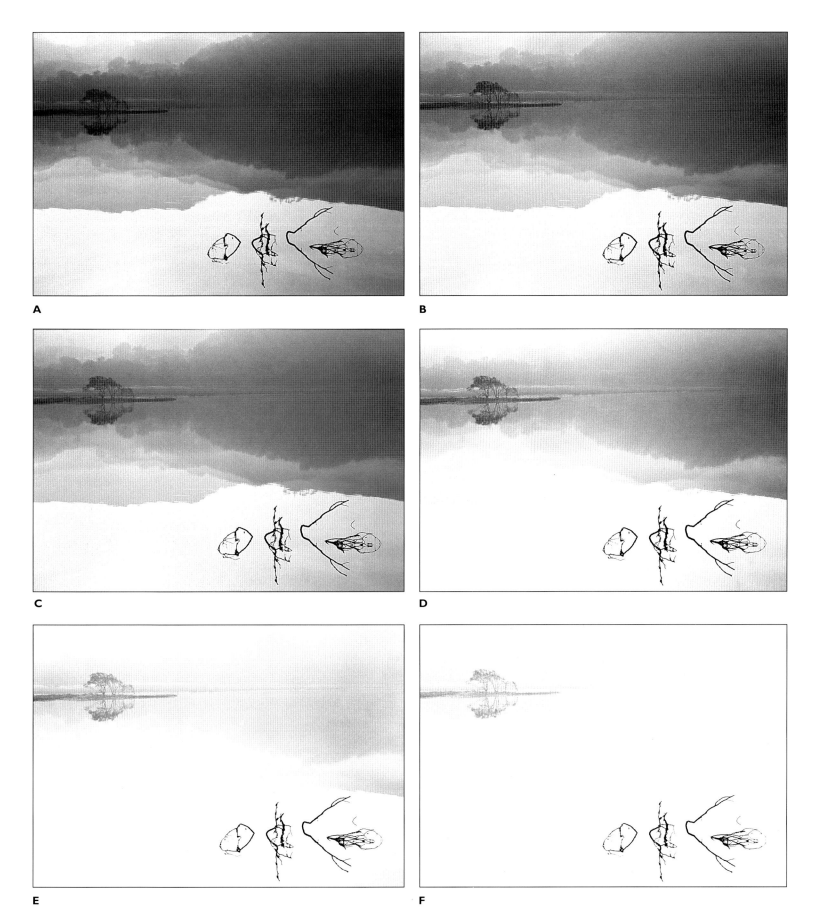

A

B

C

D

E

F

A

B

C

D

E

F

G

H

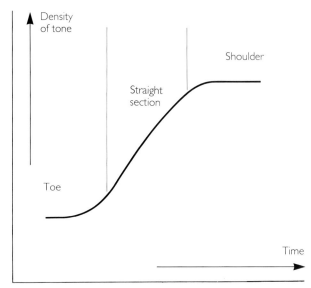

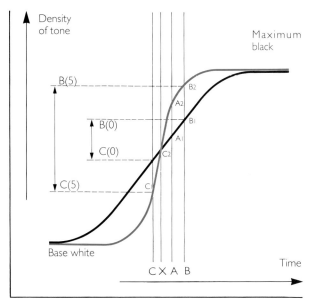

A-H *Figs A-F illustrate the effect of increasing contrast from grade 0 to grade 5 in a low-key subject. The dark tones in the centre move into black as they approach the shoulder of the exposure curve.*

Half a stop of extra exposure on the grade 0 print (fig G) produced only modest darkening, even in the centre. On grade 5 (fig H), however, this area blocks up almost completely as the tones move round the much sharper shoulder of this higher contrast.

The top diagram shows a simplified version of the characteristic exposure curve of paper, with its three sections. The bottom diagram shows characteristic curves for grade 0 (black curve) and grade 5 (red curve) papers superimposed. The different degrees of incline of the straight sections indicate different contrast levels. Contrast may be defined as the rate of increase in density with exposure time. The difference between exposures C and B produces only a modest density increase at grade 0 (C0-B0) but a massive increase at grade 5 (C5-B5).

as the exposure increases along what is called the characteristic curve of the paper. This term simply means the response of photographic paper (or film) to exposure. Many people are fazed by graphs, but the characteristic curve shown here simplifies what you have seen in the pictures, and understanding its significance will greatly help your printing.

The first graph shows the three portions of the characteristic curve: the toe (or foot), the straight section and the shoulder. Every increase in exposure, indicated along the bottom of the graph, produces an increase in density of tone up the vertical axis, as traced by the curve, from white on the left (bottom) to black on the right (top). The first units of exposure produce no tone. Then, through the toe, tiny increments of tone occur per time unit until we move into the straight line, where every extra time unit produces an equal and predictable increase in density, from very light grey to dark grey. At the shoulder the tones become compressed and even small extra exposures rapidly push the tones over the shoulder into black.

If you move your exposure right or left, along the horizontal axis, in the straight section of the curve, the print will darken or lighten, while the tones in this section will retain the same relationship to each other. Only tones lying at either end will move into the toe or shoulder, into white or black. The farther you move either way, the more tones go into white or black at the toe or shoulder.

How does all this relate to contrast and our pictures? There are two important differences between the curves at low and high-contrast grades. The second have a much *steeper* straight section. They also curve much more *abruptly* into the flat lines of total white and total black at the toe and shoulder respectively.

This means that a small increase in exposure on

grade 5 produces a much greater jump up the vertical axis than on grade 0 — that is, a greater darkening in tone. It also means that as you approach the toe or shoulder by reducing or increasing exposure, more tones disappear — and much faster — into white or black at high contrast than at low contrast.

If we combine a grade 0 and a grade 5 curve from a paper manufacturer's technical data we get the curve shown in the second graph. From this it is immediately apparent that if the exposure in our series was even slightly to the right of the crossover point X, at A, the tones might look comfortably right on a grade 0 or 1 print (A1), but would be uncomfortably close to the shoulder — and a very sharp shoulder at that — on grade 5 (A2), leading to blocking up of the shadows.

Increasing the exposure, even slightly, to B gives a lower-key rendition at grade 0, easily holding all shadow detail (B1) but pushing many dark tones over the shoulder (B2) into black on a grade 5 print. This is seen in the blocking up evident in the pictures.

Predictably then, reducing the exposure to C will pull the grade 5 shadow areas into the straight section. Because the latter is so steep, these shadow tones will be well separated. This is why, if the exposure is right, higher contrast can be so effective in separating shadow detail. It is also why the exposure is so much more critical at high contrast.

By dodging, we can pull shadow areas down the curve at a given contrast, while with subsequent burning-in we move other areas up the curve. If variable contrast is used, this can be carried out at a *different* contrast by using the technique of split filtration, which is discussed on page 77.

Similarly, we can divide a basic exposure at, say, grade 3 into two halves, of grade 5 and grade 1, to employ the properties of each grade. The overall effect will be similar to a straight grade 3 exposure, but with subtle differences.

Make sure that you fully understand the principle of the characteristic curve and how it applies to your printing. Even fix a copy to your darkroom wall.

CONTRAST VARIATION

The type of surface on the paper can appear to affect contrast. For example, matt papers, which are less reflective than glossy, appear to have less density in the blacks and therefore a lower contrast. Similarly warm-toned papers may appear to be less contrasty than cold-toned papers, where the blacks appear blacker and the whites are often enhanced with brilliant 'whiteners'. These papers are usually chosen for their individual characteristics, rather than as a way of controlling contrast, which they are not really able to do.

Enlargers also have a considerable effect on contrast, the condenser type producing higher contrast than the diffuser type. This is especially apparent in the highlights produced as a result of the Callier effect, in which the dense highlights on the negative cause more scattering of the unidirectional 'condensed' light than do the thinner portions. These highlights are therefore relatively underexposed, yielding a higher-contrast print. (They also show up dust and scratches more, necessitating more spotting later.) Point-source enlargers take this principle further, but their cost rules them out for most amateurs. Diffuser and cold-cathode enlargers produce a softer contrast — again, because of the Callier effect, mostly in the highlight range — and more closely match the tonal range of the negative.

Exposure and development manipulation A time-honoured way to fine-tune contrast is to manipulate exposure and development in printing. This is particularly effective for producing 'in-between' grades on fixed-grade fibre-based papers.

Underexposure + overdevelopment increases contrast.

Overexposure + underdevelopment decreases contrast.

These two statements have been handed down for decades as basic laws of printing, but they now need qualifying. As a result of the increased quality, availability and use of variable-contrast papers, together with the movement towards dichroic variable-contrast enlarger filtration modules, which give an infinite adjustment between grades, this contrast-control technique is nowadays used much less often .

However, not all papers are available in variable-contrast versions, and some have their own characteristic properties, for which they may be chosen to suit a particular image or assignment. For this and other reasons the demand for graded papers continues.

Nevertheless, both paper and developer technology have advanced in recent years, and the use of 'dedicated' paper-and-developer combinations increases. Some manufacturers seek to minimize errors in development by reducing the flexibility of their papers, so that even unskilled users can produce consistently good results. Others build in flexibility, which gives the experienced printer more control but may cause the novice to make more errors.

When applying the cardinal rules of printing stated above, bear in mind which of the following groups your paper belongs to.

1 Faster fibre-based papers. These usually develop fully in 1½ minutes. Their potential for manipulation is small, but consistent results are easy to obtain.

2 Slow fibre-based papers. These usually develop fully in about 3 minutes. Great control is possible, but achieving consistency of results is less easy.

3 Resin-coated papers which do not have integral developer usually develop fully in 1 minute. A little control may be possible.

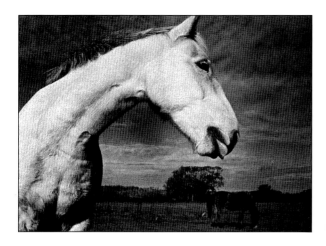 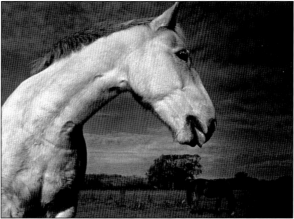

4 Resin-coated papers with integral developer develop in as little as 30 seconds. No control is possible, but consistency is very high.

'Cooking' group 1 papers is likely to simply push the image tones up towards and into the shoulder, and to cause fogging. Old papers fog very easily, so if the paper is becoming stale, try adding either of the following solutions to the developer to revive it:

1 Potassium bromide 10% : 10ml in 1 litre of working developer.

2 Benzotriazole 1% : 5ml in 1 litre of working developer.

Expose to the shortest recommended development time and then experiment if necessary, to ensure you obtain maximum blacks (see pages 43-4).

Developer temperature and concentration
Increases in either or both the temperature and the concentration of developer have traditionally been used to raise contrast. However, all of the above applies here too. Increasing developer temperature from 20°C (68°) to 40°C (104°F) may give an extra ¼ to ½ grade at grade 2, as will doubling or quadrupling developer concentration — *in certain developer/paper combinations*. However, the two prints above were made on fresh Ilford Multigrade at grade 2½ in, respectively, Multigrade developer 1 + 9 at 20°C (68°F) and Multigrade developer *neat* at 40°C (104°F). Not only is the contrast not higher in the second picture, but it is marginally lower. Ilford explains that this is probably because the high viscosity of this neat developer causes poorer diffusion through the gelatin, giving inferior image quality and a little fogging. Multigrade paper belongs to group 1, and these prints illustrate well the need to tailor these techniques to the paper and developer in use, to achieve the expected results.

Developer type Contrast can be controlled and varied by the type of developer used — hard, soft or variable-contrast — although the differences produced may be less marked with some newer papers.

All the manipulations discussed here are usually more effective with fibre-based paper than with resin-coated paper. Energetic high-contrast developers give a modest contrast increase. Soft-working developers have a more profound effect. They are in many cases metol-based and can be used alone or mixed with an energetic hydroquinone developer to produce a 'variable-contrast' developer solution, the effect of which depends on the proportions used. One of the best known is Beers formula (see below).

Two-bath development The two Beers formula solutions can also be used for two-bath development. Either bath can be used first and if they are given equal timing, the first to be used tends to produce the dominant effect. However, the duration of each bath can be varied considerably for effect, as, to a lesser extent, can concentration. For example, the soft bath may be used for half to two-thirds of the development time to pro-

BEERS FORMULA

Solution 1 (low-contrast developer)		Solution 2 (high-contrast developer)	
Metol	8.00g	Hydroquinone	8.00g
Sod sulphite anhydrous	23.00g	Sod sulphite anhydrous	23.00g
Pot carbonate anhydrous	20.00g	Pot carbonate anhydrous	27.00 g
Pot bromide	1.1g	Pot bromide	2.2g
Mix into water (at 50°C/122°F)	750ml	Mix into water (at 50°C/122°F)	750ml

Make up to 1 litre with water.

The two solutions can be mixed as follows to produce a single bath of the required contrast:

Low contrast ◄────────────► High contrast

Sol 1	8	7	6	5	4	3	2
Sol 2	0	1	2	3	4	5	14
Water	8	8	8	8	8	8	0

The first pair of prints below (A and B) received identical exposure. The appearance of the sun in the larger print is due entirely to development manipulation by water bathing, which has reduced the contrast.

The print was transferred to a water bath after only 25 sec of development. It was then selectively dipped in developer and transferred several times to the water bath over a period of 12 min.

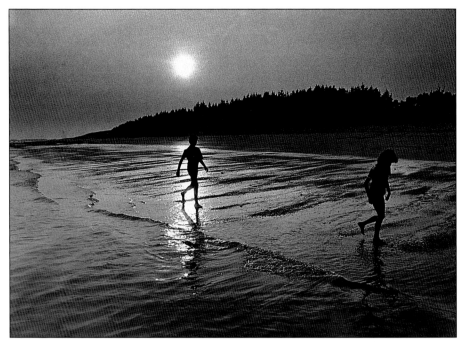

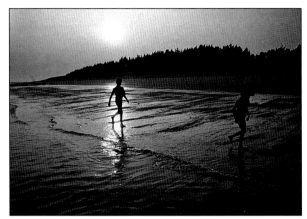

A

B

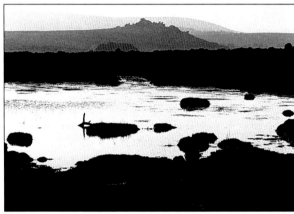

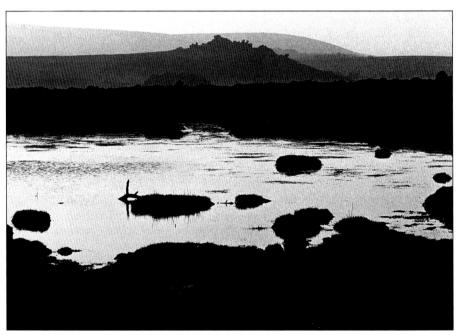

C

D

duce gentle highlight and midtones, after which the print is transferred for the remaining time to 'push in' the blacks. Mixtures of proprietary developers can be used in this way: for example, Selectol Soft + Ilford FF or Agfa Adaptol + Neutol.

Most of these manipulations may affect image colour in 'warm' chlorobromide papers, as in the picture of the horse grazing in a wood on the opposite page, and to a lesser extent in bromochloride papers. Soft-working brews tend to produce colder tones, especially if metol-based, whereas hot, strong or contrasty brews tend to give warmer tones. This in turn will affect subsequent toning treatments. If, as suggested earlier, additives are used, and if image tone is an important consideration, bear in mind that potassium (or ammonium) chloride produces warmer tones, whereas benzotriazole gives prints a colder look.

Water bathing Also known as water-bath development, this technique offers yet another simple method of controlling contrast. In both pairs of prints shown above, exposure was identical, but water bathing has softened the contrast. The technique is as follows. Next to the developer tray place a tray of water a little warmer than the developer. This can be followed by stop-bath or directly by fix. Helpful but not essential is a sheet of stiff plastic just small enough to fit into the water dish.

In the pair of prints above (C and D), water bathing has reduced contrast by holding back all the shadow areas while allowing lighter tones to continue development.

As soon as the blacks appear, transfer the print on to the plastic sheet and gently slide it under the surface of the water bath. Do not agitate as you would with development, but leave it completely still and observe. The developer works rapidly on the dark tones, where activity is greatest. It quickly exhausts and because there is no fresh developer replacing it through agitation, development here ceases. The developer's activity is progressively slower through the middle to light tones in proportion to the amount of undeveloped silver present, and so these areas continue to develop longer, the lightest tones being the last to exhaust.

This simple but clever technique therefore develops the lightest tones longest while restraining development of the dark areas. It can be a powerful tool for improving both highlight detail and shadow detail by selective development.

The print can periodically be dipped briefly back in the developer if and as required, to give the exact desired effect. This procedure can be combined with the application of developer to selected areas of the print. Similarly, areas to be restrained from all further development can be treated with fixer applied with a brush or swab. Wash the print thoroughly before returning it to the developer for the remaining areas. As with selective development, take great care to avoid trickles running across the print. As with other slow processes, you must thoroughly check your safelights (see page 14).

Contrast masks If you have a negative with such high contrast that it is unprintable even with any of the contrast-control techniques described above, a contrast mask may help. The negative is contact-printed on to slow, fine-grain black-and-white film, with extensive bracketing. Significant underexposure is needed to keep the density of the mask down, and a neutral-density filter might even be required, depending on your light source. Many enlargers have these built in, but in most cases using the enlarger at maximum height and set at ƒ16 gives convenient exposure times. The film is underdeveloped to give a series of very faint positive images of different densities. Select one of these and carefully bind it with the negative in perfect register. For this you will need a light box, a good lens, several hands and considerable patience!

The mask should always be slightly unsharp, since this makes alignment easier and helps to avoid precise registration in areas of minimal shadow detail, which could cancel out such detail altogether. The required degree of unsharpness can be achieved by separating the film surfaces slightly during the contact-printing exposure with a strip of clear film or the glass from a slide mount. A contact-printing jig simplifies this task, which is carried out in the dark. One half of a slide

mount can be incorporated into the jig to separate the film surfaces.

The thin (shadow) portions of the negative are now made denser by the thickest but corresponding areas of the positive mask — which are still very much thinner than in the original negative. The dense highlight areas are juxtapositioned with the thinnest portions of the mask, which may be almost plain film, depending on which of the bracketed frames you have chosen. In effect, the mask builds up the thinnest areas in relation to the denser portions. Exposure will be extended and the resulting print will be of lower contrast to a degree determined by the density and contrast of the mask.

In the same way, a faint *negative* mask can be used to *increase* contrast in a print. This procedure of course involves the extra step of contact printing the positive mask back on to film to produce a negative mask. It does, however, provide an opportunity to make the image a little more unsharp, and to selectively block out some areas in the process, allowing the mask to be more selective.

Printing through non-reflective glass Although this technique is mostly used for the grain-like texture it gives the print, it also causes significant loss of contrast. This texture effect is less apparent in highlights and shadows. The technique was therefore an ideal way to control contrast in the picture of the horse above, which had few light midtones and was an impossibly contrasty negative as a result of development having been pushed for the rest of the film.

The paper was pre-flashed and the sky area slightly fogged to produce a midtone. (Flashing and fogging are

A print framed behind non-reflective glass will appear to lose contrast and printing may need to be modified to offset this effect. You can exploit this property of non-reflective glass to lower contrast in printing, by laying it directly on the paper. It may also produce an attractive grain-like pattern which, being more apparent in the midtones, is not obvious in the picture above. The combination of flashing and non-reflective glass allowed the almost unprintable negative to be printed with ease.

explained in detail on pages 80-5.) A sheet of non-reflective glass was laid directly on to the paper before exposure. Provided the paper is taped down so that it cannot move, the glass can be removed after a proportion of the total exposure has been given, to obtain intermediate results, if these are required. The warm tone was characteristic of Record Rapid paper, which is particularly good for rendering shadow detail.

Lith film Printing for a pale sky fails to give a silhouette, as in the first small picture on the right. Printing for a silhouette gives a dark sky, as in the second small picture. Increasing contrast to its limit would eliminate all intermediate tones, recording only black and white, as in the large picture. This is usually well beyond the maximum contrast available on either graded or variable-contrast papers, unless the negative is exceptionally contrasty. A useful method for achieving this is to make internegatives on 'lith' film. (This is not to be confused with lith printing, which is an entirely different process and is examined on pages 100-7.)

The technique is extremely simple and consists of copying either the print or the negative on to lith film. Kodalith Ortho type 3 film is available in 35mm rolls or sheets of 5in x 4in (12.5cm x 10cm) and 10in x 8in (25cm x 20cm). For maximum contrast it should be developed in lith developer, but can be developed in print developer, in which case it gives less contrasty results. Unlike conventional film, it can be handled under a red safelight. To copy a *print* use a 35mm camera unless you have a large-format model. Bracket very widely for a range of effects. You will have an immediately usable 'negative' negative.

Copying the original *negative*, however, gives you a

For these pictures, even the use of the highest contrast grades did not permit a black-on-white effect. Printing for a white sky gave a grey subject, while printing for a black subject gave a grey sky.

Here maximum contrast was obtained by using lith film. Lacking midtones, this is particularly useful for pictures which rely on design or pattern for their graphic effect.

CONTRAST TIPS

- If in doubt, try a higher-contrast version.
- Try placing your 'tonal window' at different points along the tonal scale — particularly in high and low-key prints. Raising contrast narrows this window; lowering contrast widens it (see page 65).
- Forget 'right and wrong'. Allow yourself to be creative.
- Grain appears more apparent at higher contrast.
- Always use fresh materials if possible.
- Papers keep longer in a fridge (or wrapped in plastic freezer bags in the freezer).
- Be prepared to experiment. Failures are essential for learning and progress.
- Technology and materials are always changing, and myths about them abound, so always test products for yourself.
- When water bathing, do not allow the water to cool too much as this will slow down development even more.

'positive' negative — that is, it looks like the print, but on film. To get back to a negative from which you can print, simply repeat the process, copying the 'positive' back on to lith film to get a second-generation 'negative'. This can all be done either by using a slide copier or more simply by contact printing — that is, sandwiching the negative and lith film together under glass. Experiment with a range of exposures just as you would when making a print. If your enlarger accepts larger-format negatives, make these by projecting the original negative on to sheet film as if making a print. The second generation can then be contact-printed as above. Larger negatives are easier to spot and retouch.

Tone separation One, two or in theory any number of intermediate greys can be added by using a range of

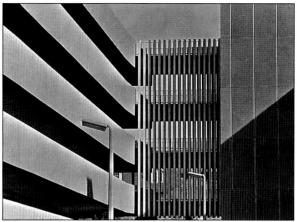

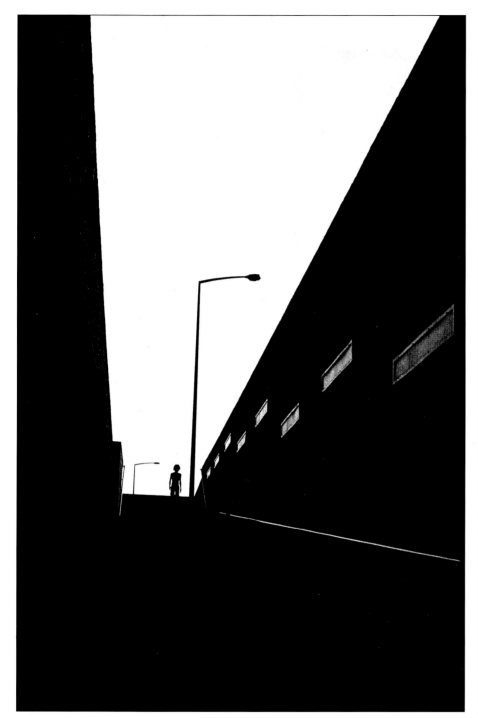

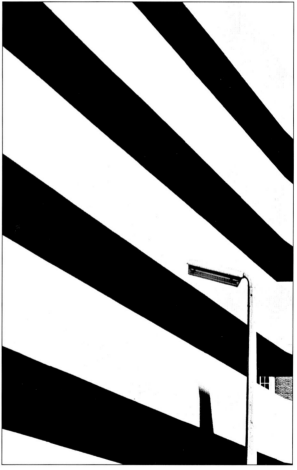

Agfa's discontinued grade 6 paper could give 'tone separation' results like those seen in the large print above. Similar effects are possible with some intensifiers, as in the print above right, which was printed from the same negative as the picture above it and on the same grade 2 paper.

increasingly dense lith negatives, printed sequentially in register. Similar results could at one time be obtained much more simply by using Agfa's grade 6 paper, as in the print on the left above. Virtual tone separation could be obtained by a single print exposure. Although the paper has long since been withdrawn, there is still a way to do this. The lower picture on the right above comes from the normal full tonal range negative which produced the picture above it. Furthermore, it was printed on out-of-date grade 2 paper! The result is at

least grade 6, and probably closer to lith. But how? Again the technique is simple: negative intensification.

Intensification Contrast can be increased by the process of intensification, which can be applied to negatives before printing or to prints after normal processing. Different intensifiers have different properties, advantages and disadvantages. Negative intensification is spurned by some printers, but used in the right way for the right reasons it can produce spectacular results

LITH TIPS

- If you are making lith negatives, use photo-opaque paint to remove unwanted detail on your first- or second-generation negatives, as this gives enormous control. It is also useful for spotting out the 'pinholes' to which lith film is prone. This avoids the task of trying to remove black spots from the print.
- Lith film is always 'sharp', since only black and white is visible, even if the original negative is unsharp. This has obvious advantages.
- Lith film can conveniently be developed by inspection in a dish, under a red safelight.
- Consider pictures with a strong design element for high-contrast treatments.
- A huge range of possibilities is offered by lith positives and negatives. Try printing minimal negatives for a black, followed by denser negatives with more detail, printed for a light grey ('tone separation'). Try sandwiching positives and negatives just out of register. Try combining different negatives, or lith and full-tone negatives. There are no rules. Give your imagination free rein, and remember that failures may spark off new ideas and lead to successes.
- Keep toxic chemicals away from the skin and eyes, and safe from children. Store them in well-stoppered and labelled containers. Never smoke, drink or eat when using them. Ensure good ventilation and keep everything connected with their use spotless. Use rubber gloves.

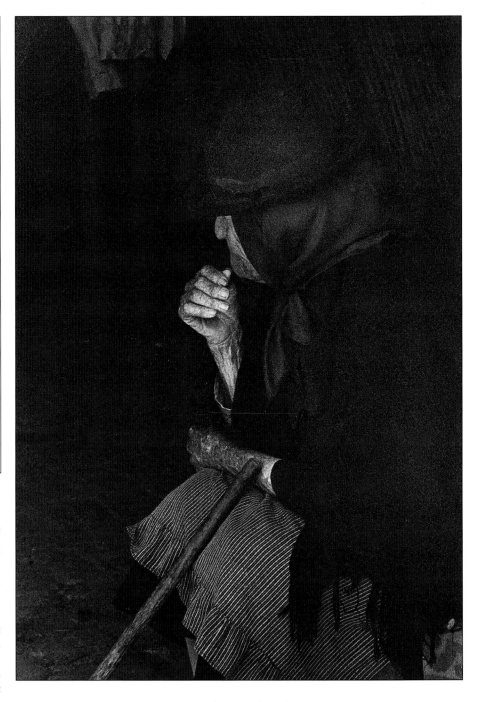

or at least may make an unprintable negative printable. If the negative is flat from underexposure and/or under-development, printing on a hard paper may salvage it. If not, intensification could well be the answer. It can never bring out detail that does not exist on the negative, but when care is taken it is surprising how much minimal detail can be reproduced on a print .

There are many intensifiers, based on copper, selenium, mercury, uranium, silver and dyes, but few are generally available. Some act mainly on the dense areas of the negative; some — proportional intensifiers — on all areas equally; and some mostly on the thin shadow areas. Chromium intensifiers give a modest increase of about 1 grade when bleaching in potassium dichromate and hydrochloric acid and redevelopment in print developer are carried out. Speedintense, made by Speedibrews, gives a greater contrast boost of 2-3 grades. It uses silver iodide and a red dye, and therefore prints with greater density on blue-sensitive paper. This is a 'totally proportional' intensification: if it is on the negative at all, all detail will be proportionally affected, rather than that at just one end of the tonal range.

Mercury intensification My favourite negative intensifier, used in the lower-right print on the previous

page, and in the two prints shown here, is based on mercury. Before we look at it use, note that mercury is the most toxic of the heavy metals. It is also persistent and bio-accumulative in the environment, making safe disposal difficult. Therefore it is subject to restrictions in many countries. In the UK, preparations containing more than 1% mercuric chloride are classified as Schedule 1 poisons, and their supply — to approved purchasers only — is recorded. Very small quantities are required to intensify negatives, after which the solutions should be kept for re-use and not discarded. If you use mercury, treat it with the utmost respect and never

The original version of this flat, low-light indoor shot called for intensification. A relatively high degree of intensification (4 grades) enhanced shadow detail and produced a granularity that suits the textures in the picture.

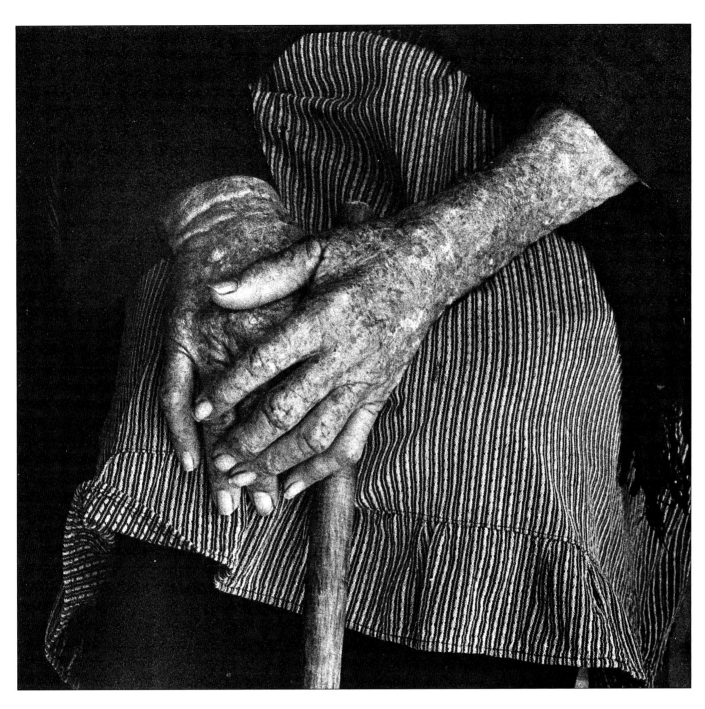

In this picture, despite intensification of about 5 grades, and enlargement of two-thirds of a 35mm negative, detail is preserved in the stitching of the apron. The colour was produced by two-bath toning in selenium sulphide.

share it with others without ensuring that they fully understand the dangers.

The advantages of mercury intensifier are:
• It is simple to use — no bleaching is required.
• It can give the tiniest sparkle or up to five extra grades of contrast.
• It enhances shadow detail beautifully.
• Its effect is reversible — a major advantage, as it does not permanently alter the negative.

The results of using this intensifier can be truly gratifying, especially in dark prints with deep, rich shadow detail, where it is particularly active. Flat, dense nega-

tives also can be enhanced, and here the mushy grain takes on an attractive, almost pointillistic appearance. Used briefly, it can emphasize large grain pattern or intentional reticulation (a crazed pattern on the emulsion produced by marked changes in temperature or pH during processing).

The formula for mercury intensifier is:

Mercuric chloride powder	13g
Magnesium sulphate purified powder	60g
Potassium iodide USP granular	30g
Sodium sulphite anhydrous (desiccated)	15g

Mix in water to make 1 litre at 21°C (70°F).

Mercury is absorbed through the skin, but rubber gloves give adequate protection, and should be worn whenever it is used. Stir the mixture thoroughly until no more will dissolve. Allow the yellow sediment to sink to the bottom. Filter it into a dark-brown bottle and store in a dark place, as mercuric chloride is unstable in light. Stored properly, the solution keeps for many years.

Soak the negative in water for 10 minutes and transfer it, emulsion side up, to a small dish containing the mercury intensifier. Because the emulsion is vulnerable, do not use tongs. Agitate gently and continuously out of direct sunlight. A yellow deposit will slowly build up on the emulsion. After 2-3 minutes, a contrast increase of two or three grades is usually apparent.

For grain or reticulation enhancement 30 seconds may be enough. However, if you are in doubt, remove the negative, wash it for10 minutes and dry it without touching the emulsion. This process can be repeated if required, but the maximum effect will have been achieved after 10 or 12 minutes. To remove the intensifier, return the negative to hypo, then wash it. To make the effect permanent, immerse the negative in 1% sodium sulphide for 2 or 3 minutes.

I have negatives which have kept their intensification for 15 years *without* sodium sulphide treatment, and I still have the option to return them to normal.

Selenium intensification A more modest negative intensifier is selenium toner, which is also toxic. It gives an increase of only about 1/2 grade, but this can be useful with graded papers, particularly as apparent grain tends to be reduced rather than increased as in most contrast-enhancing manoeuvres. Its effect is permanent.

Having made your print, it is possible to intensify it to a degree by after-treatment. This is not nearly as dramatic an effect as negative intensification. It can be useful, however, either in addition to the measures described above, where you need to pull out every last stop, or when the dry print looked flatter than you expected, having assessed it wet. It also helps to enrich the blacks.

Selenium toner is used routinely by many printers to add a final touch to prints. It enhances blacks as well as giving slight intensification and an impression of extra luminosity. When used with certain papers it can produce a colour shift, which is discussed in more detail on page 119. Many other toners, especially blue, also tend to boost contrast.

Potassium dichromate intensification You may want to intensify a print without changing its colour, in which case you can use potassium dichromate. This bright-orange bleach first removes the image down to a biscuit-brown colour. The print should then be washed

until the orange colour has gone, and then redeveloped in daylight. If required, a high-contrast developer can be used to increase intensification further. The process can be repeated, to create more marked results. Potassium dichromate can also do wonders for some subsequent toning processes and can be worth using for this reason alone.

The formula is:
Solution A: 5% potassium dichromate
Solution B:10% hydrochloric acid
Working solution: 1 part A + 1 part B
+ 6 parts water.

This solution works mostly by darkening shadows. In some cases it can be helpful to brighten the highlights too. To do so, use:

Solution A: 10% potassium ferricyanide
+ 5% potassium bromide.
Solution B: 20% plain hypo.
Mix 1 part A and 5 parts B.

Immerse the wet print and remove it at the *first* sign of highlight brightening and wash it swiftly in warm (or hot) running water. Wash it thoroughly before proceeding. If you are doing this after intensifying a fibre-based print in potassium dichromate, be sure to wash the print for an hour between stages or some of the black enrichment will be lost.

PRE-DEVELOPMENT BLEACHING

Despite the advances in variable-contrast papers, there are situations where graded papers are preferable, as is proved by the fact that they retain a place in the market. Users of cold-cathode enlargers experience difficulties with variable-contrast papers. Many papers are used for their own individual characteristics and not all have

In potassium dichromate print intensification the print is bleached away in a bright orange bath, to leave a buff-coloured image. After washing, this can be redeveloped in any developer. Here I used Ilford FF to give an intensified result with cold, blue-black tones.

PRE-DEVELOPMENT BLEACHING

This negative used for the series of pictures on the right was chosen because it contains detail in both deep shadow and bright highlight areas. It also has a large area of even grey to show up streaking and blotching. The fluffy clouds contain delicate detail which could easily be bleached out in post-development bleaching, but which, as seen, are not affected by pre-development bleaching. The results seen here are all from straight, unmanipulated exposures, processed identically except for the degree of bleaching, and give a glimpse of the control obtainable with this process.

A Straight grade 5 print
B Straight grade 3 print
C Straight grade 1 print
D Straight grade 0 print
(1-4 received the same exposure (T1) on Multigrade paper.)
E Grade 5 print, T1, 5ml in 1 litre, 4 min; matches grade 3 closely but retains brighter highlights.
F Grade 5 print, T1, 10ml in 1 litre, 3 min; matches grade 1 closely but retains brighter highlights.
G Grade 5 print, T1 + ½ stop, 20ml in 1 litre, 1 min; matches grade 0 closely but retains brighter highlights.
H Grade 5 print, T1 + 1 stop, 20ml in 1 litre, 1 min; highlights match grade 0, with darkening of other tones.
Infinite variations are possible on the above.

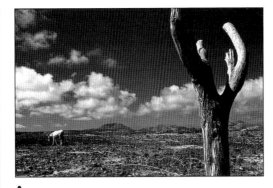

A

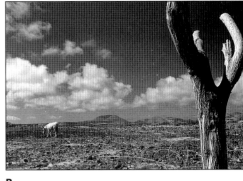

B

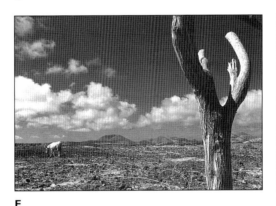

C

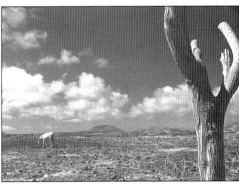

D

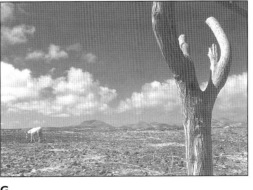

E

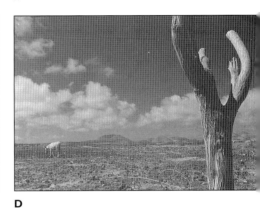

F

G

H

variable-contrast equivalents, and certainly not in fibre-based versions. Whereas resin-coated papers have advantages in processing, washing speed and drying, many after-treatments are more effective or predictable on fibre-based papers. In addition, the latter produce qualities in the print that many find more attractive.

For users of graded paper there is a little-known yet simple technique for changing the apparent contrast grade downwards to any grade below the one in use. In other words, you can print any grade from 00 to 5 with a packet of grade 5, 00 to 3 with a packet of grade 3 and so on. The print is passed through an extremely dilute bath of potassium ferricyanide after exposure but *before* it is put in the developer. 'Ferri' is an essential ingredient in any serious black-and-white printer's darkroom. It has many uses on the formed image, from local 'brightening' to changing image colour, toning and what is referred to as pseudo-lith printing. However, its use here is quite different in that it works not on the visible image but on the *latent*, still undeveloped image.

'Contrawise' bleaching When used on the formed image, ferri acts as a bleach, attacking highlights first and then other tones. But when used on the latent image it does the opposite — what Kachel called 'con-

trawise' bleaching. It affects shadow areas first and most, midtones less, while highlights may remain unaffected, depending on the amount of bleaching permitted. In this way ferri changes contrast, not of the *paper*, but of the latent *image* on the paper about to be developed. Since the highlights are little if at all affected, they can retain the characteristics of the grade of paper chosen. This allows great control, so that, for example, you can print an image on grade 2 or use a grade 4 paper pre-bleached to give grade 2, yet retain a brightness in the highlights approaching that of grade 4.

For this last reason it can even be worth using this technique with variable-contrast papers. In fact it works particularly well with Ilford Multigrade, allowing a brighter highlight in a mid-range grade, yet retaining more subtleties than from post-development bleaching, where subtle highlight tone is so easily lost.

Prints bleached to grade 2 from papers of grades 3, 4 and 5 will all have slightly different highlight characteristics. The results are also affected by the ferri's concentration, the length of time the print is in the ferri bath and the type of paper. Such permutations are enormous, and the series of prints on the previous page shows something of the potential for experimentation.

In pre-development bleaching, ferri is used in extremely weak solutions:

Stock solution: 10% potassium ferricyanide — 100g dissolved in 800ml water and made up to 1 litre. (You can use 25g in 250ml of water, but you will discover other uses for this solution throughout this book, and it keeps well in a dark bottle.)

Sub-stock solution: 10ml of the above in 990ml water (0.1% solution)

Working solution ('one-shot'): This can be varied from 10ml to 100ml of the above and water at 20°C (68°F) to make 1000ml (0.01%-0.001% solution). In practice I find 10ml-30ml adequate, and occasionally 5ml.

Agitate the print continuously for 1-3 minutes. Experiment in 1-minute increments for each strength, using a 10ml/litre (0.001%) solution for 1 minute as a reasonable starting point, until you reach the level required for that print on that paper. A 10ml syringe is very useful here. It is important to discard and replace this bath after every print; it is almost water anyway.

Effects on different emulsions Since paper manufacturers use different emulsion technologies, the results of the above technique do differ considerably between papers, and further variation is likely as new products are developed. The following notes on my own experience with a range of papers may prove useful, but because of the variability of results I recommend that you also experiment for yourself.

Ilford Multigrade works extremely well even when

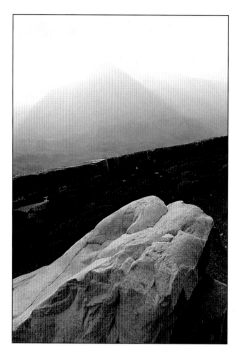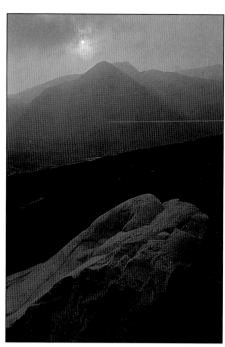

bleached back 4 or 5 grades. When it is heavily bleached there may be a small speed loss of +/- ¼ stop, necessitating exposure adjustment. Occasional but minimal streaking may occur at higher concentrations.

Galerie, by contrast, is very sensitive to pre-development bleaching and it can be difficult to get good results with it, since it is prone to blotchiness and a marked speed loss of 1 to 2 stops. The reason for this is unclear, but is possibly connected with the regular cubic-crystal make-up of Galerie's new emulsion. The blotchiness is most marked with grade 5 and with a busy negative it could go unnoticed on grades 4 downwards. Pre-soaking in water does not help, but energetic agitation in the developer and the use of full development time seem to minimize the problem.

The speed loss is proportional to the amount of bleaching and simply requires an increase in exposure times to compensate for it. This is not difficult but can be tedious. Another feature of this paper is that concentrations of bleach as low as 5ml/litre for 1, 2 or 3 minutes produce a marked effect.

Brovira usually gives good results, but occasionally it produces streaking. It may also produce a moderate speed loss.

Oriental Seagull also works well, producing possibly better highlight detail than Brovira when very heavily bleached.

VARIABLE-CONTRAST PAPER

The first (resin-coated) variable-contrast paper, with its flat, muddy tones, was not impressive. Although variable contrast offered certain advantages, I, like many others, stuck firmly to graded fibre-based papers.

The two straight prints above show the effect of printing the negative for the foreground and the background respectively.

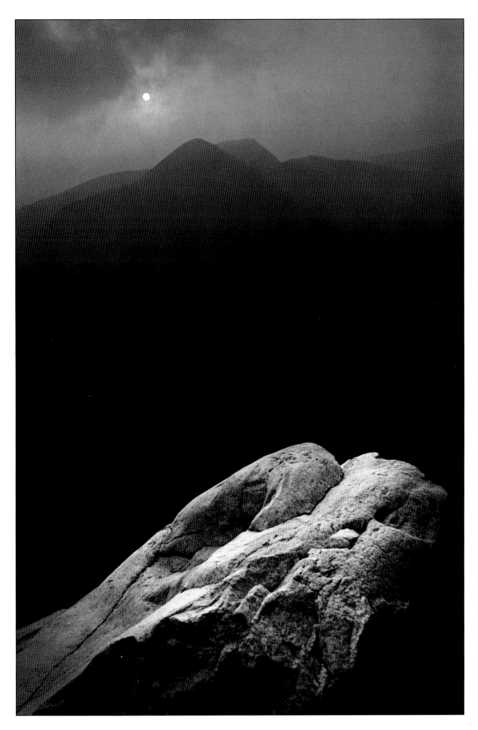

Using more than one contrast grade on the same print can be done in different ways (see 'Split- or multiple-grade printing?' on page 79). For the final print above, the top and bottom halves were exposed separately, using grades 1½ and 5 respectively, to produce a symbolic rather than a realistic picture.

achieved by using above- or below-lens filters, or multigrade or colour-dichroic enlarger heads. Filters usually give half-grade increments, whereas multigrade or colour heads allow infinitely variable adjustments. Manufacturers give recommendations on colour-head filtration for their own products (see table of filter settings on page 154).

Split- and multiple-grade filtration In addition to allowing you to stock just one box of paper instead of several in different grades, variable-contrast papers offer a huge advantage in that different grades can be used on the same print. When you start experimenting, however, keep it simple. Rather than try to print five grades on every picture, save the technique for occasions when it has a clear use. For example, you may want different grades for highlight and shadowed areas. You may decide to split areas of the print into two different grades for impact, as in the print on the left. You may want to add a few soft tones with a secondary exposure, or conversely boost the blacks with grade 5 in a soft grade 1 print. Imagine how you could combine the effects of the grade 0 and grade 5 shots of a misty lake on page 63. Making a print with two exposures at grades 00 and 5 can give an intermediate grade, which is correctly balanced for the highlight and shadow areas of the negative.

Changing grades can also be extremely useful when you are burning-in. Remember the basic principles: high contrast grades split tones more widely and convert light and dark greys into white or black, respectively. Soft grades bring tones closer together (and give more tones) and allow tones to spread into the white and black areas. For example, if you want to burn-in a black-and-white striped sweater, grade 5 will tend to make it appear more prominent by deepening the blacks while initially preserving the white stripes. Grade 0, on the other hand, will suppress it more effectively by adding greys to the white without deepening the blacks as much.

You might choose grade 5 for separating elements in mist, for smoke against dark backgrounds, for darkening pupils or irises without veiling the whites of the eyes, or, with skies, to darken blue toward black while preserving trails or cloud edges. Conversely, use grade 0 or 1 to darken a sky and 'lose' cloud or other detail, or to gently burn-in the clouds, keeping them soft without making them look like solid black chunks. These grades assist control with difficult, over-contrasty skies, where sun breaks through clouds, and when burning-in 'sun stars' and flare, or any light spot where you might be left with a dark halo after burning-in on a single-grade paper. Light halos, too, can be a problem when burning-in, and along horizons. Whatever grade was used for the main burning-in, grade 0, with burning-in carried out through a hole in a travelling card, will help to

However, variable-contrast papers have since come of age. Ilford's Multigrade FB, with its beautifully rich blacks, has long been my paper of choice, unless I want the specific properties of other papers, such as the tonability of Oriental Seagull, or the effects this gives with lith developer.

Variable-contrast papers contain two emulsion layers of different contrast, each containing a dye which limits its sensitivity to light. By changing the colour of the light projected, the contrast can be altered. This can be

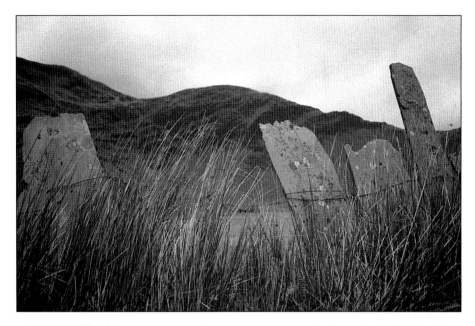

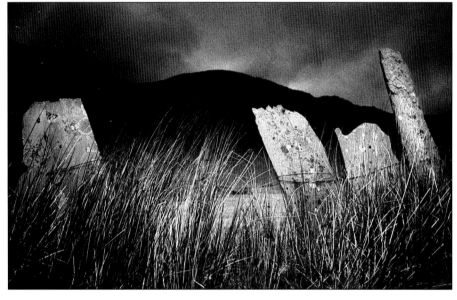

In the final print above, multiple filtration was combined with acetate masking to put the exposures and the contrast grades where they were needed in order to convey some of the feelings aroused by the place. This expressive component was lacking in the straight print.

fill light halos in without affecting the adjacent tones too much.

The facility to use different contrast grades on the same sheet made variable-contrast paper the ideal choice for the print *Twin Peaks*, seen on pages 76 and 77. The straight shots destroy the fantasy but illustrate the reality — a mundane lay-by on a mountain road. Large rocks had been placed along the wall, presumably for both aesthetic and safety reasons. The backdrop was moody and evocative, but lacked foreground interest. Sadly, the rocks were no longer in the natural landscape and appeared not to belong to the scene. Their texture was interesting but minimized by soft lighting.

This print attempts to marry the two elements — to show the grand landscape and the detail of which it is composed, in the same picture and in a symbolic rather

than realistic way.

I printed on Ilford Multigrade FB and developed in Ilford FF high-contrast developer. The foreground was printed on grade 5, with the top half masked. The top half was then printed on grade 1½, with the bottom half masked. The central section was burned in on grade 0 to 'lose' the wall. Burning-in exposures were given as required to the sky and the area around the rock. After development, the rock was enhanced with potassium ferricyanide and the print bathed in dilute selenium toner to enhance the blacks. (These techniques are covered on pages 108 and 119.) The two straight prints shown on page 76 were exposed for the rock and the sky, respectively.

Acetate masking In *The Spirit of Cwm Orthin* I tried to capture something of the atmosphere of the vanished Welsh slate-mining community of that name. I find the sense of the lingering presence of its long-departed inhabitants overwhelming as I walk past the ruined buildings. I feel I can almost hear their voices raising what is left of the chapel roof. It is an uncanny and moving experience — easy to feel, difficult to describe and even harder to capture on film.

The slate fences suggest headstones, their bizarre angles hinting at movement and at the presence of spirits, and for me this feeling is omnipresent in that place. By using Ilford Multigrade paper, I was able to convey some of this feeling in the final print, whereas it was completely missing from the bland, unemotional straight print.

The initial exposure was on grade 4 and calculated for the tone of the slate to the right of centre. The other slates were individually dodged to even the tones, which on grade 4 were less even than the straight grade 2 print suggests. The background hill and sky were burned in for 1¾ stops, and grade 5 was used to retain the lighter tones in the sky and preserve the tonal separation between sky and hill while making the hill dark, even menacing.

During this exposure the slates were protected by using the acetate-mask technique described on page 55. This allowed the accurate and simultaneous dodging of several areas during one exposure. With the mask in place the top half of the print was darkened with a card that was kept moving to prevent a visible line appearing. Grade 5 was essential to keep the tones widely split in the central area. A lower contrast would have caused the grasses to darken against the black hill, and they are too fine to be individually masked with the slates on the acetate. Further exposure was given to the top edge and upper-right corner. Some of the unwanted brighter areas were suppressed on grade 2. The print was developed in Ilford FF and then selenium-toned to produce D-max enhancement.

SPLIT- OR MULTIPLE-GRADE PRINTING?

These terms are sometimes used interchangeably and this can cause confusion. I now use the term 'split-grade printing' (or 'split grading') for the technique of dividing the basic exposure into two components at the extremes available — grades 00 and 5, or 0 and 5+, depending on the system in use. The proportions are determined by the simple two test-strip method described here. This swiftly gives the correct exposure/ contrast balance for the negative. Complex dodging/ burning manoeuvres are sometimes rescue operations for mismatched exposure and contrast and become unnecessary after 'split grading'. This also allows dodging during either component, permitting adjustment of local contrast as well as density, if required.

The term 'multiple-grade printing' is best used when different grades are used in different parts of the print, usually by dodging and burning back at a different grade, or by burning in with different grades as described on page 77.

The picture below, seen earlier in dodging and burning-in, also illustrates split filtration. The basic grade required was about grade 3. Because the main exposure was divided into two halves — one for the whole print and one for the print with the rock masked out — it provided an opportunity to split the exposure into two grades, the first on grade 4 and the second on grade 1½. The only exposure received by the rock was therefore at grade 4.

The rest of the print received a mixture of grade 4 and grade 1½, which put in some good blacks but also some soft grey at the horizon, where the sky otherwise tended to come out too light. The subsequent burning-in exposure given to the sky was again at grade 4 in order to produce fairly dense tones without suppressing the clouds or the light streaks more than was necessary. Using grade 5 would have preserved this separation better, but the sky would have begun to compete with the rock if its contrast had been allowed to become too high.

WHITE LIGHT

Given the importance of making your darkroom lightproof, it may seem strange that 'unsafe' light can be an extremely useful aid in printing. To be effective, however, this 'white light' must be completely controllable, and this in turn necessitates a light-safe workspace.

In this context, the term 'white light' has nothing to do with colour temperature. It can be any colour to which the paper is sensitive, and simply refers to light falling on the paper without first passing through a negative. In this form it is uniformly even all over the paper. In theory the colour of the light can affect the result if variable-contrast paper is used. But in practice it is simpler to ignore this fact and, for convenience and consistency, always use the same single light source. White light is used for flashing, fogging and blacking out, including the creation of shadows.

FLASHING

The technique of 'flashing' is useful for softening contrast and extending tonal range. The simplified exposure curve seen below shows what happens when a sheet of photographic paper is exposed to light. The first units of light (in the horizontal axis) that fall on the

paper do *not* produce any visible tone. They merely overcome the paper's 'inertia' to light (A-C). If the paper were developed at this stage, having been exposed up to but not beyond C, it would still be 'base-white'. If it were developed at D, it would have a light visible tone (D1). If it were developed at Y it would show maximum black (also known as D-max), while after further exposure, there would be no change, for you cannot produce a blacker black than D-max.

Flashing means giving the paper just enough exposure to white light to get it to C, before you expose through the negative. White-light exposure beyond this point results in a different effect, known as 'fogging', the use of which is discussed below.

Uses of flashing Sensitizing the paper to C before you expose the negative causes three things to happen:
1 The next photon (a tiny unit of light) that falls on a previously burnt-out highlight produces a tone, improving highlight detail.
2 The sensitized paper now requires an exposure through the negative typically 10-20% less than it would otherwise need, depending on the paper and whether it is fully or partially flashed (for example, to B). Reducing exposure by this amount produces a relatively larger reduction in exposure to the shadow areas since more light per unit time floods through the thinnest part of the negative than anywhere else. The result is improved shadow detail.
3 Because the effect described in 2 applies to a progressively lesser extent tone by tone throughout the tonal range, the overall contrast is reduced. (But see the following notes.)

When to flash First, since it reduces contrast, flashing can be useful for fine-tuning contrast control. It is an effective means of obtaining 'between' grades with both fixed-grade and variable-contrast papers. But bear in mind that:
• You do not have to flash to 'max flash' (C in the exposure curve). You can flash to any fraction of this you choose — for example, B in our graph.
• You do not have to flash the whole sheet. In a landscape it is often helpful to flash just the sky. Do this by 'holding back' part of the sheet, as in printing. *Note*: Do not lay a holding-back card directly on the paper or a visible line will appear on the finished print.

Secondly, where you cannot capture one or both ends of the tonal range for the degree of contrast you

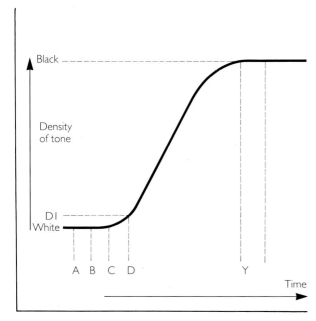

Photographic paper has an initial inertia which has to be overcome during exposure before a tone is produced. The characteristic curve of paper seen in the graph on the left shows how the first units of light falling on the paper sensitize it but produce no tone until the maximum flash point, C.

To determine the maximum flash point, a flash test strip is made, as shown below. Maximum flash is the step before a visible tone appears, and is determined by comparing the exposed and unexposed halves of the completely dry strip. The increments are ¼-stop steps, from 3 to 24 sec.

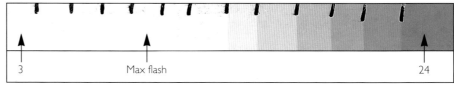

want, flashing will enhance highlight and shadow detail from these difficult negatives.

If you have read the section on contrast, you may be wondering: why not simply drop a grade of contrast and achieve the same result? In fact, you can have the best of both worlds, for you can go *up* a grade in contrast to maintain the midtone separation you want, and flash to extend detail into both highlight and shadow areas. Excessively compressed midtones can kill a print. Opening them up by raising contrast can give them a luminosity that lifts the image. However, doing this also diminishes detail at both ends of the tonal range if you expose for midtones — unless you flash. A higher-contrast paper also helps you to achieve better separation of shadow details, now without compromising highlight detail.

Many negatives do not require flashing, and if used inappropriately the technique will produce prints that are either flat or have an unnaturally long tonal range, which may not suit the subject. Use it selectively.

How to flash In order to flash, you must first have an infinitely controllable light source that is precisely duplicable, so that you can repeatedly achieve predictable results. The most obvious light source is your enlarger, which should be set at maximum height and with the lens at minimum aperture. Since this will usually be connected to your timer, you will be able to reproduce any predetermined exposure. A disadvantage of this set-up is that you have to keep moving the enlarger and removing the negative for flashing between print exposures.

If you have the space, use a spare enlarger (an inexpensive second-hand model will do). Alternatively, a weak night-light directed at a wall or the ceiling of the darkroom will give weak, omnidirectional illumination. Ensure that this light evenly illuminates the baseboard and that no shadows are cast across the paper by the enlarger or any other structure. This secondary light source can easily be connected, together with the enlarger, to the timer via a switchable gang. This arrangement is particularly useful as the light sources can be used separately or together for fogging exposures, where you may need to see the projected image simultaneously in order to position masks.

Using your white light source, make a test strip on the top half of a letterbox-shaped strip of paper, keeping the bottom half covered throughout. Start your test strip with the whole top section exposed for 1 time unit (for example, ½ sec). For the second exposure, cover one strip, for the third two strips, and so on for about a dozen strips. Although different papers vary enormously in how much light is required, you should always keep your light source unchanged.

Develop, fix, wash and dry the strip in the usual way

and tape it to the front of the paper box. *Do not assess it wet* as the lightest strip may be invisible before dry down occurs (see page 44). Examine the dry strip and find the section where a faint tone is first visible against the unexposed bottom half. 'Max flash' is the step *before* this, or point C on the graph. Anything before C is flashing; anything after C is fogging.

A practical tip: mark the sections on your flash strip with an indelible waterproof pen before making your

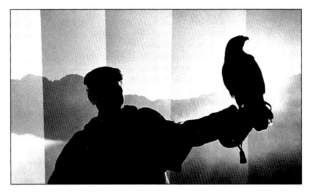

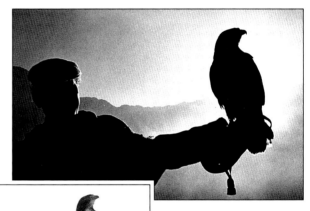

A *A test strip revealed the difficulty in capturing both highlight and shadow detail.*

B *Printing for the background put the figure in silhouette.*

C *Printing for detail in the face and scarf gave no sight of the mountains in the background.*

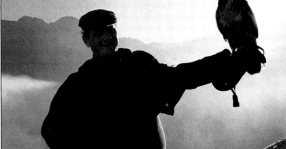

D *Flashing before giving the same exposure to the same paper as for C brings up the mountains and swirling mist even on an otherwise straight print.*

E *Final burning-in was easily accomplished on the flashed print, revealing all the shadow detail the negative held, as well as the background highlight detail previously lost in the sun's glare. The print was made on Oriental Seagull grade 4 and toned in weak selenium and weak gold toners.*

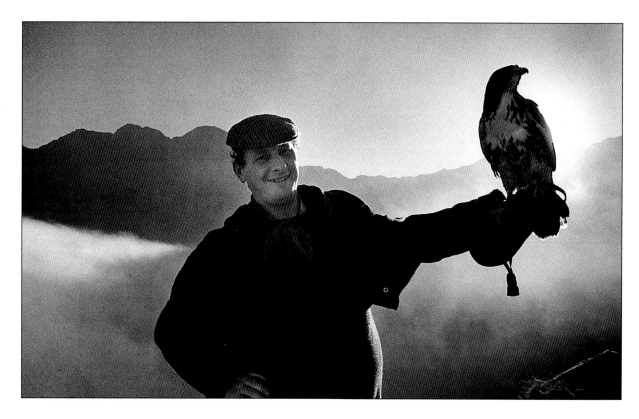

exposures, as you will not see any steps before C and may forget in the future how many you gave. For flashing, simply give this exposure to the paper before making your print, but remember to make all your print test strips on flashed paper too.

Retrieving detail by flashing The negative of the hawk on this and the previous page is potentially difficult to print for two reasons. First, the contrast range is great, since the sun is behind the bird. Secondly, shadow detail is only just captured on the negative around the scarf. In order to separate these shadow tones, grade 4 is required, and this would exacerbate the contrast problem already present.

The test strip (fig A) shows the difficulty in capturing highlight and shadow detail. Printing to capture the mountains behind the arm and bird gives a silhouette (fig B), while printing to capture detail in the scarf and face (fig C) gives no sight of the mountains in the right-hand half of the picture at all.

Fig D shows the effect of flashing the whole sheet, using the same exposure and paper. The mountain range and swirling mist have been captured with ease — even on a straight print. Final burning-in is now easily accomplished to produce fig E, which shows all the shadow detail the negative holds, as well as background detail previously lost in glare. This picture was printed on Oriental Seagull grade 4, flashed, burned-in, washed in weak potassium ferricyanide in hypo and toned first in dilute selenium and then in gold.

FOGGING

If we look again at the exposure curve on the opposite page, we see that, while flashing imparts no tone to the print, if the paper is exposed beyond maximum flash (C) to, say, D, the print is 'fogged' and a faint tone D1 will appear when the paper is developed. Naturally the greater this exposure — for example, to E — the darker this tone (E1) becomes, eventually reaching black (Y1)

Although it is a problem if it occurs unintentionally in a 'leaky' darkroom, fogging can be a useful printing aid when it is used under control. By contrast with flashing, it is rarely necessary to fog a whole sheet. A very light overall tone can occasionally be useful if highlights are subsequently bleached back or toned, but there is little hope for any print with an overall fogging exposure to E.

Selective fogging However, *selective* fogging is a completely different matter. Consider the problem in fig A on the opposite page — a straight print on grade 2½. A dark figure stands in front of a sun-drenched white wall in a Mediterranean village. For a number of valid reasons the photographer preferred not to use flash. Therefore the choice was between exposing the film for the face and letting the wall burn out completely, or exposing for the wall and letting the figure go into silhouette, or, as here, splitting the difference, hoping to capture detail in both.

Making the print also presents problems: of exposure and of contrast. Exposing the paper for the face gives an

A-D *Fig A reveals the contrast problem of a dark figure against a light background. As fig B shows, grade 1 is not the answer. The print contains tones, but is flat. Higher contrast is needed to separate the tones and put 'light' into the face. In fig C a test strip made on grade 4 shows better facial tones, but there is a loss of tones in the wall. Fig D shows the mask cut to allow fogging of the background only, preserving the facial tones. In the final print the man only is seen in grade 4 tones. Wall detail was burned-in and fogged to emphasize texture. This extra tone gives the illusion of more light in the face.*

A

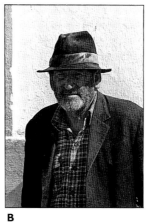

B

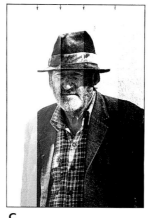

C

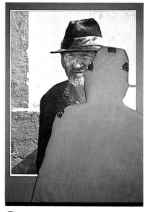

D

A flash strip, as seen on the right, can be used as a guide to the exposure needed to achieve a certain tone by fogging. This

occurs when the paper is exposed to white light past the flash point C in the exposure curve below.

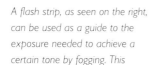

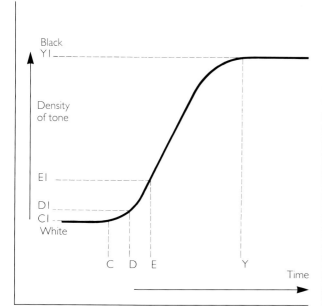

almost burnt-out wall. Exposing for the wall gives a near-silhouette. Even holding back the face and burning-in the wall produces a lacklustre print. To overcome this excessive contrast it would seem necessary to print to a lower contrast. But this is not so: fig B shows that printing on grade 1 does in fact capture the wall detail. But what a flat print! The facial tones need separating and this requires an *increase* in contrast to grade 4 to inject some light into it. The grade 4 test strip (fig C) shows that the wall detail is, as expected, even less available at this contrast grade. After printing on grade 4, a mask was used (fig D) to burn in the wall but to give a simultaneous selective fogging exposure to a degree determined by guesswork or by the flash strip.

The ability to give both the fogging and the burn-

Heavy fogging, to a point approaching the shoulder of the curve, can be useful, for example to isolate a subject from a messy or unsuitable background. Bright background areas like those in the small print above resist burning-in but succumb quickly to fogging, or a combination of the two, as in the larger print.

ing-in exposure simultaneously or separately, as required, is useful. It allows you, while fogging, to position a mask accurately with the aid of a projected image as a guide. You can do this by plugging your enlarger(s) and flashing/fogging lamps into a three- or four-socket gang with a separate switch for each socket. Connect the gang in turn to the mains, if possible through your timer. You can then have the enlarger(s) and fogging lamp(s) activated together or individually, and controlled by the timer.

The enlarger exposure burns in the desired detail. The fogging exposure first sensitizes the paper to the enlarger's exposure (as in flashing), enabling it to capture every nuance of detail despite the use of grade 4. It then goes on to impart a tone to the wall by fogging the image. In the final print on the previous page this not only gave a beautiful texture but also lessened the impression of a silhouette, as the face now appears lighter in relation to the wall behind the man.

Farther up the curve Even the black and nearly black tones that occur at the top end of the curve can be useful when added by fogging — or a combination of fogging and burning-in — to selected areas of the print. The picture above illustrates this well, for here fogging affects an even larger area, and was done to a much greater degree, than in the previous example. The original intention was to contrast the beggar with the sumptuous evening gowns in the shop window behind her, as shown in the small straight print. The photograph does not succeed in this aim, however, and is more effective if the woman is isolated against a dark background.

Burning-in this background, particularly on a graded paper, is fraught with difficulties. The highlights are so dense on the negative that they resist even extensive

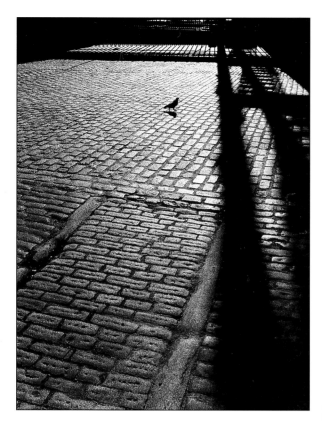

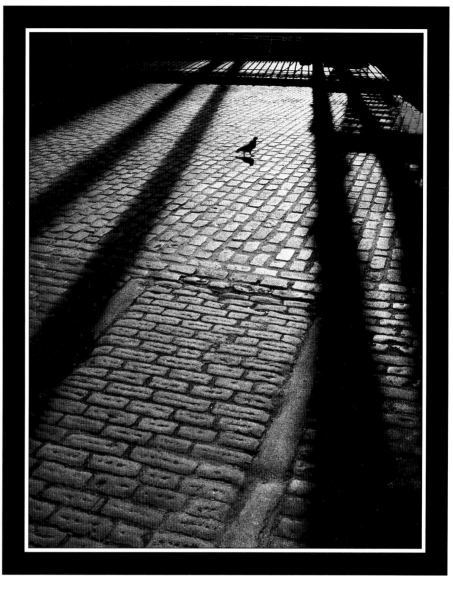

Selective fogging to a dark tone can be useful either to 'bury' unwanted detail, or as a compositional tool, as in the pair of prints on this page. A mask was used, as seen on the right, to transform the straight print by adding fogged shadows.

burning-in, while the shadows 'block up' almost at once. By using exactly the same technique as in the previous example, it is easy to suppress these bright patches, along with the darker areas, to whatever depth of tone you require. Furthermore, you can dictate the degree to which these details are suppressed or maintained by means of the ratio of fogging exposure to burning-in exposure that you use. This ratio can be varied by changing the brightness or proximity of the fogging light, or by altering the aperture of the enlarger lens, or by varying the time, as a proportion of the total exposure, for which either is used.

Creating shadows When, many years ago, I first showed the above picture to a photographic judge, he remarked on how 'lucky' the photographer had been that the pigeon happened to be in that precise position between the shadows, and, moreover, that the shadows

were so balanced. It would have been just his luck, he added, for the shadows to have been in the wrong place, or too numerous.

However, as this pair of pictures shows, the truth was quite different, for printers commonly make their own luck. In this case it was entirely attributable to a cut-up Agfa packet and the light switch! This distinctly low-tech solution imparts a whole new meaning to 'shadow control', for shadows can be manufactured at will for emphasis, to help composition, or even to hide unwanted objects.

MULTIPLE PRINTING

 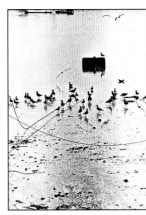

Multiple printing can be one of the most exciting aspects of printing, giving you some of the freedom to interpret reality that painters enjoy. It can also free you from the restraints of the negative, allowing you to 'mix 'n' match' good foregrounds, midgrounds and backgrounds. You can even change the season or time of day in your prints.

However, in practice multiple printing can prove very frustrating for the beginner. The technique, usually described in books as 'simple', of laying precise cut-outs from cardboard on the print to mask each component in turn, rarely gives perfect results. When learning anything it is important to experience early success with an easy technique, rather than failure with something too ambitious. The simplest multiple-printing procedures are silhouettes and sandwiches.

SILHOUETTES

The attraction of a simple silhouette is that there need be little or no masking or blending. Even if you print a sky all over it, it simply does not show, as the silhouette is already black. Therefore start to build a collection of:
• Silhouetted elements with a strong pattern or shape. Shoot against the sun, overexposing to wash out the sky. Avoid orange and red filters, because they darken blue skies, which then have to be masked out. Use blue filters to achieve paler skies, making combination printing easier.
• Birds in flight, for incorporation into other pictures. Again you should select overexposed, blue-filtered, toneless skies. Shoot a whole roll of film and develop it for high contrast.
• Strong skies of all types, to combine with the above subjects. Here, use orange and red filters to deepen blues and emphasize clouds. Experiment with different magnifications. Use fine-grain films like Ilford XP2, so that you can pick portions of your negative without experiencing problems of very evident grain.
• Your own silhouette-type negatives, which you can make on 'lith' film (available from Kodak in 35mm and sheet form).

Lith silhouettes By copying your negatives on to lith film you will get a 'positive' negative which consists of

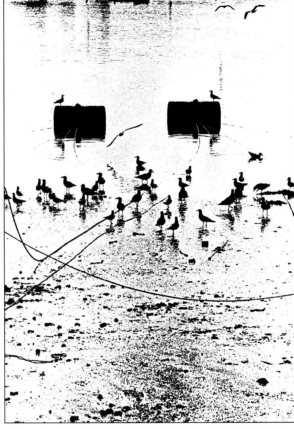

Projecting or contact-printing onto lith film produces a 'positive' negative. Bracketing the exposure gives a choice of such positives, above, from which to contact-print onto another piece of lith film in order to produce a working negative containing the amount of detail required. The print on the left was made by simply 'dropping in' the second drum (reversed) by printing it through a hole in a card. This form of multiple printing is easy and versatile.

only black and white, with no greys. Because it is effectively a silhouette, it is easy to multiple-print the same motif all over the paper in repetitive patterns, and in different sizes and densities, or to combine it with other lith or full-tone negatives.

The multiple printing of negatives in sequence, as in the series of photographs shown on these two pages, allows changes in scale, position and density to be made and unwanted areas of either negative to be 'held back' either with your hands or a piece of card during that exposure. The final print (right) is a variation in which a short third exposure rendered the leaves out of register, giving a lighter grey. The variations you can

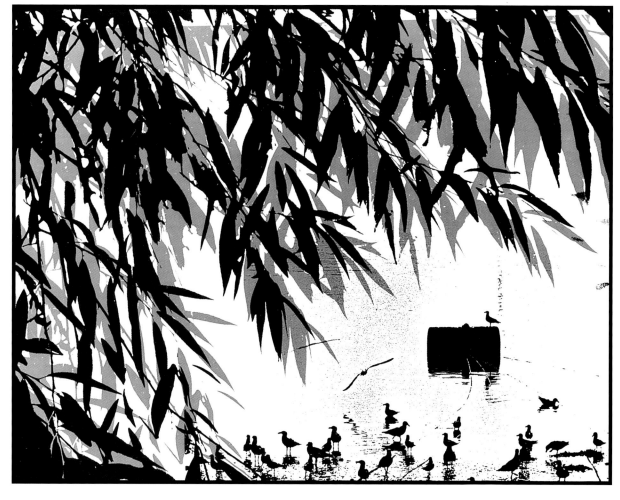

The first of the two prints above was made by printing a lith negative of waterside leaves over the birds and drum. In the second print photo-opaque paint was used to block out some leaves on the negative. This allowed the inclusion of more birds and a larger drum higher in the picture. The larger print on the left was made in the same way, after moving the drum. A second, shorter exposure of the leaves was made, using the traced sketch, above far left, as a position guide

produce in this way are almost limitless. They have visual impact and are easy to do.

Combining skies and silhouettes It is easy to print another sky onto a silhouette, as in the series of pictures on pages 88-9.

1 Make a test strip of the silhouette area and make a print at the *shortest* exposure which gives you a maximum black in the silhouette. This ensures that the background is no darker than necessary.

2 High-contrast paper helps to give the blackest blacks while losing some light greys into white. Variable-contrast paper is ideal because you can use the highest grade for the silhouette negative and a lower grade for the sky exposure if appropriate.

3 If too much tone shows in the sky, increase contrast and/or dodge the sky roughly with your hands or a card. This need not be precise.

4 Expose several sheets identically to the first negative.

5 Always fold over 1mm (1/16in) of paper at the top-right

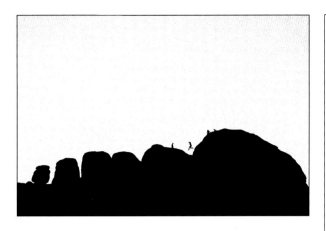

A sky can be printed over this silhouette without using joining or blending techniques.



SILHOUETTING TIPS

• Start with something simple. Success boosts confidence.

• Use bold, strong shapes for impact.

• Remember that blue skies are lightened by blue filters and darkened by orange and red at the picture-taking stage.

• Use high contrast grades for the silhouette exposure to give dense blacks and minimum background tone.

• Mask the silhouette sky roughly with your hands.

• Shoot plenty of stock skies, silhouettes, birds, planes and so on in different sizes and positions in the negative.

• Keep a note of all technical details when printing.

• If you are experimenting with lith negatives, keep the positives and experiment with sandwiching them on a light box to see how a positive print would look.



corner of each sheet before putting it away, so that you know which way up to use it later.

6 Before moving the negative or easel, insert an old reject print (always keep some handy) face down in the easel and roughly outline the subject with a black felt-tipped pen, as in the sketch below.

On the back of a reject print, make a sketch of the silhouette. The sky negative is projected onto this and the composition arranged.

7 Change negatives, enlarge, shrink and compose your chosen sky onto your sketch, taking care to place important components in the right places. Consider reversing skies or even turning them sideways or upside down if they are suitable.

8 Make new test strips in the usual way, and allow for 'dry down'.

9 Remove the sketch and replace it with one pre-exposed sheet, ensuring that the top corner is the right way up. Expose, burning-in or dodging as required for emphasis and balance. Develop and inspect the result.

10 If the result is faulty, make appropriate adjustments and repeat the procedure on next sheet. If it is perfect, move on to another sky and choose the best one later.

Two further practical tips: first, depending on the density of the blank sky area in the first negative, you may need to slightly reduce the exposure indicated by the test strips for the second sky, as the paper may have received a small exposure here already. This may also slightly reduce the contrast of the second sky on the combination print. Second, if you are using graded rather than variable-contrast paper, try using a grade

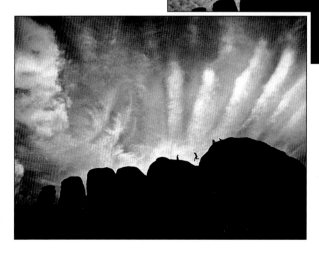

Different skies evoke different moods. Having decided on the one you want to use, work out the composition and magnification that work best.

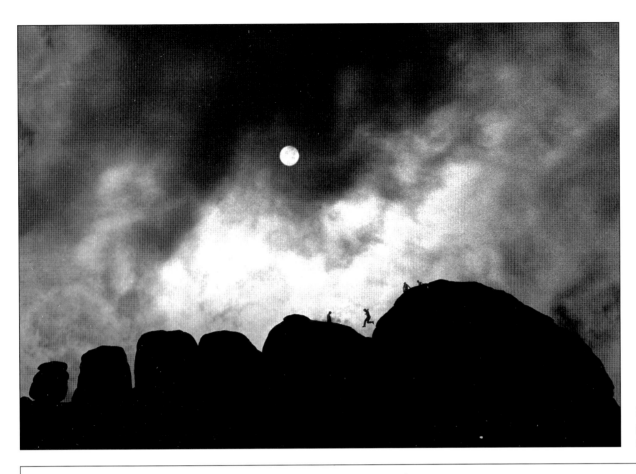

The sky negative was deliberately printed out of focus to add to the impression of a 'boiling' sky.

SANDWICHING

When a bright area is printed sequentially onto a dark area such as a silhouette, the dark area is dominant in the print.

The two prints shown here illustrate the main difference between printing two negatives sequentially and sandwiched together in the enlarger. Both use a silhouette, which is clear on the negative, and a sunburst, which is dense on the negative. In the first picture, an example of printing in sequence, the dense silhouette overprints the bright sunburst. The second picture was produced by sandwiching. Because the dense sunburst negative is placed against the clear silhouette negative in the negative carrier, the net result is still a density on the 'negative', which stops light passing through. The result is the opposite to the first print, and the sunburst overprints the silhouette.

When a bright area is sandwiched with a dark area, the bright area is dominant in the print.

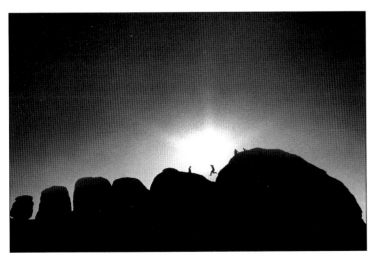

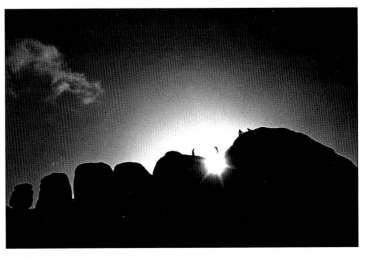

higher than you need for the sky you will use in the second exposure. This will help in printing the silhouette as explained. You can then flash the paper between exposures to reduce contrast in the second sky. But remember to take this into account when interpreting your test strips.

Inserting a moon If there had been no moon in the large picture on the previous page, one could have been

inserted by sandwiching it in another clear sky, with the sky shown. However, it could not have been superimposed onto the darker clouds by the sequential printing method. Alternatively, it could have been simulated by placing a coin or an aspirin on the paper for half the exposure. The other half would have printed clouds over it, leaving the 'moon' visible through the clouds, rather than as a pure white disc.

The technique of sandwiching negatives is useful when you are 'dropping in' light objects — for example, the sun or moon — on to dark subjects. But a disadvantage is that it does not allow you to select negative detail. Unless you make special negative derivatives, you are forced to use everything on the negative. By contrast, using one or more silhouettes and printing negatives sequentially immediately gives you the freedom to change scale, axis, contrast grade (with variable-contrast papers) between exposures and to withhold or lose unwanted detail from any of the negatives.

BLENDING IMAGES

Sooner or later, however, you will want to make a multiple print in which neither negative is a silhouette.

A wet afternoon was changed to night simply by adding a sky and printing darker than in the original print. Turning the second negative upside down and back to front made it possible to enlarge it so that it fitted snugly around the tree. Blending low-key subjects is not difficult — only rough dodging at the overlap is needed.

Using registration marks on the easel blades will guide you when you are dodging 'blind' onto a blank sheet.

Then it becomes necessary to join images, for which you will need the following:
• Plenty of paper
• A large wastebin
• Scissors
• Card
• Masking tape
• Blu-tack or similar
• A sheet of good-quality glass considerably larger than your easel
• Audiocassettes or books
• Pliable wire or a rigid ring of 4-6in (10-15cm) in diameter.
• A lack of illusions about instant success, combined with patience and the determination to eventually achieve mastery.

Sharp-edged joins Joins can be sharp, very diffused or anything in between. A mask cut and laid on the paper gives a sharp edge most suitable for subjects with simple, preferably straight, edges. Acetate masks (see page 55) also produce sharp edges and are easier to adapt to more complex outlines, or areas in central parts of prints. They can be placed in the easel perfectly in register even when 'blind' — that is, with no projected image during placement.

Soft-edged joins I find a soft-edged join more useful and much more flexible than one with sharp edges. When a mask is lifted above the paper its edges become softer and its outline less distinct. The closer it gets to the enlarger, the more evident this effect is. It is infinitely variable, and helps images to blend rather than simply adjoin one another.

Image blending enables you to combine the most unlikely elements, either for a realistic effect or to create a fantasy. The soft-edged join discussed below is especially useful for changing skies, so that you can radically alter the mood, time of day or even the season in your picture.

The large picture on the opposite page of the tree with the moon behind it is the result of going a simple step on from the silhouette technique. No masks were used — I simply held my hands above the paper and moved them gently to avoid creating halos. The straight print, without the moon, was made from a picture shot on Dartmoor one dull mid-afternoon in heavy drizzle. The second negative, one of a series of the moon over my home town, when reversed, turned upside down, enlarged and rotated, just fitted the shape of the trees.

The multiple print was made as follows:

1 The first image was printed darker, to evening or night light levels.

2 The paper was removed (with the top-right corner

folded over) and replaced with a sketch.

3 Strips of masking tape were placed on the easel blades, and the levels of landmarks were indicated on the masking tape with a felt-tipped pen. These marks told me where the rocks were when I projected the sky onto the still blank paper.

4 The sky was composed to fit around the trees on the sketch, and test strips were made.

5 The paper was replaced, and a check made that the top-right corner was correctly oriented.

6 The sky was exposed, and the area of the boulder roughly dodged by using the guide marks on the masking tape (which can later be removed, leaving the easel unmarked). *Note*: Here it is wise to dodge sparingly, as light spilling on to the rock is less noticeable than a bright halo around it.

7 After developing and fixing the print, it was still possible to retrieve any desired but lost detail by using potassium ferricyanide bleach.

Straight horizon joins Seascapes looking out to the horizon offer you the opportunity to make a straight, uninterrupted join, as in the case of the picture on the next page of a West Country lobster fisherman. The straight photograph — the first of the small pair (fig C)— was taken in the early afternoon, but changing the time of day by adding a sunset made the shot much more evocative (fig D). The absence of a light path across the sea is explained by the fact that the sun was shot as it sank behind an island (fig E). However, a light path could have been added by using potassium ferricyanide or iodine.

Despite the oft-given advice, the join cannot be absolutely sharp without being apparent. Raising the mask 6-8in (15-20cm) above the paper gives enough softness to blend the two images. Experiment to find what height suits your negative. A sheet of spotlessly clean glass on two stacks of audiocassette boxes or books can be adjusted widely in height. However, if it is too low, not only will your join be too precise, but you will not be able to open your easel.

The procedure is as follows:

1 Project and compose the first image. Outline the main elements on the back of a reject print in black, medium-thick felt-tipped pen, as in the sketch (fig A).

2 If you need to eliminate sky (this depends on your negative) place the soft-edged mask in place just above the horizon (fig B). It is important to indicate this on the sketch with a black dotted line .

3 Leaving the mask in place, make the usual test strips, including the horizon. Do not change the lens aperture.

4 If the horizon is invisible or too visible, move the mask down or up, respectively. When you are satisfied, mark the horizon with a broken line that is clearly different from the first line.

5 Remove the sketch, then expose three sheets of paper and return them to the packet after folding over the top-right corners.

6 Replace the sketch, change the negatives and recompose the image. Then move the masking card to mask the new unwanted foreground.

7 Position the mask to overlap the first mask line on the sketch. This is necessary because the print fades away towards the edge of the mask for a distance of between ¼in (0.6cm) and 2in (5cm), depending on the height of the mask from the paper, the lens aperture and the size of the enlargement.

8 Mark the new mask line and the main picture elements in a colour other than black that is visible under the safelights.

9 Make sky test strips. Do not subsequently alter the new lens aperture.

10 Replace the sketch with the first exposed sheet and expose, develop and fix it.

11 Examine the result critically. The second mask position was a guess and will probably require improvement. If there is a light band above the horizon you need more overlap, so move the mask down. If the band is too dark, you have too much overlap and need to move the mask up. Make a small adjustment as necessary and mark the new position on the sketch.

12 Reprint on the second sheet, leaving the third sheet for fine tuning, or for a duplicate print if the second is perfect. The large picture shows this second stage. The mask still needs to be moved down on the left and up on the right, although probably by as little as 1mm (¹⁄₁₆in).

A *Trace a sketch map of the original print under the enlarger. This is essential, both for composition of the sky negative and for masking the join.*

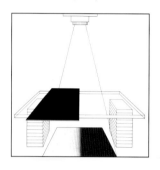

B *A side view of a mask used to make a semi-sharp horizon join, as seen in fig D.*

E *Changing sky negatives alters the picture's mood.*

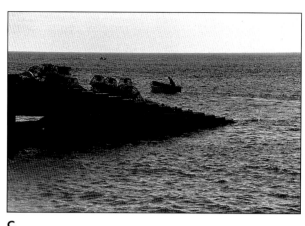

C

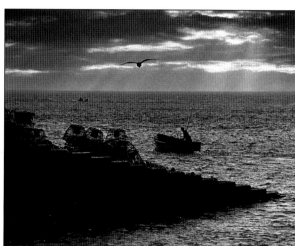

D

E

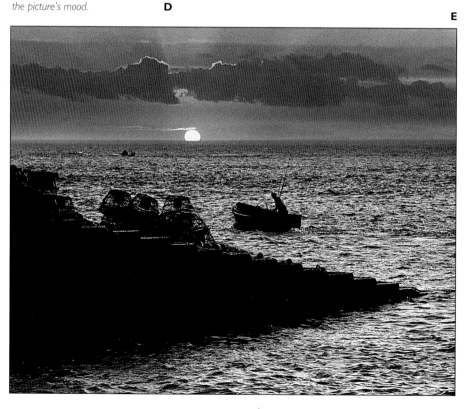

Broken horizon joins The original shots in the series of pictures shown here, figs A and B, were taken in dull light and rain. In fig C the rider is left to absorb the sky tone, which looks more natural in this setting than would holding him back by dodging. Similarly, rather than join the land to the sky, I allowed the land to absorb the sky tones, which are masked slightly below the horizon. With my fingers I gently dodged, or 'feathered', the area just above the cut-off, to soften the blend.

Unlike in the example on the opposite page, the horizon in the horse-riding series is broken up by figures seen against the skyline. It is simply not practical to cut a mask around these. In fig D the single rider was placed against a light area, minimizing the need for any masking around him. The whole image was printed in low key and low contrast to enhance this effect.

Combining dodging and masking techniques sometimes works better than masking alone. For fig E, I decided to depict a sunny spring day by using an attractive sky shot on Ilford XP1 and printed on Galerie, a paper which renders clouds particularly well. This film has fine grain, so that you can use smaller portions of the negative without experiencing grain problems when you make enlargements.

The same soft-blend technique was used, but this time with easel markers, as explained on page 91, to show me where to put in a little 'blind' dodging for the figures. A brighter atmosphere was produced by increasing contrast and retrieving detail in the riders with potassium ferricyanide, which also brightens the

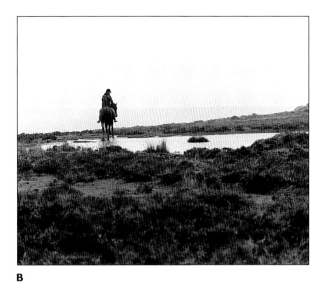

B

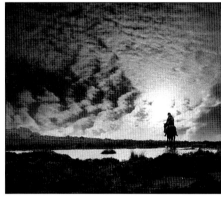

B-D *Fig B shows a nondescript afternoon, while figs C and D are two alternatives simulating a moody end to the day. In each case the sky's shape determined the composition, and the rider was positioned accordingly.*

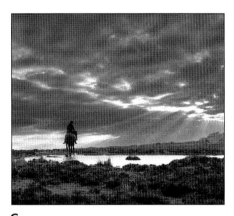

C

D

E

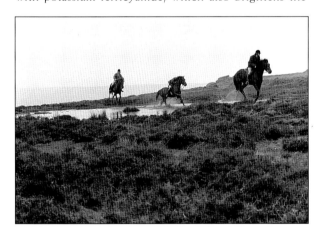

A *Changing the sky in a picture can change not only the weather and the time of day, but even the season. The dull, wet winter's afternoon in fig A was transformed into a bright spring day, complete with fluffy clouds, in fig E.*

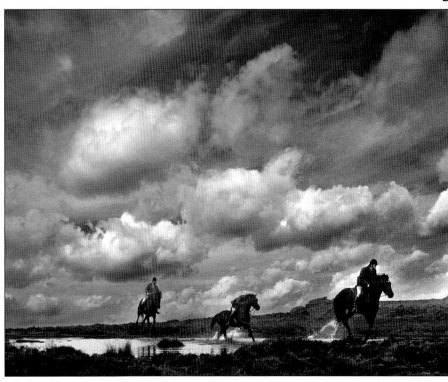

The visual tension in the final print, below, between the surging water and the static birds could not have been created with a single negative. The two small prints supplied the key elements.

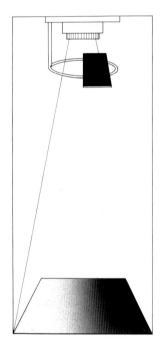

spray in the added 'sunshine'. I also gave the print more overall sparkle, to strengthen the atmosphere of spring, by pulling it briefly through a bath of 'ferri'.

Ultra-soft joins For the seascape seen here, a much softer blend was needed than for the previous series, so I placed the masks on a wire ring about 4in (10cm) below the lens, as illustrated below. The ring is hung either from the Multigrade filter attachment or even from the negative carrier. Small strips of card form the masks.

The basic technique used here has already been described. However, bear in mind that, with the masks at this distance above the paper, you must not change your aperture setting throughout the procedure, other-wise the mask shadow will alter even more significantly.

The print on the left is the straight print. Since I was not carrying a neutral-density filter, I used all the filters I had with me — orange, red and polarizing (the latter accounts for the vignetting) — at ƒ22 so that I could use

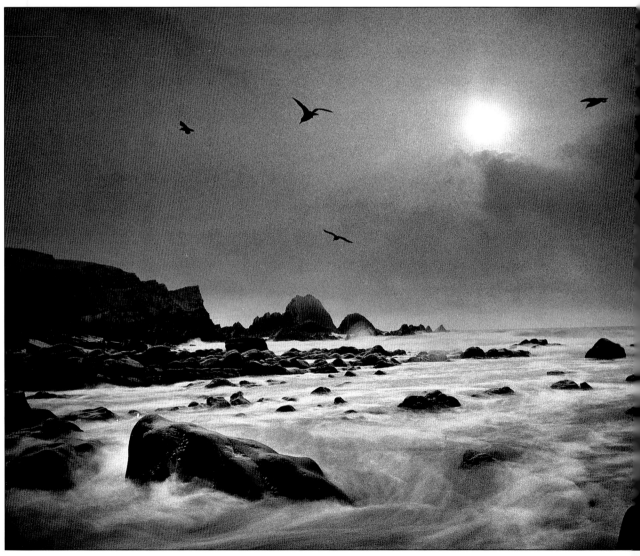

A soft join is often easier to achieve than a semi-sharp one. The mask should be used a few inches from the lens, as in the above diagram.

a long shutter speed to blur the water. The next day I shot the birds, in the first small print, to add in the darkroom. Juxtaposed, the moving sea and the stationary birds create a tension and a feeling of unreality.

With pictures like this, where you are introducing an additional light source, be aware of the direction of the light and keep it consistent — unless you want the light sources to conflict for effect. In the original shot of the sea, the light comes in from the right. Appropriate burning-in altered this in the final print, giving a watery central light on the sea. The sky tones also required considerable redistribution.

Foreground blending So far we have looked mainly at using multiple printing to change skies — first with silhouettes and then with the 'soft-blend' technique. The latter approach can be taken further, enabling you to blend not only skies, but also foregrounds, midgrounds and backgrounds. The ability to do this has three advantages.

First, it enables you to use all those negatives that were *almost* great pictures but were let down by, say, a poor background or an empty space which should have been filled. Again, some pictures feature a terrific background that you simply could not ignore, even though you could find no foreground interest in time. Multiple printing allows you to shoot striking foregrounds and backgrounds separately, and marry them together in the darkroom.

Second, it is great fun. It allows you to be as creative as you want, whether your aim is to produce realistic images that nature was unable able to offer, or fantasy images.

Finally — and this is a major advantage — no one can copy your shots, for the simple reason that they cannot find where they were taken.

When you have read about the technique, go into the darkroom and try it. Do not worry about the mistakes: they are essential stages in the learning process. This 'image blending' is an extension of the soft-edge technique described earlier. Here the mask is placed very close to the enlarger lens — typically ¼-1½in (0.6-3.75cm) from the front element. Try 1in (2.5cm) for a 10in x 8in (25cm x 20 cm) print and 1/4in (0.6cm) for a 20in x 16in (50cm x 40cm) print, and experiment from there.

At these distances the baseboard image will gradually bleed out, as in the first illustration on page 97. The closer the mask is to the lens, the more gradual this effect is, and the wider the overlap. Make a print with just one image in this way, having marked the mask edge under the red safe filter before developing. When the print is developed you will see that the image bleeds into white *before* the marked position. This is important, since the masks from the foreground and

MIX 'N' MATCH LANDSCAPES

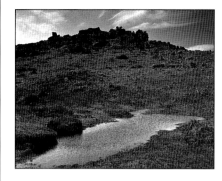
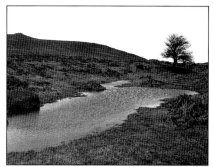

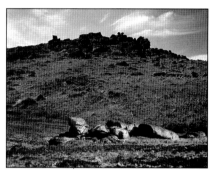
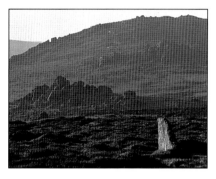
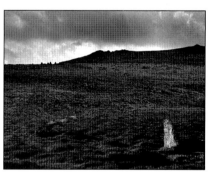

Elements from different negatives can be swapped at will when you use this soft-edged joining technique. Never again need you be stuck for a picture, for you will now have more possible picture combinations than you have negatives. Experiment with softer or harder edges to suit the picture, by moving your mask closer or further from the lens.

background negatives must overlap and not just meet.

Invisible information Although the paper is white along the area between the mask's marked position and the first visible detail, it has been sensitized and holds 'invisible' information which will appear when it receives further exposure. The secret of this technique is to ensure that as one image fades out, the other fades in to balance the tones exactly. Too little overlap will give a light strip, while too much will give a dark strip. Once the first mask is in place it is worth making a strip print along the overlap to check that nothing vital has bled away. The fact that you can see it on the easel

does not guarantee that it will appear on the final print.

The procedure is explained here step by step. Once you have grasped it, start to experiment by altering the lens-to-mask distance. Different degrees of blending suit different negatives and with practice you may mix them. You will be surprised how easily some apparently incompatible negatives blend together.

1 Carefully choose the negatives you wish to combine. Two will be enough until you have gained some expertise. Pay attention to the direction of light: it should be consistent between the images unless you are quite sure you do not want it to be. Reversing a negative sometimes helps to achieve consistent lighting. In general, flat lighting is less interesting but easier to match.

Fig B shows an attractive grouping of three backlit sheep. However, a dull background spoils the picture. Fig C shows the selected background negative and fig D shows it printed to reveal sky detail. (There is no reason why another sky, from a third negative, could not have been added.)

2 Insert a blank sheet of white paper in the easel — the back of a discarded print will do — and compose your first negative on it.

3 Shut down the lens down to the aperture to be used for the print, and position the mask even closer to the lens than in the diagram on page 94. Adjust the mask to obscure the top part of the picture as required.

4 Draw the basic outlines plus the mask edge in black felt-tipped pen, as in the sketch (fig A).

5 Replace the drawing with photographic paper and make test strips in the usual way with the mask in place. Make a strip print of the join area to make sure that everything will be as you want it on the final print. Work out the dodging and burning-in required at this point, and make a note of these details.

6 Expose three sheets of paper as perfectly as you can. Fold over the top-right corner of each and store them in a light-tight place.

7 Replace the sketch in the easel. Replace the first negative with the second. Compose the second negative on to the sketch of the first negative.

8 Shut down the aperture to the setting required for correct exposure. This need not be the same setting as for the first negative, but should be close to it. Position the mask at the working aperture. It is important not to change the aperture once the mask is in place, otherwise its edge on the baseboard will alter. The edge should overlap the position of the first mask (figs E-G). Complete the sketch with a felt-tipped pen of a different colour from that used for the first negative, and include the edge of the mask as accurately as possible, despite its being fuzzy.

9 Replace the sketch with photographic paper, make test strips and work out the dodging and burning-in required, again making a note of the details.

10 Insert one sheet exposed through the first negative, after checking the orientation of the top-right corner. Following your notes, expose the paper through the second negative and carry out any dodging or burning-in required. Develop and fix the print. This is likely to be imperfect. Fig F shows a typical first attempt with a light band. This indicates that there was insufficient exposure at the join. The mask for the second negative needs to be lowered further into the image from the first negative.

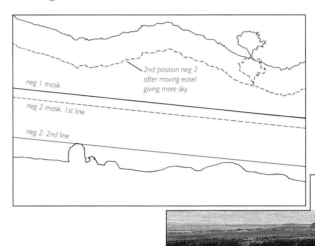

A *A printing map indicating corrective adjustments for blending. This was made on the baseboard by tracing the two projected images in turn.*

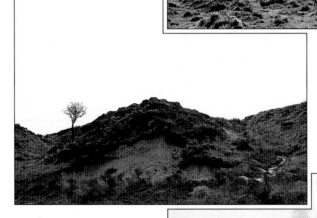

B *The straight print — an attractive group of rim-lit sheep, let down by a poor background.*

C *The proposed replacement background.*

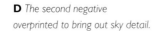

D *The second negative overprinted to bring out sky detail.*

E *The edge of the print fades out before reaching the mask edge, leaving a band of white. The second mask must therefore overlap the first.*

F *If the two masks do not overlap sufficiently, a pale band will show on the print.*

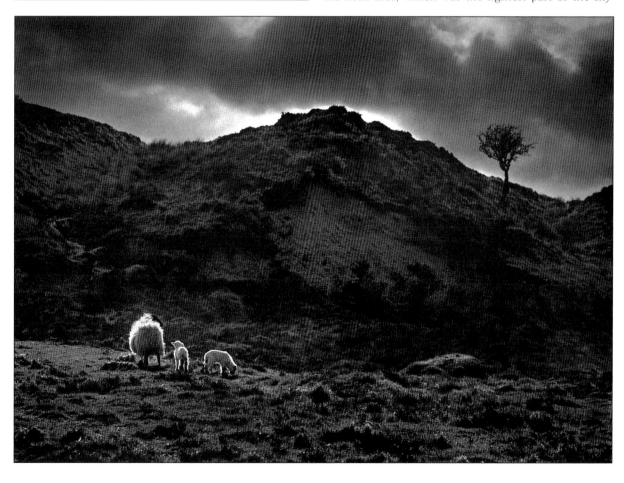

G *Increasing the degree of overlap, pushing the easel further up into the second negative image, and burning-in the entire strip, are three different ways to eliminate the pale band in order to produce a seamless join.*

11 Replace the sketch in the easel and adjust the mask, using your previous line as a guide. Mark the second position with a dotted line so that you can distinguish it easily from the first. Alternatively, move the baseboard to compress the images as I have done here. Fig A shows how the sketch has been lowered on to the sheep. Always mark any new position on the sketch.

Occasionally you may find that you cannot move the mask without overprinting something important. Here any further lowering of the mask printed grass over the sheep. In such cases, simply give extra exposure to the join by burning-in. You can do this through a hole in a card or by holding two cards above the paper, with a gap between them. They must be kept moving to avoid a tell-tale mark.

12 Having made your adjustments, make your second print. Determine any final fine tuning, and make the finished print on your third sheet.

In the shot on the next page of the young man with reflective sunglasses, the intended subject was the reflections in the lenses (fig A). However, the sky lets the picture down.

I added the sky by using a soft join with a mask about 1in (2.54cm) below the lens. This allowed the sky to fade into the crowd. With my fist I then dodged the head area, which was the lightest part of the sky

97

A *The light sky was easily removed by holding back with the hands.*

B *A replacement sky was chosen to fit the subject with minimal dodging.*

C *An acetate mask could have been used to dodge the sunglasses when making the first exposure.*

D *The second sky was dropped onto each lens of the sunglasses in turn, by contact printing under a card mask with the lenses' shape cut out. Burning-in and shading were done as with any sky.*

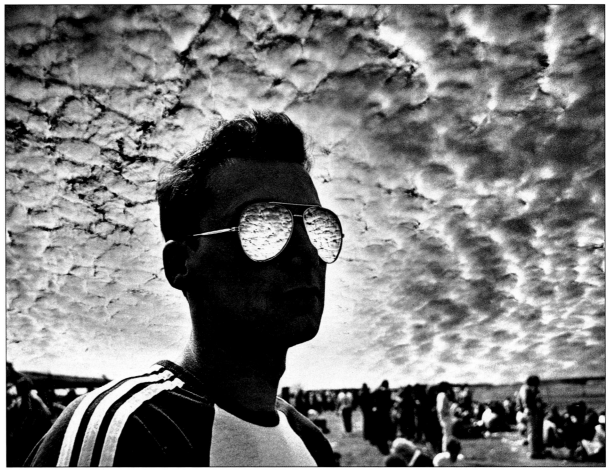

negative. The sky now had more impact (fig B), but it did not work well with the reflections, so I chose to create an unreal look instead by replacing them altogether.

This required a sharp-join technique which could have been done by using photo-opaque paint on acetate (fig C). It could also be achieved by using card cut-outs, which was what I decided to do, despite the fact that positioning them accurately is tricky. I replaced the original reflections with a matching sky, using a card mask and registration marks.

To produce a 10in x 8in (25cm x 20cm) print, the negative for the sunglasses was contact-printed by taping it to the back of the mask, exposing through it and burning-in as required on to each lens in turn. On the 20in x 16in (50cm x 40cm) print (fig D), the enlarger could just about project the tiny image.

As multiple prints become more complex, a variety of soft and hard-join techniques may be combined. There is always a way. For the series on the opposite page, *You Are Not Alone*, three different negatives were used. By now you have been told everything you need to know to work out for yourself how it was done.

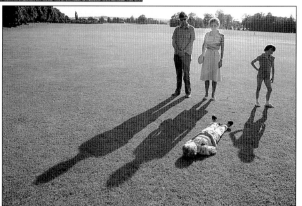

IMAGE-BLENDING TIPS

• Position your masks on your sketch plan, at the aperture you will use for the print. If you 'open up' to get a clearer view, your mask edge will move to a different position.

• Not all negatives require the same lens-to-mask distance. One may require a sharper edge than another on the same print. Experiment.

• Do not try to cut accurate masks at this lens-to-mask distance — you will not succeed. However, you can vary the mask edge — for example, from straight to curved.

• You may want to dodge or mask selected areas more accurately than the rest. This you can do with your hands or by using card cut-outs held close to the paper even with the lens mask in place, using guide marks on the easel as explained on page 91.

• Make test strips with the mask in place, since it may affect the exposure. This will also give you a visual guide to the effect of the mask and to whether you are losing important details near the join.

• When your aim is to create a fantasy, consider combining negative and positive images. The only limiting factor is your imagination!

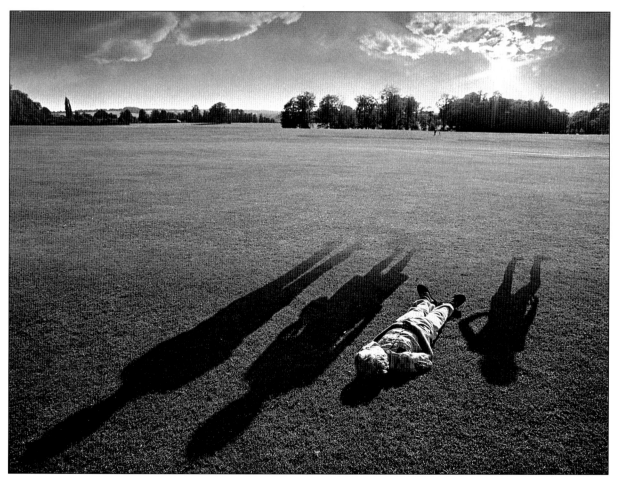

This multiple image was pre-visualized, unlike the example on the previous page, which was 'developed' in the darkroom. The long shadows were so pronounced that they seemed to be moving about with a will of their own. Their owners seemed superfluous. The three component negatives were shot from the same spot and combined by using an ultra-soft blend.

LITH PRINTING

Lith printing has nothing to do with printing from lith negatives. It can be very rewarding, but it is time-consuming and often frustrating, and you must be ready to ignore some of the normal principles of good darkroom practice. Heavily overexposed prints are processed in highly diluted lith developer by 'infectious development' and the print is 'pulled' prematurely to produce a variety of warm or coloured tones. Pulling the print is essential and critical to the outcome.

Infectious development In normal development, if there is no agitation developer will exhaust, slow down and eventually stop working in the shadow areas, where it has to work hardest. The highlights and midtones continue to develop. As we have seen in discussing water bathing, this can be used to control contrast. However, even with the vigorous agitation used in lith printing, infectious development causes the darker tones to develop faster. The darker these become, the faster they continue to develop, until an almost explosive rate of acceleration is reached in the dark tones.

Colour Image colour in chlorobromide or bromochloride papers depends mainly on the grain size in the paper's emulsion. In the early part of development the grains are fine and a variety of warm tones are produced. At full development the grains are large and the image is cooler — black or almost black.

If you leave a lith print in lith developer until the completion of development you simply get a cold-toned dark print — in other words, one that is heavily

The typical warm tones of a lith print can be seen in the larger print of each of the two pairs of straight, untoned pictures on these pages. The draped car was printed to create impact. The trees were printed on the same paper and processed in the same developer to produce a romantic, dreamy effect. This flexibility of interpretation is one of the attractions of lith printing.

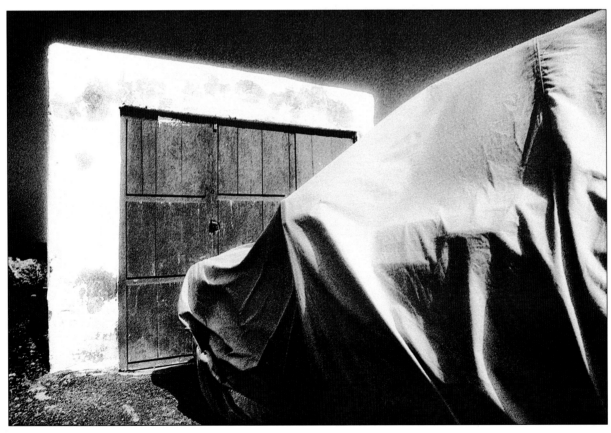

overexposed. However, infectious development allows you to snatch the print when the rapidly progressing dark tones reach the required density. The lighter tones are still way behind, but overexposure will have ensured that these are sufficiently dense. Removing the print at this 'snatch point' gives characteristic blacks in the shadows, while the lighter tones vary from buff to peachy pink or olive-yellow, depending on the paper and your processing technique.

Because the light tone grain is so fine, it is possible to get wonderfully delicate, soft highlights at the same time as high- contrast characteristics in the lower tones. The effect can be striking. Alternatively, you can achieve high-contrast and heavy grain throughout the

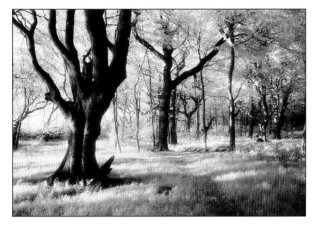

The coexistence of soft and hard tones in the same print is characteristic of lith printing. Here the print was pulled as the blacks formed rapidly by infectious development. Below can be seen an enlarged section of the main print, showing the blacks emerging from the light-brown tones.

print — again depending on the technique employed.

Varying interpretation The pairs of prints on these pages show straight prints and their lith counterparts. The covered car was processed in lith to achieve a dramatic impact, whereas the shot of trees was processed to convey a gentle, romantic enchantment. Note how flat the straight print of the car is in comparison with the lith print, despite the fact it was printed on Ilford Multigrade grade 4½.

No dodging, burning-in or toning has been used on these lith prints — their appearance is due entirely to the use of a lith developer. These are high-energy, high-contrast developers containing large amounts of hydroquinone and potassium bromide. The first sets up the infectious development cycle; the second restrains the chemical fogging that takes place when development is prolonged.

Hydroquinone starts working slowly, producing warm tones. Paraformaldehyde converts oxidized hydroquinone into the active semiquinone, which is a development accelerator. It also combines with sulphites to produce the strong alkali sodium hydroxide (NaOH), thus increasing alkalinity locally on the surface of the print. In this way development is increased most where activity is greatest in the dark tones. Here again paraformaldehyde acts as a catalyst to ever-faster development.

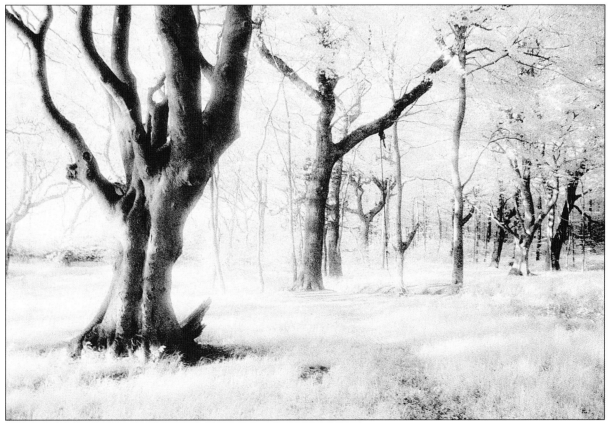

Making the print The following guidelines will give you a grasp of the basic principles of lith printing, but it is important to realize that this technique in particular lends itself to experimentation.

• Start with relatively strong solutions or you may find that you are still looking at a blank sheet after five minutes and give up. But note that such a wait is not unusual, since, depending on the required effect, temperature, dilution and exposure, development can take from 5 to 25 minutes.

• Fresh developer does not give the most interesting results. The best results will occur after a few prints. Alternatively, add used lith developer at 1:4.

• As development is incomplete, overexposure is essential to ensure sufficient image density at the snatch point. Test strips in lith developer are more difficult than with normal developer, as the (shadow controlled) snatch point will be different for each strip! Whilst shadows are controlled by development, highlights are controlled by exposure and only they will provide a means of selecting the correct strip. A simpler, faster method is to develop a test strip in normal developer to completion as usual. Add two or three stops of exposure to the time of the correct strip and make a lith print. The amount of extra exposure required may vary with different papers, different lith developers and the contrast required.

• Burning-in may be required in areas of minimal detail, although the overexposure already given will have lessened the need for this.

• Dodging is less critical as the print is snatched when shadow detail is 'right', but it may be needed in secondary areas. You can snatch only when one (the most important) area is ready.

• Flashing is occasionally useful to pull in faint highlights, but cannot be assessed accurately when developing to an end point with a flash strip (see pages 80-2).

• Development may be long and constant agitation is essential. Never be tempted to leave the print face down and do something else, or different depths of developer caused by the dish's construction will cause patterns on the print. After a while a faint milky image appears and very slowly builds up. This may try your patience if you are used to the instant response of resin-coated paper.

• Assessment can be difficult because you are seeing faint pink or sepia tones under red or amber safelights. This problem is made worse by some graphic-arts papers, which have a milky film that only vanishes in the stop bath or fixer, suddenly revealing what you could not see in the developer.

• Watch for the emergence of a dark tone. This starts to accelerate and at this point I find an LED safelight torch invaluable. At the appropriate moment, slide the print swiftly into the stop bath. Do not hold it up to drain or the critical moment will have passed.

• Fix and wash the print carefully. If scum marks appear,

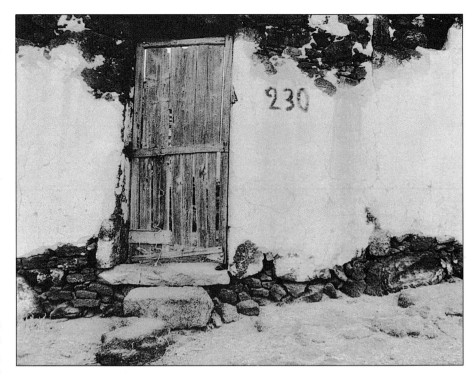

soak it in 3% acetic acid and then rewash it thoroughly.

Drying Hanging the print up to air-dry is wise if you plan to tone it later. 'Dry down' — the process by which tones darken as the print dries — is marked with some papers (about one-third of a stop with Process Lith paper, for example). Colours may change markedly on drying, and with most of these papers they can be altered either subtly or dramatically by toning.

This series of three lith prints shows the progressive blocking up of the shadows. Dodging may be necessary to ensure that these areas 'complete' at the same time as the most critical tone, which determines the 'snatch point'.

The print below was made on Process Lith paper in dilute lith developer. Although, in accordance with the manufacturer's specifications, it gives 'greater than grade 5' in the shadows, wonderfully soft tones are also present in the delicate highlights. The subtle near-white tones may be lost here in reproduction. Note: Although Process Lith paper has been discontinued since the earlier imprints of this book, many excellent similar and different alternatives are available. Some are described in the Materials box on the next page.

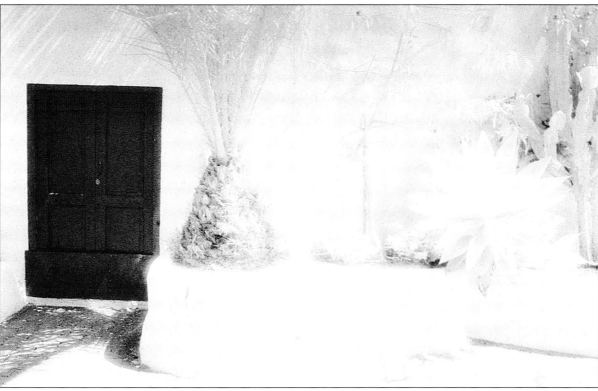

Controlling the lith process Most darkroom enthusiasts are interested in two aspects of any process: first, how to control it to yield predictable and reproducible results, and secondly, how to exploit it, vary it and extend its possibilities. Lith printing will challenge and appeal to such people. It has a reputation for being difficult to control and impossible to reproduce exactly,

and it can be manipulated to produce effects ranging from subtle and delicate to the outrageous.

The two prints on page 104 show something of the flexibility of the process. One negative and identical materials (Process Lith paper in Kodalith) were used, and only exposure and development were varied. Although some prints will inevitably lose some subtlety

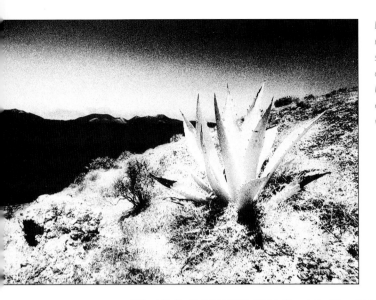

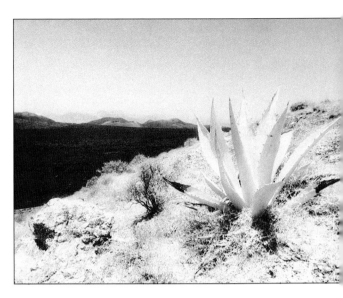

Lith printing allows widely varied results to be produced from the same paper and developer combination. In this pair of prints, left untoned for comparison, only exposure and developer time were different.

MATERIALS

Since this book was first printed there have been many changes in the materials available for lith printing, but the basics of the process remain the same.

Papers Currently (2004) only two papers are marketed as lith papers: Fotospeed's Lith FB paper is in its third incarnation, now as an uncoated version, and Maco's 'Lithpaper RC F' in Europe (Cachet Lithpaper RC F in the US). However, there are currently about 60 papers worldwide that work well for lith printing and many different colours and effects are possible. As papers come and go any list will date, so why not try your favourite general-purpose papers, but bear in mind that warmtone chlorobromide papers are likely to work best and RC papers with incorporated developer or accelerator are less likely to be suitable. There are, as always, exceptions to these generalizations.

In addition to the above, my current FB favourites include Maco and Cachet Expo papers for milky coffee colours, and Kentmere's Kentona, Art Classic and Document Art papers for pinky and sandy browns. Fomatone MG Classic and Forte Polywarmtone — the most colourful of the excellent Foma and Forte ranges with the lith process (they all will work at present) — produce richer colours in golden yellow brown, orange brown and pinks. The various hues from lithed Fomatone toned in selenium are especially attractive. Fomatone MG (FB and RC versions) is probably the last cadmium-containing emulsion, but will doubtless soon become cadmium-free under EEC regulations, so its lith printing and toning characteristics will certainly change.

There are now several RC options for lith printing. My current favourite is Paterson's Acugrade Warmtone, which offers a considerable variety of colours according to the developer dilution and technique used. Forte and Foma also produce some RC versions of some of their excellent lithable FB papers.

Developers The range of lith developers has increased since the first edition of this book. Most were designed for processing lith film, and their instructions may reflect this. Therefore, unless it is stated that the instructions are for lith Printing the recommended working solutions will be too strong and fast for this application. Increasing dilution by a factor of three is a good starting point. Strong brews are fast and give colder, more graphic results. More diluted solutions are slower, more controllable and give more obvious separation between high-contrast shadow tones and in soft creamy highlights. Some papers, e.g. Acugrade Warmtone, also change colour dramatically when developer dilution is significantly increased.

Apart from Speedibrews' Lithoprint, all current lith developers come as two solutions, mixed and diluted immediately before use. Unmixed, they have a very long shelf life. Mixed, they oxidise quickly and have a short working life. Also, the more dilute, the less active developer there is in a given volume and the smaller is the capacity. This can lead to sudden standstill in mid print unless replenished. Fresh lith developers generally give less interesting results until a few prints have passed through them. I suggest bottling the 'old brown' developer at the end of a session and adding some of it to the next fresh mix.

Kodalith concentrate is available only in 2x5 litres, making around 120 to 300 litres for lith printing, so it may be expensive for the low-volume user, although it will keep for years unmixed. The differently formulated Kodalith Super RT developer powder gives 7.6 litres of film-strength developer. Champion Novolith is 2x5 litres, giving 40 litres of film-strength developer. Smaller quantities are available from other brand names: Forte Lith in 2x1 litres; Fotospeed LD20 lith in 2x500ml with two useful additives; Maco Superlith, claimed to be a 'high energy' long-working developer; Moersch, Easylith and Masterlith kits, also with a range of additives; and in the USA, Naccolith, which in my limited experience of it, produces warm-browns but gives fewer other warm colours in the pink and orange ranges with some papers. Despite its name, Dokulith is not suitable for lith printing.

Stop bath A normal acid stop bath is essential to instantly arrest the rapidly progressing infectious development at the critical point.

Fixer Either acid or alkali fixers are suitable, but don't over-fix, since this may bleach out the subtlest tones.

Safelights These are determined by the paper rather than the process. As lith printing requires prolonged handling it is wise to be extra cautious. Do safelight tests based on extended times. If in doubt use red rather than amber and partially screen it, or move it further away. Safelight torches are invaluable just before the snatch point. I recommend the LED safe torch from RH Designs.

of tone in reproduction, you will see that one of the pair shows high contrast, with very large grain and cold tones, while the other is soft, with very fine grain and very warm tones.

Because the usual rules of printing do not apply here, it takes a few sessions to become used to the process. Proceed logically, changing only one variable at a time. Keep notes and analyse what you are doing to make the process more predictable. Also bear in mind the following points, which will all help to put you in control:

• Dilution of the developer substantially alters the lith effect. Start with a relatively strong solution — for example, Kodalith Super RT sol A:1 part, sol B: 1 part, water 3 or 4 parts. To increase the effect, increase dilution to 10 or 12 parts water or more, adjusting exposure and development time.

• Expose for mid or light tones, depending on which are most important in the final print. Develop for shadow details. Watch them carefully and snatch the print when they are ready. Remember that you are dealing with infectious development here — not normal development. If the mid or light tones have not come up enough at the snatch point and after dry down, try increasing exposure by 50% or 100%.

• Contrast can be affected by exposure, developer type, dilution and freshness and by the snatch point. Exposure controls light tones. Assuming the image has a black, reducing exposure progressively lightens the upper tones, thus increasing contrast (ultimately to just black and white). Extending development moves more lower tones to black, without (initially) affecting highlights. This also increases contrast and additionally alters image colour (colder) and texture. Higher dilutions and well-used developer tend to give warmer, softer results, which vary with different papers. Prints A, B and C opposite were each exposed one stop less than the last, lightening the highlights. Print D, an intermediate exposure, was snatched later, increasing the blacks.

• Timing depends on the desired result and the state of the developer, which usually exhausts quickly. Ignore the clock and watch the critical shadow area.

• Tone or colour can be affected by most of these variables as well as by different papers, different developers, flashing through development, bleaching and redevelopment, and subsequent toning. Experiment with these effects — the permutations are endless. Fresh developer may give less interesting tones or colours than used developer. The addition of stored used lith developer is a favourite ploy to overcome this problem. Try a ratio of 1:4 used lith developer to fresh developer.

• The capacity of developer is very limited at these dilutions, and can fail quite suddenly. Be prepared to discard it when development times extend, but keep a little used lith developer for the next batch. For consis-

tent results you may need to do this often.

Late-development flashing As it can be difficult, under amber or red safelights, to judge the progress of a lith print, with its characteristic pale colours, an LED torch is invaluable. Alternatively, because of the long development times, flash on the room light very briefly when approaching the snatch point in order to assess progress. The print will not stay in the developer long enough to develop fog because the light tones appear much more slowly than the rapidly accelerating dark tones. This technique can be used with care at the end point without significantly affecting the image. Further

A-D *This series of prints illustrates different contrast effects. The first three prints show increasing contrast resulting from lightening the upper tones by reducing exposure. D shows the effect of a later snatch point, increasing the blacks, cooling the tone and adding more grittiness.*

A

B

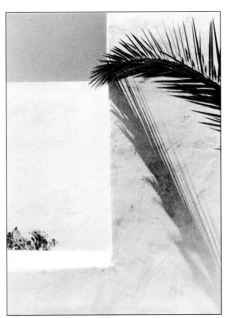

C

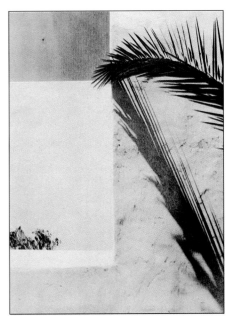

D

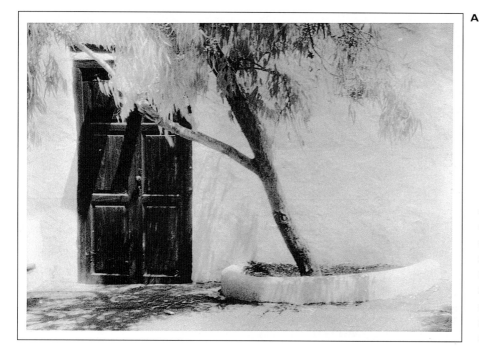

A

A and B *Flashing in late development can be used to alter the final image colour in some papers, as in figs A and B. In the case of B, the paper was heavily overflashed to emphasize the effect. The borders are inevitably affected and may need to be trimmed off or overmatted.*

experimentation, flashing progressively earlier in development, for different lengths of time, reveals interesting results with some materials.

In the series of prints on these pages, fig A shows the typical pinkish-buff colour of a TP5 print in Kodalith (untoned). However, this print was made in fresh developer and flashed three-quarters of the way through development. It shows no sign of fogging on the previously unexposed border, but overcomes the 'fresh developer' black-and-white look on TP5.

Fig B was quite heavily light-fogged halfway through development and has a deeper red colour with obvious fogging of the border. Even so, it is an interesting and acceptable effect, particularly if placed behind a window mount to mask the border. A range of colour effects from fawn through lilac to red can be produced, with or without solarization, by using this technique. To enhance the highlights, the print can be gently partially bleached back, but the colour will change.

Oriental Seagull produced a gentle effect reminiscent of a watercolour painting, while Kodak Rapid Plus (RP7) changed from a fairly straight print (fig C) into a curious grainy result not unlike a pencil sketch (fig D). This effect is quite reproducible on RP7 and can be controlled by varying the flashing, to give most attractive results.

Redevelopment If a black-and-white print is bleached away in a hypo-free halide-containing bleach — as used for sepia toning — it can be redeveloped in room light in a developer with the same or different properties to the one previously used.

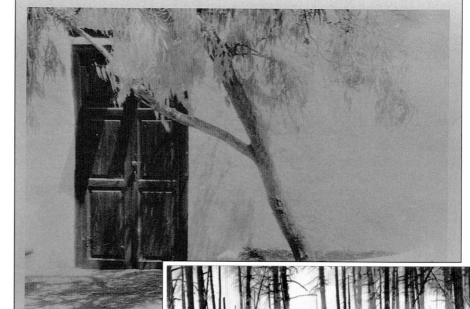

B

C

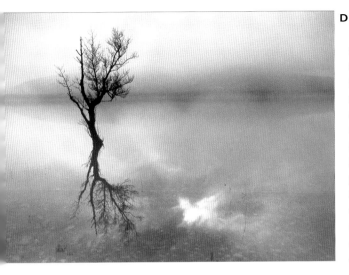

D **E**

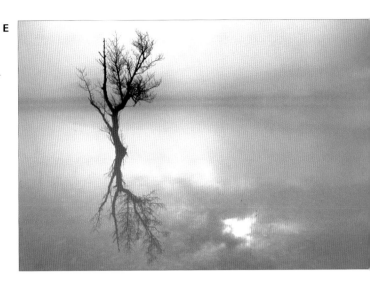

C, D and E *Bleaching a print that was initially developed either in normal or lith developer allows the print to be redeveloped in dilute lith. The results will vary with papers, techniques and bleaches. Some papers give lith lookalike effects, while others give colours and grey duotones, before finally reverting to black and white. C was made with Forte Polygrade V; D with Kentmere VC; and E with Ilford Multigrade Warmtone.*

So why not use this technique for making lith prints in room lighting from previously overexposed conventionally developed black-and-white prints, by using a lith developer for redevelopment? The good news is that this does work. The bad news is that it is not generally an easy way of making normal lith prints. More good news is that although results can with a few papers resemble 'normal' lith prints, with many other papers they can be very attractive, but in quite different ways. The further good news is that this technique also works with many 'non-lithable' papers, thus extending the creative options. A few papers do not work. Some produce passable lith lookalikes. Others yield interesting colours — pinks, olive, blue-greens and yellow-browns — commonly as mixtures, or duotones with grey. A few produce lith/black-and-white hybrid prints.

The colours come from the small grain sizes of early arrested development. If left to develop fully the print will revert to black and white. Some overexposure is necessary to ensure adequate density. Exactly how much depends on how far the print is developed and on the desired density of colour. Some papers evolve through a colour range in the lith bath, so an adjacent water bath is useful to slow down the endpoint changes.

The print will lighten in the fixer, and the earlier development is terminated the more pronounced this will be, hence the need for overexposure. Colours, too, can be fickle, lightening or changing in the fix, occasionally disappearing — or doing so on drydown. If this happens try another paper. Changing the first developer or the bleach also can vary results. The cupric sulphate bleach in the formulary section is capable of producing extraordinary results. Using lith developer for both first and second development produces different results again. A whole new repertoire awaits the experimentally minded. A chapter on this technique can be found in my lith printing book, *The Master Photographer's Lith Printing Course.*

Non-lith alternatives If you do not want to buy lith developer in the quantities sold, and have no one to share your interest and your developer with, you can gain similar results by adding sodium hydroxide (NaOH) to your developer. You will recall that this compound is produced in the infectious development cycle when paraformaldehyde reacts with sulphite. NaOH can cause burns and should be handled with gloves. It works best with PQ developers such as Ilford PQ Universal.

However, the picture of steps above was made on Oriental Seagull in Multigrade developer with NaOH added at 5g to 1 litre of working strength. Although warm and cold tones are present, they are not necessarily where you would expect them to be and it really is not a true lith print; nor is the development infectious. More convincing results may be obtained with PQ Universal + NaOH and true lith paper.

The effects of peripheral techniques like this vary greatly with different paper emulsions. Some are worthwhile, others are not. Even small unannounced changes in a paper's emulsion can change their response, so experiment. I have gained results akin to soft watercolour painting and to pencil sketches but also many 'bin prints'!

BLEACHING

We have seen how dodging and burning-in can dramatically alter an image and widen the scope for creative expression. But although these techniques are extremely useful, they have their limitations. Sooner or later you will want to lighten an area of a print but will not be able to do it by dodging. This is the time to reach for the bleach!

Bleaches are used to lighten negatives and prints. Probably the most widely used is potassium ferricyanide, commonly known as 'ferri' or 'liquid sunshine'. Its many uses range from pre-development bleaching for contrast control to post-development highlight enhancement, as well as controlling of image colour; it can also be used in redevelopment and toning.

Although they work by oxidation rather than reduction, bleaches are often called reducers. In simple terms, areas where they are applied become lighter as the silver is changed into a soluble form and washed away. However, bleaches do not all work in the same way and this fact can be exploited to your advantage.

Subtractive reducers The group of bleaches known as subtractive reducers, the most widely used of which is potassium ferricyanide, affect all tones by the same amount. In fact, this convenient description of their effect is misleading, for small density reductions in deep shadows may be quite imperceptible, whereas a faint highlight tone reduced by the same amount may disappear altogether.

Consequently, potassium ferricyanide often appears to work preferentially on the highlights, only later affecting mid and low tones (unless the tonal range in the print is very restricted, when this may not apply). This effect, seen in the pictures on the opposite page, can be used to great advantage, for with care you can brighten highlights without much affecting the surrounding tones. However, much depends on how ferri is used, on its concentration and whether it is used with or without hypo. Above all, the key to its effective use is the ability to assess the concentration needed for the task in hand.

Concentrated solutions of ferri-based Farmer's Reducer work quickly, so that for local use they should be allowed to remain on the paper for no more than a few seconds, although they can be reapplied as often as necessary. These solutions strip down highlights, affecting dark tones little, but are not suitable for delicate surrounding tones. Weak solutions work more slowly and apparently less selectively. Midtones can easily become degraded if allowed to go too far this way.

Proportional reducers The solutions known as proportional reducers work by reducing all tones in the same *ratio* — that is, darker tones are reduced by a greater *amount* than light tones. (Weak ferri sometimes appears to have this effect.) Potassium permanganate reducers and iodine or thiocarbamide reducers act in

Dodging and burning-in were ideal for controlling the tones in the bottom half of this print, but the cloud required bleaching with potassium ferricyanide.

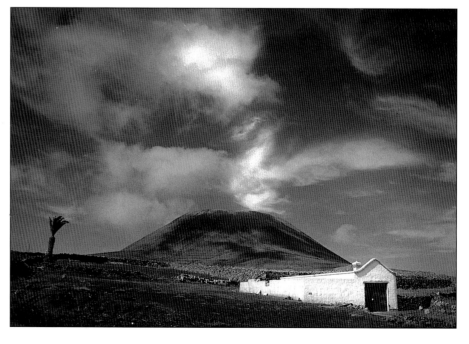

this way. They also have a distinct advantage in that they may be stain-free. Like ferri, they can also be used as a bath for prints that have been overdeveloped or overexposed. It is usually simpler to make another print at the time, but if it is not apparent until after dry down and/or if the print was exceptionally difficult to make, they can be useful.

Super-proportional reducers Predictably, reducers referred to as 'super-proportional' lighten dark tones to a greater degree than highlights. They are therefore useful for lowering contrast, just as fairly strong ferri can raise it. To reduce deep shadows without much

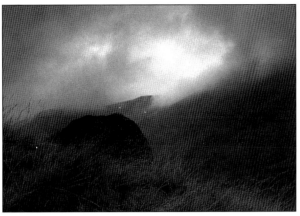

affecting highlights, try:

Ammonium persulphate	25g
Sodium chloride (salt) approx. 1% solution	25ml
Sulphuric acid 1% solution	30ml
in water to make	1000ml

Potassium permanganate — 0.25g in 1 litre of water, with 1% sulphuric acid added in sufficient quantity to give the required speed of action (assess this with a test strip) — also reduces shadows preferentially, although to a lesser degree. However, its colour may make progress difficult to follow. Reduction is halted and the colour cleared by transferring the print into a tray of fresh 1% sodium metabisulphite. The final image colour may be slightly warmer — not from staining (the whites are unaffected) but because the grain size has been reduced.

Local effects Bleaches are often used in toning and to create special effects, but many printers use them on specific areas of the print, to::
• Enhance back- or rim-lighting effects.
• Draw the eye or create impact — for example, by lightening a face in a group.
• Lighten hair strands, eyes or other subjects too difficult or small to dodge.
• Lifting local shadow detail (this must be present on the negative, of course, even if it is lost in the print).

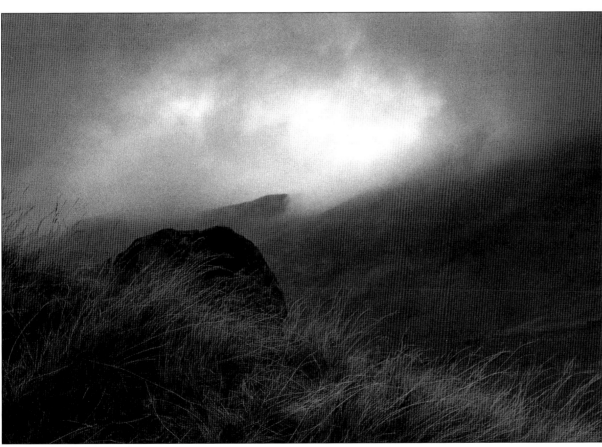

A subtractive reducer can have an apparent preference for highlights over darker tones. Here a fairly strong solution of potassium ferricyanide was washed quickly over the foreground grasses several times. This brightened them, avoiding the need to pick them out individually. Dodging, or bleaching with weak ferri would have left a grey area in the foreground.

- Lend reflection or sparkle to water.
- Create 'light paths' on water (for example, in multiple printing when an additional light source is introduced).
- Enhance, or create, sun rays.
- Strip out a light background. Other reducers are better for removing dark background clutter without leaving the yellow ghost image which may occur with ferri in these areas.
- Rescue burning-in faults — for example, 'dark halos' can be lightened, while hilltop detail and other structures, blackened by burning-in the sky, can be retrieved and lightened to the required tone.
- Enhance the impression of perspective by lightening distant objects.
- Reduce local contrast.
- Increase local contrast.

General effects Used as a print bath, bleaches can also:
- Generally 'sparkle up' a print. Some printers routinely overprint by ¼ stop and 'pull back' with Farmer's Reducer.
- Retrieve, by bathing, an overexposed print. If the print is too dark, provided you can see detail when you shine a light through it from behind, it is retrievable, with practice, with the appropriate bleach. However, in many cases it is better to reprint.
- Produce a change in image colour.

Using potassium ferricyanide Potassium ferricyanide is not as toxic as the name suggests and is therefore readily available. However, as with all chemicals, treat it with respect. Ferri is used as follows.

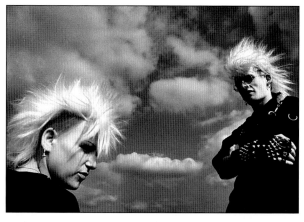

Fine, intricate detail such as strands of hair can be picked out by applying bleach with a fine brush. In this print, lightening the hair by dodging would have created an inappropriate halo.

Appropriately, ferri is sometimes called 'liquid sunshine'. 'Nature' can always be on your side in the darkroom, even if not in reality, as shown by this bleached print.

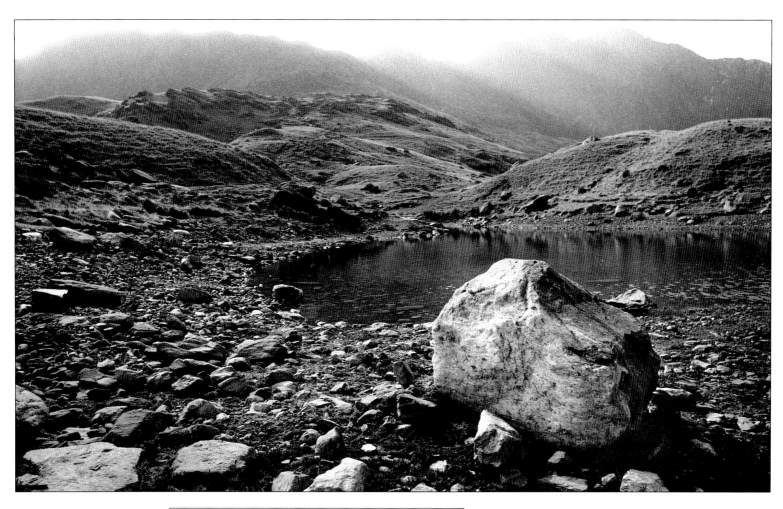

The right bleach can enhance shafts of light and at the same time give sparkle to the print, as in the picture above.

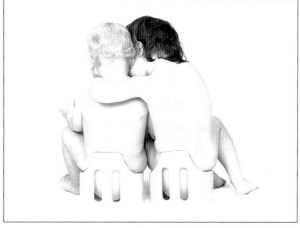

In a high-key shot like the example shown here, a bleach can be used to eliminate background shadows and unwanted detail.

Prepare a 10% stock solution by dissolving 25gm potassium ferricyanide crystals in 250ml of water, or pro rata. Store the solution in a dark bottle out of direct light as light slowly reduces it to potassium ferrocyanide. You may already have ferri in stock if you have carried out pre-development bleaching (see page 75).

Ferri can be used alone, when its effect can be reversed by immersing the print in developer, or with hypo, when it is irreversible and less likely to give a tonal shift. This fact has important practical implications, for if the print is inadequately washed and still contains hypo, the ferri's effect will be permanent whether you intended it or not.

The formula for Howard Farmer's famous reducer is:

Sodium thiosulphate (hypo) 10%	1 part
Potassium ferricyanide 1%	1 part
(use a 10-to-1 dilution of your 10% stock)	
Water	2 parts

For local use of ferri I keep an eye-dropper bottle (purchasable from your local pharmacy) containing 10% ferri stock, and put between two and six drops into 5ml of weak fixer (plain hypo is said to be better) in a small pot or eggcup. I use weak solutions on light-toned prints and for lowering local contrast, and stronger ones for dark tones or for increasing local contrast.

Bleaching with ferri is a skill acquired only by practice, and although it may seem impossible at first, suddenly the knack comes. Do not begin by experimenting on an important print. Instead, keep all your test strips for this purpose. The more you use ferri, the more you will learn about its versatility.

It helps to have a sheet of plastic or Formica on which to place your print. Work over a sink with the

When bleaching with a brush it is best to have running water to hand.

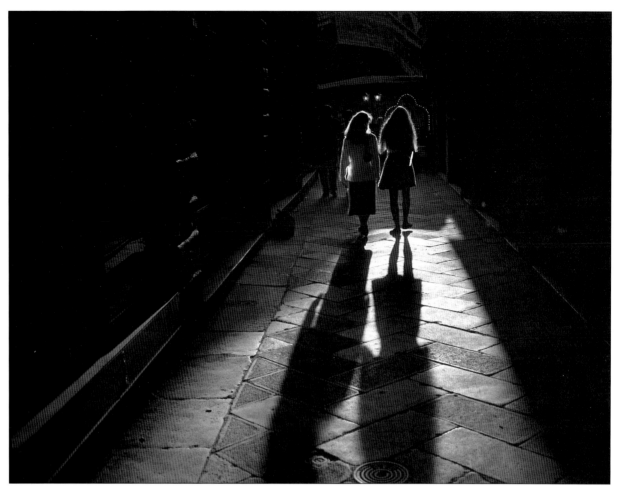

print tilted slightly away from you, and a hose playing water below the area on which you are working, as shown above. This will enable you to swiftly rinse the area free of ferri, and it will carry away any ferri running across the print, so preventing light 'trails' being left behind. These occur much more easily on light areas than dark, so work with light areas at the top, because ferri will not run uphill.

Blot or wipe the print dry, and apply ferri with a brush (labelled and used solely for this purpose) or cotton-wool buds and swabs. *Never* leave ferri in contact with the print until you see a result. Wash it off after a few seconds and apply more. After a while lightening will begin. Impatience will lead to overbleaching and yellow staining, which can be extremely difficult to remedy, although an application of fix and extensive washing may help. Sodium metabisulphite is sometimes recommended, but I have found it of little or no use. If the problem persists, you can always sepia-tone the print or bleach it out and redevelop it in a warm-toned developer, in order to disguise it. Working under a blue daylight bulb can help you to identify staining at an earlier stage.

Your solution of ferri and fixer will get paler and become inactive after 10-15 minutes, depending on its concentration and the strength and freshness of the fixer. Top it up as required.

Because using ferri is a slow, gradual process and your eye gets used to its effect, it is easy to go farther than you realize. Therefore it is wise to stop before you think you need to. You can always do a bit more at the next session, but you cannot effectively undo what you have done. You may find it helpful to keep an identical wet, untreated print alongside the one on which you are working, so that you can see immediately how far you have gone.

Some printers use ferri while the print is still in the fixer. They lift it out, dabbing or blowing 'dry' the area concerned, and apply ferri before returning it. This procedure is very useful when you have acquired the skill but may lead to prolonged fixing which might affect other highlights and will certainly make very prolonged washing necessary to remove all the fixer from fibre-based prints.

Local 'dry' reduction Thiocarbamide and iodine in alcohol makes an excellent reducer that can be used on a dry print. It is particularly useful for fine work as

Local 'dry' bleaching with thiocarbamide and alcohol is perfect for precise work such as emphasizing, or creating, rim lighting.

BLEACHING TIPS

When using any of the bleaching techniques described here, be patient, always work slowly, and remember:
• Never leave bleach in contact with a print for long.
• Strong solutions of ferri washed off swiftly will selectively brighten light tones, apparently raising local contrast. Weaker solutions used more slowly can produce apparent loss of local contrast.
• Fibre-based paper responds better than resin-coated paper.
• Never use your spotting brush to apply bleach.
• Expect everything to go wrong at first — but persevere.
• Keep old test strips to practice on.
• Never unscrew a bottle of ferri above the print. Apart from spills, tiny dried ferri particles will fall unnoticed on to the print and leave yellow or white 'holes'.
• Work with dark areas downhill, light areas uphill.
• Stop bleaching too early rather than too late.
• Use a wet, untreated print as a guide to how much you have bleached the working print.
• For *very* fine lines, dry the area as much as possible to reduce 'creep' - or use thiocarbamide and alcohol.
• You can work on a print straight out of the fixer, or a dried print, after re-soaking.
• Ferri continues working after being washed off, so it is easy to overbleach.
• Wash the print thoroughly after bleaching. Use hypo eliminator on fibre-based prints that are to be subsequently toned.

This is a dark, low-key print reduced to finality with ferri. As long as there was no fixer present in the bleach — or the paper — the print can be restored by reimmersion in developer or certain toners.

the bleach does not 'creep' in the same way that it would on a wet print, and therefore allows finer work. If used with care, it also allows greater reduction, from dark tones down to white without staining, as seen in the picture on the opposite page.

I find that thiocarbamide is sometimes better than ferri for fine work, but not if it is used as a wash on large areas, when it tends to produce blotchiness. The three solutions required are:

Sol A	
Iodine	2.3g
Methyl alcohol	50ml
Sol B	
Thiocarbamide	4.6g
in warm water to	50ml
Sol C	
Methyl alcohol.	

The technique is quite different from that used with potassium ferricyanide. Mix small equal quantities of solutions A and B immediately before use, and work with a brush on a dry print in daylight. After applying the solution, swab it off with methyl alcohol, Sol C (methanol). It is wise to wear a latex or rubber glove on your swabbing hand since prolonged contact with methyl alcohol dries your fingers out considerably. Because alcohol rather than water is used, it quickly evaporates, leaving a relatively dry surface to work on, consequently producing more controlled results.

Whereas ferri in fixer quickly needs topping up, if you use a small quantity of thiocarbamide solution it can get stronger as the alcohol evaporates. Therefore take care if you interrupt your task and return later, for it may work too quickly or produce a stain — either way spoiling the print. Thiocarbamide is much better suited for use with fibre-based paper, when it can be better controlled.

After thiocarbamide-iodine bleaching, it is important to put the print straight into fresh fixer *without* first rinsing it in water, which induces silver-sulphide staining. For this reason the process is not suitable for use on mounted prints.

If these instructions are followed, reduction can be taken right down to the paper's base without staining. However, staining will occur if the solution is used too strong, if it is not fixed as described, or if it is used after other bleaches on fibre-based paper without an hour's thorough washing in between. Unlike ferri staining, this may be a strong yellow, brown or orange.

Another useful stain-free bleach can be made up from iodine, potassium iodide, and sodium thiosulphate, as follows:

Sol 1	
Potassium iodide	15g
Iodine	5g (stock)
Water	100ml

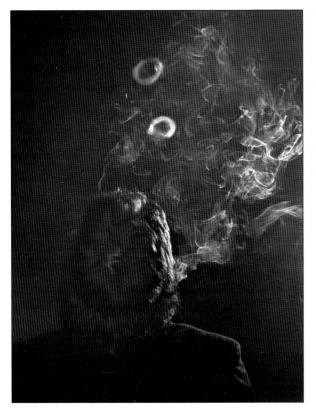

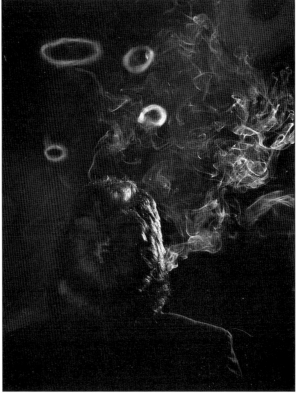

In this print the properties of three different bleaches were exploited. Potassium dichromate was used to subtly intensify and 'cool' the image. Ferri was used to enhance the existing highlights. Finally, because of its ability to reduce blacks to white without staining, iodine with potassium iodide was used to add more smoke rings. Thorough washing was necessary between bleaches.

Sol 2

Sodium thiosulphate 200g

in water to 1 litre

Dilute sol 1 in the proportions:1 part + 5 parts water. Use the solution as described for potassium ferricyanide and then fix it in sol 2. Wash the print thoroughly.

Note that the term 'stain-free' applies to the effect of the working-strength solution on the print. It does *not* apply to the effect of iodine on fingers, clothes, work-tops and just about everything it touches except glass. Take care therefore when making up solutions containing iodine. Stains may be removed with methyl alcohol.

Print baths Immersing the whole print in a bath of one of the bleaches, as well as lightening it, can raise or lower contrast, depending on the bleach used. Some printers deliberately slightly overprint and then pass the print through a bleach bath (often of Farmer's Reducer) to brighten the highlights. However, it is very easy to destroy highlights in this way and the temptation to watch until the desired effect is seen must be resisted, since the bleaching action continues for a short while after the print is pulled from the bleach.

The American photographer Ralph Steiner is said to have used an *alkaline* version of Farmer's Reducer with added sodium hydroxide, to enhance the delicate highlights in his cloud formations, after printing slightly dark and slightly low in contrast. In the final prints the clouds were brighter and showed higher contrast than

the rest of the image, but without loss of detail. This made them more striking than they would have appeared in a print of overall high contrast. The formula is:

Sol A

Sodium thiosulphate crystals 32oz

Water 16 US fl.oz

Sol B

Sodium hydroxide 1oz

Water 10 US fl. oz
Sol C
Potassium ferricyanide 3oz
Water 10 US fl. oz
(NB: Handle sodium hydroxide (caustic soda) with gloves since it can cause burns.)
Working solution: A 10oz + B 0.75oz, then add C 0.25oz.

Agitate the working solution vigorously. When the yellow fades, add a further 0.25oz C if required, and reimmerse the print. Do not use weaker solutions to slow the process down, since this can give flat results. Instead, Steiner is said to have recommended adding 'cane sugar' to the solution A + B, before adding C. When the treatment is complete, pass the print into a stop bath.

As with the thiocarbamide solution, fibre-based prints that have been in a hypo-based bath of this kind for long periods need prolonged washing, and a hypo clearing agent is advisable for archivalling or if subsequent toning is envisaged.

If a print is immersed in ferri alone until 'finality', a rather insipid light-brown image results, as seen in the photograph on page 113. However, provided the ferri was not mixed with fixer and none was left on the print after washing, this stage need not be the end point, for if the print is placed back in developer the image will reappear. This procedure allows redevelopment under different conditions — and in daylight — to modify the image, as it can now be recaptured in higher or lower contrast, or warmer or colder tones, depending on the developer used.

Warm-tone effect Very weak ferri, without fixer, can be used to create a warm-toned print or even a result resembling a lith print. For the photograph below, a 0.05% ferri solution was produced by putting 5ml of my 10% stock into 1 litre of water. The print has taken on a pleasantly warm tone after 30 minutes, with continuous agitation. Note that if you bleach a print slowly in plain ferri to warm the tones, you must wash it long and well *before* putting in the fix, otherwise the highlights may disappear.

Do not be put off by all this chemistry — you don't have to *know* any of it. Just mix and use the chemicals according to the instructions, and start experimenting.

The image tone can be altered by very slow bleaching in a very dilute bleach bath. The properties of ferri appear to change when it is used in this way. Highlights are usually fairly well preserved but if necessary can be protected by flashing the paper before exposure. To protect the highlights from unwanted bleaching, be sure to wash all the ferri out before fixing the print.

TONING

Many photographers routinely tone all their prints, but not always for all the same reasons. Toning can be used to make the image archivally more permanent or to add effects ranging from the subtlest of finishing touches to a 'between the eyes' impact.

The range of toners available can appear bewilderingly large to the newcomer, but the following checklist should help to clarify their uses:

• Just as different papers have cream, ivory or coloured base tints, so some toners dye the emulsion gel on which the image is formed. Tetenal Gelatine toner is one example.

• Some toners change the colour of the silver image on the paper. The effect can be dramatic or subtle, natural or bizarre, and in one or more colours. These toners may also increase or reduce contrast or density, and so you should adjust the printing accordingly for best results.

• Some toners increase the archival permanence of the prints, while others make the image less stable.

• Toners can be single-bath, two-bath — in which case the first is usually a bleach — or multi-bath — for example, Tetenal multi-toner and Colorvir. Combination toning is a mixture of any of these techniques, and the permutations are virtually endless.

Silver halide (silver bromide and chlorobromide) prints deteriorate over time, particularly if they have been poorly fixed or washed. In addition, they are slowly attacked by the chemicals in mounting boards, boxes, files, glues and the air. Archival toners — sepia, selenium and gold — render prints more resistant to these problems, with or without significant colour change.

SEPIA TONING

The toning process most often used by amateur printers is sepia toning because it produces a definite and easily recognizable colour change to brown. It is widely available, simple to carry out and inexpensive compared with the use selenium or gold. It is also an archival process, so that the silver-sulphide prints you produce by sepia toning will probably be around for your great-grandchildren to admire.

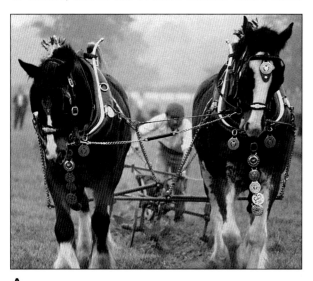

A

A The untoned print can be the beginning or the end of the creative process. A series of identical prints containing a full range of tones was made (figs B-K), allowing direct comparison of different thiocarbamide sepia toning techniques.

B

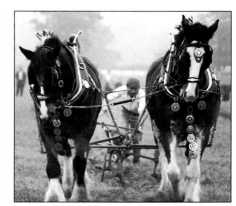

C

G

H

B, G Prints can be fully bleached before toning (fig B) or partially bleached, leaving the shadow tones unaffected (fig G).

C, H These prints derive from B and G respectively, and were toned in a light-brown thiocarbamide sepia toner. In fig H the shadows are unaffected.

Sepia toning has an undeserved reputation for being always the same and thus rather boring. In fact, it is both very flexible and controllable. Below are a few examples of the many effects possible with sepia toning, using a series of identical prints for direct comparison.

Uses Although it is an archival process, since it always colours the print, sepia toning is usually carried out for aesthetic reasons. Its unmistakable brown tones are reminiscent of old photographs and are often used to convey a feeling of nostalgia. Any photograph can be sepia-toned, but those with a hint of yesteryear are particularly suitable. While some pictures definitely call for a cold, black look, others benefit from being 'warmed up' by sepia toning, either to enhance their atmosphere or, for example, to produce more agreeable skin tones. A print can be given warm tones by selecting the appropriate paper and processing it with warm-toned chemicals. However, sepia toning allows you to make a cold-toned version and then convert it to a variety of warm-toned options to see which you prefer.

Prints destined for hand-colouring are often best sepia-toned beforehand, or at least partially or split-toned. A cold-toned black-and-white print may jar with the colours that are added, whereas the warm browns of a sepia print will blend with them more comfortably. Other toning processes are used for the same reason,

either alone or in combination with sepia.

The term 'sepia' is generally used to include sepia-sulphide and thiocarbamide toners. These may require single-bath or two-bath processes involving a first stage of bleaching with ferricyanide, followed by a toning bath which brings the image back in brown and white. Resin-coated papers need only a brief wash of 1-2 minutes after bleaching, whereas fibre-based prints should be washed for 20-30 minutes. Experimentation is therefore easier with resin-coated paper.

Sepia-sulphide toners Sulphide-based sepia toners are used less often nowadays, because they have two distinct disadvantages. First, they produce a foul smell of rotten eggs. Secondly, the hydrogen-sulphide gas responsible for this smell has a powerful fogging action on unprocessed photographic materials and can age overnight paper stored in your darkroom paper safe . To those unaware of it, this can prove to be a very expensive drawback. Hydrogen sulphide may also accelerate the fading and ageing process of any *finished* prints, especially if they have been poorly fixed or washed and are not already archivally toned.

Thiocarbamide and variable sepia toners Most sepia toners now are thiocarbamide-based. This is not smelly, does not cause fogging and is flexible in that it

D The fully bleached print was toned in a mid-brown toner to give a slightly darker tone than in fig C.

E, I These derive from figs B and G respectively and show the effect of adding more sodium hydroxide to the toner to give a richer, darker brown.

D

E

F

J This shows a reverse split tone, achieved by partially redeveloping the fully bleached print (fig B) before toning. Varying this process can produce light brown on blue-grey tones.

I

J

K

F You need not tone the whole print. Toning selected areas on a monochrome print can be very effective and is easy to do.

K Here three-band toning was used and taken far in the second bleach, to give a wide range of bleached midtones.

can be adapted to produce variable-sepia toners. These are widely marketed and usually are thiocarbamide toners with an extra alkaline additive which serves as an activator. This allows a choice, according to how much is added, of end tones ranging from pale yellowish browns to rich reddish browns, as shown in the series on the previous pages. Variable sepia toners are easy and cheap to make up, and the ingredients are worth buying, as they have further uses in the darkroom. Experiment with the following:

Stock solution 1
Thiocarbamide 200g to 1 litre water
Stock solution 2
Sodium hydroxide(NaOH) 100g to 1 litre water
Stock solution 3 (bleach)
Potassium ferricyanide 100g to 1 litre water.
NB: Sodium hydroxide is caustic. Use gloves or a spatula, and add it slowly since it can splatter.
To vary the print colour, adjust the toner solution as follows:

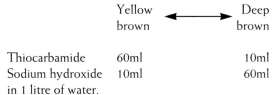

	Yellow brown	Deep brown
Thiocarbamide	60ml	10ml
Sodium hydroxide	10ml	60ml

in 1 litre of water.

For the bleach solution use your stock 10% potassium ferricyanide thus: 50ml into 1 litre water. (Unlike Farmer's Reducer, this solution *must* be used without fixer, because the image is intended to be recoverable after bleaching.)

Potassium bromide may be added to the potassium ferricyanide, either at 100g per litre to the stock or, if you wish to keep your 10% ferri solution unchanged, to your working solution. Use about1g per litre — the amount is not critical.

Variations on sepia toning Use of the bleach described above gives a range of possible tones, but it is by no means the only available option. Rather than considering sepia toning as simply an end point, it is more fruitful to view it as part of a development/redevelopment cycle which is infinitely variable.

A developed and fixed print gives a (relatively) permanent image. As we have seen, it can be bleached away by potassium ferricyanide and other bleaches. Provided no fixer is used, this image can be brought back simply by putting it back in developer. It can also be reclaimed in brown by putting it in sepia toner (and in a variety of other toners). This cycle of rebleaching and reclamation can be repeated with various permutations and materials.

These processes show that considerable control and experimentation are possible. For example, after it has been fully bleached and washed, the print may be put in a diluted toning bath. This will tone, slowly and evenly, allowing the print to be 'pulled' before toning is complete but without producing a patchy result. The print can now be washed and the rest of the reclamation achieved in developer. This produces a different colour with a mixture of sepia and black-and-white tones which varies according to the time the print spends in each solution.

Alternatively, after complete bleaching and washing, the print can be placed in developer diluted 1 + 10 or 15 with water until it is partially redeveloped (in black and white) and then transferred after washing to the toner. This can produce a 'reversed split-tone' effect with brown shadows and blue-grey highlights, as seen in fig J. The results vary according to the times and concentrations used. If the print looks too 'black-and-white' at this stage, wash and replace it in bleach and it will brown quickly. It can then be finished in toner, or given a briefer development before the toner.

The only reason for washing between these steps is to keep the toner free of developer for subsequent prints so that you can achieve reproducible results. However, you can also add quantities of dilute developer to the toner to get a darker result than sepia toner alone will give.

All these techniques produce a mixture of black and brown tones, and the browns can range from yellow to rust, depending on the make-up of the toner. To take the process even further, several rebleaching/redeveloping cycles can be used to involve different developers, different bleaches and different toners.

Note: Once the print is *fully* bleached and *fully* sepia-toned, it is fairly resistant to potassium ferricyanide, since sepia toning is archivally stable. I have found that stronger bleaches such as potassium dichromate will still attack it and this provides another way of getting a reverse split-tone print if the partially rebleached print is brought back in developer. However, the results are less easy to predict with accuracy.

Split toning Further variation can be achieved by split toning. This involves toning one end of the tonal range only. Potassium ferricyanide attacks the highlights preferentially. If the bleach bath is now diluted to slow this effect, the print can be pulled a third or halfway through bleaching, leaving either the dark or the mid and dark tones almost unaffected, as in fig G. Toning such a print will produce brown highlights and black shadows. Midtones will vary according to the degree of bleaching permitted.

This technique can also be used to give the most subtle touch of warmth to a print by a very brief bleaching stage, terminated before visible bleaching has occurred. The subsequent toning bath adds just a hint of warmth to the highlights.

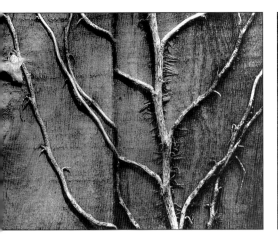
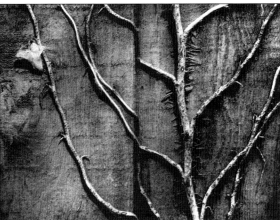
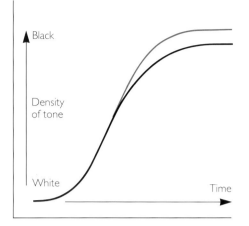

The pair of prints above compare the effect of selenium 1 + 20 toner, which produced no colour shift on Ilford Multigrade, with selenium 1 + 6 after chromium intensification. The second method allowed split toning, which affected only the darker tones.

Dilute selenium can produce a true, measurable increase in D-max, as shown in the exposure curve at the top of the page. The selenium curve is shown in red and the untoned curve in black.

Dual and three-band toning Split toning is useful not only because of the pleasing appearance it gives, but because it allows two further effects: dual toning and three-band toning.

Because sepia toning is an archival process, the tones converted to silver sulphide are very stable and unless bleached are impervious to other toners. Split toning therefore allows the light tones to be sepia-toned while leaving the remaining tones available to be selectively toned in a second, different or similar, colour — for example, blue, copper or selenium — in the technique of dual toning.

In three-band toning the print is first split-toned using a short bleach stage, in order to tone the highlights only. It is then subjected to a second dilute bleach bath for the midtones. The already toned highlights are unaffected, and the print is removed before the bleach attacks the shadow tones. It is fixed at this point without the use of further toning. This leaves a pale bleached tonal band between the black shadow tones and sepia highlights, which enhances the split-tone effect. The width of this band is controlled by the time and dilution of the second bleach, as well as by the degree of the first bleach, which determines the amounts of black and sepia there are to start with. As with simple split toning, darker tones are available for another colour tone if desired.

Three-band toning can be refined to give some very subtle results. Instead of fixing after the second bleach, transfer the print back to a sepia bath of a different colour from the first — that is, containing more or less sodium hydroxide. This will give highlights in light tan, midtones in red/brown and shadows in (near) black — or alternatively, and more strikingly, highlights in dark brown, midtones in tan and shadows in black or, if you prefer, blue.

A general point to bear in mind is that although the results it produces are very flexible, sepia toning may marginally increase contrast and reduce density, depending on the formulation of the chemicals used.

Therefore the print may need to be made a little darker and flatter than the result required in the final print, or flashed, in order to retain highlight detail after toning.

SELENIUM TONING

Although selenium is probably the most widely used archival toner, its use is often misunderstood. Selenium toner is now widely available from many manufacturers. The instructions which follow are based on Kodak Rapid selenium toner, which contains approximately 2% sodium selenite. Other makes vary in strength.

Selenium toner may seem expensive, but it has a high capacity, is diluted in use, and keeps for years. The results it produces vary widely, according to the paper, development and concentration, and so it is suitable for both archival and aesthetic purposes. I keep three strengths permanently made up: 1 part + 5 parts water, 1 + 10 and 1 + 20. As the solution gets used, toning times become longer. When they are unacceptably long, it should be discarded rather than replenished.

An important word of warning: selenium is toxic if inhaled, swallowed, or absorbed through the skin. Good ventilation and gloves are essential, especially at stronger concentrations. Kodak recommends solutions down to 1 + 3, and I have used 1 + 1 or 1 + 2. However, these concentrations are rarely necessary and the fumes are extremely noxious at such strengths.

Bromide papers I routinely use Kodak Rapid selenium toner 1 part + 20 parts water for D-max enhancement — that is, enrichment of blacks. Although the wet bromide print shows little or no change at this dilution, the dry print will be subtly improved. D-max is measurably increased (see diagram above), the blacks look richer and juicier, luminosity appears enhanced and contrast is marginally raised. Good print quality appears even better, approaching the elusive quality of the wet print.

The print may be safely left in the toner for 10-15 minutes. It will be archivally improved and this will

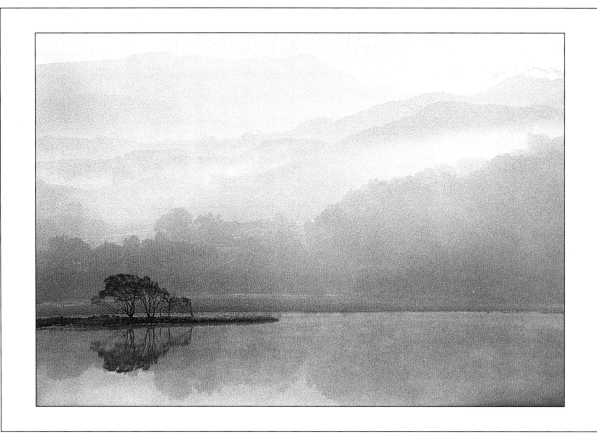

This is another version of the print seen on pages 28-9. Here it is printed in a lower key and split-toned with sepia in the highlights and selenium in the shadows, to produce an attractive duotone.

show, for the image will now be impervious to other toners if it has been fully selenium toned.

If the toner is used at a greater strength, say 1 + 5, it may impart a subtle, colder purplish-blue-black tone to a bromide print. Pure bromide papers are few and far between, however. Most are 'bromochloride' and may exhibit an initial cooling off, followed by a warming of tone, depending on the nature of the processing used. Resin-coated papers may prove less responsive than fibre-based papers.

Chlorobromide papers A quite different reaction is seen with chlorobromide papers. These warm-toned papers initially cool off slightly, neutralizing the olive tinge that some have. They may then develop a characteristic plummy blue-brown, or eventually even a rich tan, depending on the paper and the chemistry used to process it, as well as the strength of the toner and the time involved.

Experimentation is worth while, and I recommend you keep and use all your test strips as 'pilots'. Make sure you time them all, for you can afford to overshoot the effect you want with test strips to see what happens next, but note down the times as changes proceed. You can then 'pull' the main print at the right point, and swiftly transfer it under a running hose.

The test strips should be fully fixed and washed

before toning. If you are using very dilute toner, to slightly modify the colour of a chlorobromide print, progress will be insidious and gradual, and may initially go unnoticed. It helps to have a wet, untoned print alongside for comparison.

Lith prints Selenium toner produces a very positive response with lith prints. These may also benefit from the gentlest modification, which could easily be missed without a reference print. They are also generally easy to split-tone. Kentmere Kentona deserves special mention as a paper with a spectacular response to both selenium and gold toners when processed in dilute lith developer. Prints made on this paper pass through a sequence of colours and can be 'pulled' at any point or cross-toned with another toner. Examples are shown in the series on pages 122-3.

SPLIT TONING
Because areas toned with selenium are archivally stable, they are highly resistant to chemical reactions, not only from the environment but also from other toners and bleaches.

Selenium affects the deepest tones of a print first. If the print is pulled at this point, a 'split tone' is produced. On a bromide print the lower tones do not change colour but are 'stabilized', leaving the higher

tones available for colour change with another toner. In a chlorobromide print the lower tones ultimately become a warm brown and the higher tones may stay colder grey. The secret here is to use the toner strong enough to give a rich tone, but not so fast that it cannot be pulled in time. Try dilutions of about 1 + 9.

Bleaches and selenium Not all papers 'split' well, but I have found ways to persuade some reluctant ones to cooperate. For example, Ilford Multigrade fibre-based paper does not normally split easily in selenium. I routinely selenium-tone all my Multigrade prints in 1 + 20 to enhance their luscious cool blacks. Some warming can be obtained with stronger solutions, but I have found that it can be impressively split-toned if it is first bleached in potassium dichromate 5% and hydrochloric acid 10%. I redevelop the print in Ilford FF and then tone it in selenium 1 + 5 to 1 + 10, depending on the toner's freshness. Typical results can be seen on pages 35 and 119.

The colour — and therefore the contrast between the browns and greys — is affected by concentration. A word of warning is needed here. If you need to 'ferri' or bleach local areas, do this first, thoroughly fixing and

washing before bleaching with potassium dichromate. If you use ferri afterwards you may induce striking changes in local tone. You may, of course, choose to exploit this phenomenon for artistic affect.

Alternatively, Ilford Multigrade can be modified to a cooler tone by bleaching out with ferri and redeveloping in metol, and then selenium-toning. Even colder images, with a rich blue-black or purple-black hue, can be achieved in selenium by using a cupric sulphate, sulphuric acid and sodium chloride bleach (see page 150). After thorough washing, redevelop the print in metol 10g, sodium sulphite anhydrous 33g and sodium carbonate anhydrous 33g — all to 1 litre with water. Wash the print thoroughly and tone it in strong (1 + 3) selenium. This works better if the solution is hot and the print is soaked in hot water before it is transferred into the selenium. Again watch closely with a wet reference print alongside and be ready to pull the print before it starts to go brown. Extremely good ventilation is essential when you are using concentrated hot selenium.

Selenium-sulphide toning Quite different from the processes we have just looked at, selenium-sulphide toning involves a bleach stage (solution A), then a wash

Selenium sulphide toner is a two-bath toner which gives rich brown tones with all papers. The depth of colour is affected by the nature of the paper and the concentration of the toner.

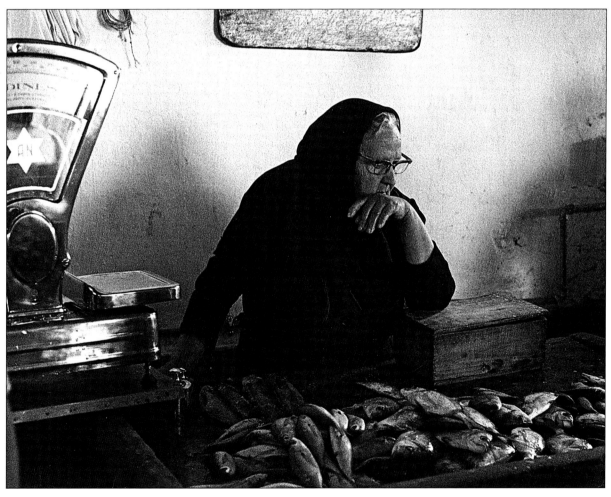

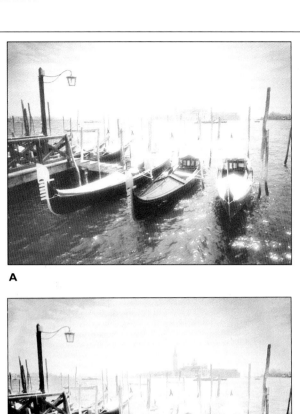

A

B

C

D

E

F

A-F Kentmere Kentona in lith undergoes spectacular colour changes in selenium. Compare fig A, the untoned print, with figs B-D, pulled from the toner at progressively longer times. Dark tones change colour first, then midtones, by which time the dark tones have changed again. Light tones follow the same sequence, but much more slowly. By pulling the prints at different times, a variety of multicolour multi-split toning results can be produced. Figs E and F show the effects of gold toner on Kentona in lith after 30 sec and 20 min. Further variations are possible by using selenium and gold in sequence.

PREVISUALIZATION

The combination of infrared film, lith development of Kentmere Kentona chlorobromide paper, and selenium toning produced the soft, surreal colours of this dreamlike picture. 2004 footnote: Kentona is now made in cadmium-free form, with different toning properties.

Knowing which techniques to use to produce the image you have in mind is as important in printing as in picture taking. Ideally previsualization should span both stages, and provide continuity between them. I felt a dreamlike treatment would enhance the scene in the series of photographs on these pages. I combined infrared film, a printing technique and materials, and a toning process that would produce a picture characterized by both hard and soft tones, and surreal colours and flare. To achieve a wide range of colours on the single print shown here, I used selenium toning after lith development of Kentmere Kentona paper — an unusually versatile combination of toner and paper. The printing was calculated to complement the linear perspective produced by the choice of

viewpoint and wide-angle lens. It conveyed aerial perspective by emphasizing light, airy tones in the central distance and dark corners. Infectious development caused the light tones in the top right corner and right side to emerge very slowly. Burning-in of 4 stops was therefore needed to darken these areas so that in the final toning bath their colours would match the rapidly changing colours on the left. The 'snatch point' — when the print was pulled from the developer — was when the small craft passing in front of the distant church of San Giorgio Maggiore suddenly darkened and separated from it. The rapidly progressing dark foreground tones therefore had to be controlled during exposure, to 'complete' at the same time.

and finally redevelopment in a thick brown toner (solution B). It works with all papers and gives a much deeper, richer brown than sepia toning, as seen in the photograph on page 121. For this reason, I find it particularly suitable for low-key prints. The colour deepens to a purplish brown if treated longer and at higher concentrations. I do not know of a manufacturer, but selenium-sulphide toner is easily made as follows:

Sol A	
Potassium ferricyanide	50g
Potassium bromide	50g
in water to	1 litre
Sol B (stock)	
*Sodium sulphide (pure)	250g
Selenium powder	5.7g
in water to	1 litre

* Dissolve sodium sulphide first. Heat to 40° C (104° F). Stir in selenium.

NB: Selenium is toxic. Use gloves and ensure that there is good ventilation.

To tone with selenium sulphide, dilute some solution B, 1 + 19 with water (solution C). Bleach the print in solution A, then wash until it is clean and the yellow stain is gone. Tone the print in solution C and then wash. Discard working solution C after the session, but keep stock solutions A and B, which store well in dark containers. This toner is useful for producing rich selenium-type browns in 'cold' papers that do not go brown in selenium monobath toners. It is worth while experimenting with Solution C in a variety of concentrations.

Washing Prints on fibre-based paper must be thoroughly washed for 45-60 minutes after fixing and *before* toning. Kodak recommends mixing selenium toner with hypo clearing agent to shorten the process, but in this way the toning effect is reduced and, of course, both solutions must be discarded when either is exhausted. In addition, there is less opportunity to control the concentration, so I prefer to keep them separate. After toning, do not fix but wash partially toned prints for at least 30 minutes and fully toned prints for one hour.

GOLD TONING
Very expensive and with a very much lower capacity than selenium, gold toner is highly protective and is

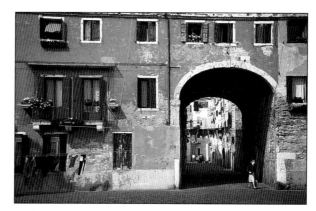

This pair of prints was made on a warm chlorobromide paper — Agfa Record Rapid. In the smaller print, gold toner produced a 'cooling off' effect, with a hint of blue. In this case the print was not toned to completion. The larger print was bathed in selenium 1 + 5 to give extra warmth to the image.

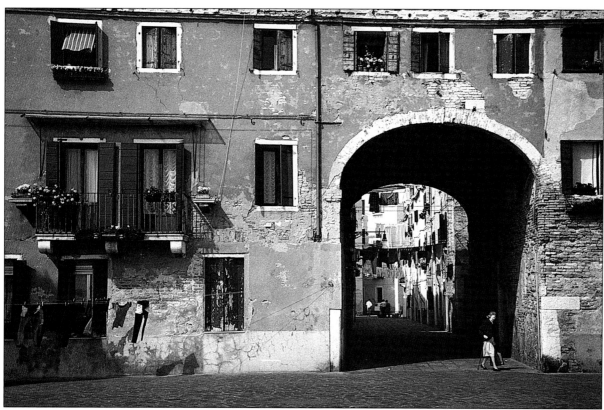

particularly useful for archivalling. This it can do without significant colour shift when used briefly or in a dilute form. Whereas selenium reacts with silver to produce the more stable silver selenide, gold acts by coating the silver with gold, which is chemically non-reactive. Gold can also be used artistically for a variety of colour effects.

Bromide papers When they are gold-toned, bromide prints exhibit a subtle cooling down to a slight blue-grey. This imparts a definite 'cold' feeling, which is particularly suitable for bleak landscapes and snowscapes. It is especially pleasing in pictures with a limited range of (light) tones. This characteristic coldness is most noticeable when compared with untoned prints.

Chlorobromide papers Prints made on chlorobromide paper react much more positively to gold toning, to produce a blue tone. The warmer the original print tone, the bluer the result. Therefore consider using warm-working developers here, or overexposing and underdeveloping the prints.

Lith prints Gold toning can give a wonderful gentle clear blue to lith prints. The result is quite unlike the blue produced by a blue toner, which is coarse in comparison. This effect can be enhanced by washing the print in hot water before toning. Progress may be slow.

Here are seen the different effects gold toner has on bleached and unbleached areas of a chlorobromide paper (Oriental Seagull). A drop of sepia bleach was placed on the lamp before toning. The hues obtained in response to gold toning can be modified by the original development. In particular, developing for warm tones strengthens blues.

Bleached prints A print that has been bleached and sepia-toned responds quite differently to gold, giving anything from a pinky-yellow to red, depending on which bleach, toner and paper are used. Split toning with sepia allows only the highlights to be affected. If the bleach stage is very dilute, this effect is more controllable and can be quite delicate. A warm-toned paper will produce an attractive duotone, as the unbleached lower tones gradually turn blue. Gold toner may work much more slowly than you are accustomed to with other toners, especially if it is not completely fresh. So have patience and be prepared to leave the print in the toner for 20-30 minutes if necessary. Examples of bleached and sepia-toned prints are seen above and on page 125.

Other toners Archivalling is by no means the only use of toners. Other toners exist which may be used alone, or in combination with each other and/or those above, to produce an almost endless variety of effects. Again consider this a starting point for your own experimentation. The following should give you a good foundation to build upon. It helps to number all your prints on the back with a waterproof marker, and keep detailed notes of the:
• Toners and their brands (which vary)
• Dilutions
• Sequence
• Times in each solution — this can be very important
• Paper type and its processing.
Two of the simplest and yet most effective of these toners are iron blue and copper red. Neither is archival, and in fact prints toned in them become less permanent.

They produce, respectively, an iron or copper ferricyanide derivative.

BLUE TONING
Iron blue toners are available from most manufacturers, although the formulae and the resulting hues vary from brilliant to sombre. Whatever the brand, the resulting blue can be greatly modified in the processing.

All papers can be blue-toned, but warm-toned papers may give murky results. A variable increase in both density and contrast occurs, so initial prints should be cool-toned, low-contrast and on the light side, like the example on the opposite page.

Controlling the colour The strength of blue produced decreases as more prints are passed through the toner. If you like the more faded blue, pass some test strips or reject prints through at the beginning of a session and/or dilute the toner. If you prefer the blue produced by fresh toner, use small quantities as a one-shot treatment for consistent results.

The colour may be intensified by using hot water, in which case it helps to pre-soak the print in hot water before toning. If the blue-toned print is returned to the developer, it will revert to black and white. This can be useful for three reasons:
1 If you do not like the result in blue you can get rid of it.
2 If you want the blue stronger and more vivid you can achieve this by returning the print to the developer, washing it thoroughly and then retoning in blue. This cycle can be repeated for even stronger effects. The density is likely to build up, and the highlights become

A-F In the series of photographs on the opposite page, fig A is an untoned print which was printed lighter and with lower contrast in readiness for blue toning. Fig B shows the effect of partially exhausted blue toner, which gave a softer, faded look. Shorter toning times give more subtle results. Fig C shows the effect of standard-strength fresh blue toner taken to completion. Fig D is a fully toned print bathed in very dilute (1 + 30) developer to give a colder blue. Longer bathing gives blue and grey. In fig E the colour was modified by a post-toning bath of weak (0.0005%) sodium hydroxide. The colour varies from navy blue to purple, depending on the time, dilution and original toner formulation. A stronger sodium hydroxide solution (0.01%) was used on fig F to take it right back to grey. On retoning, the highlights toned selectively.

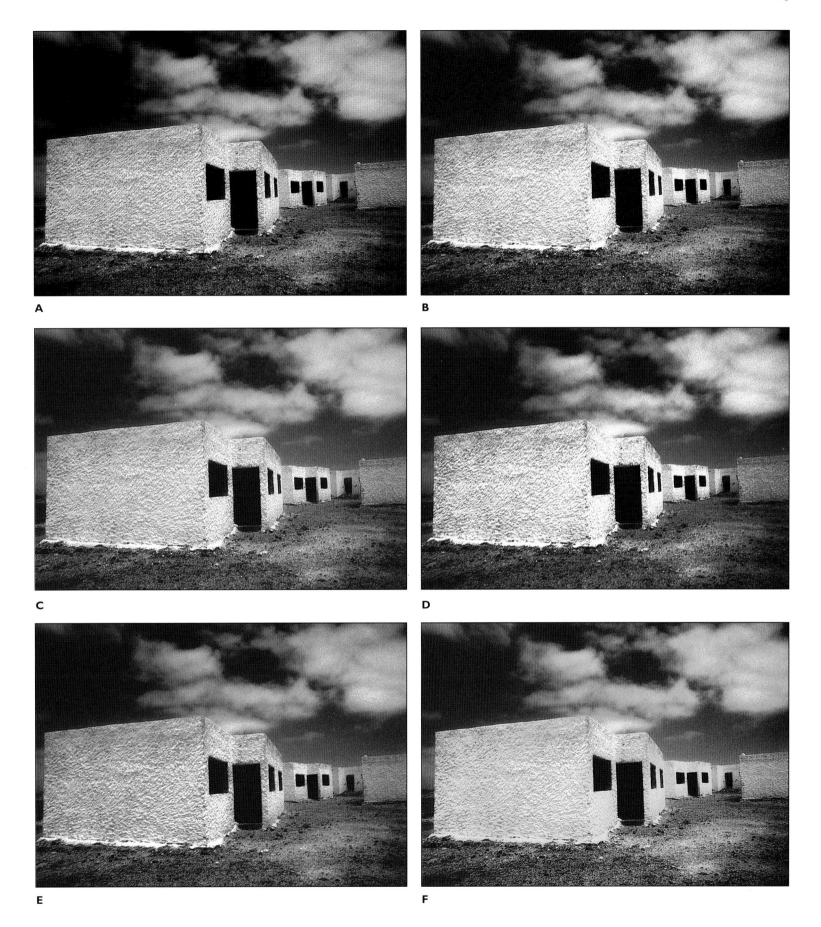

A

B

C

D

E

F

progressively paler.

3 If, on the other hand, you feel the blue is too strong you can return the print briefly to very diluted developer, which will weaken the blue and may add a partial grey, depending on the dilution and time. This can give more subtle effects which can be very pleasing.

Small quantities of very dilute developer (for example, 1 + 50) can be added to the toner for a more subdued colour. The blue tone can also be weakened by extended washing, which reduces it without replacing it with grey.

The borders and highlights often have a yellow cast after blue toning. This usually disappears with washing, but eventually so does some of the blue, so time your washing carefully. Alternatively, soak the print in a solution of salt, or briefly in very dilute fixer (1 + 50), both of which will clear the highlights.

If you have a problem clearing borders of a blue tint, carefully clean them with very dilute developer on cotton wool. Dab the print touch-dry first and take care to prevent developer running across the print, since it will remove the blue there too. Work slowly, with running water to hand, repeating the process several times if necessary. Stronger developer may work faster, but it is more prone to 'creep' onto the picture area when the print is wet.

After completing your blue-toned print it is all too easy to ruin it at the drying stage. Avoid heat drying at all costs. Either hang the print up to dry or gently wipe it with soft tissues and then allow it to dry flat.

COPPER TONING

Although it works in a similar fashion to blue, copper toner gives attractive pink or red tones instead. Another

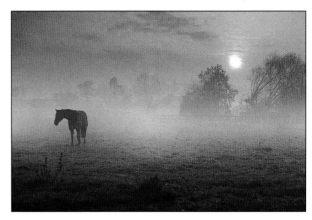

The untoned print, bottom left, was made on variable-contrast paper, using split filtration. Half the exposure was on grade 0 and half on grade 5. This produced cleaner midtones and more depth in the blacks than a grade 2½ print and, importantly, enough grey in the mist to withstand the lightening effect of copper toning. The first print on the right was lifted from the copper toner after only 2 min, for a subtle effect. Leaving the second print in the toner for 10 min gave the maximum colour achievable in one toning. After the same time in the toner, the third print was taken back to grey in the developer and after thorough washing was retoned in copper. The result is a brighter colour and lighter highlights. In the fourth print this cycle was extended, with thorough washing between each stage, to: copper — developer — bleach — copper.

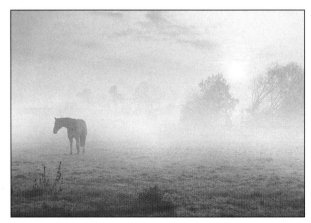

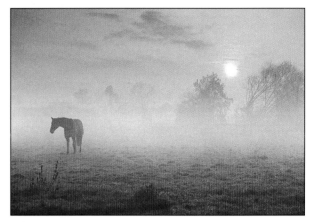

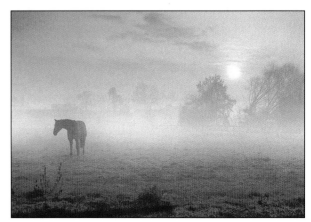

Sepia and copper-toning techniques were combined in the print below. A weak sepia bleach was followed by thiocarbamide, to tone just the highlights, and then the toning sequence: copper — developer — copper — bleach — copper. The resulting colour is surprisingly different from the last print on the previous page, given the limited amount of sepia toning used in the print below. Chemical solarization is common after repeated toning — development — bleaching cycles.

difference is that, unlike blue toner, it produces very pleasing results on warm-toned as well as colder papers.

Copper toner tends to lighten not only the highlights but the whole print. Therefore the ideal starting print differs from that for a blue toner in being of lowish contrast and slightly dark. The colour from copper toner can be varied in a similar way to blue toner. The longer the print is toned, the richer the colour. The effect can be further increased by returning the print to developer and then retoning it in copper after thoroughly washing. This procedure may also enrich the blacks. A little weak developer can be added to the toner to modify the colour if required.

A rich colour can be obtained by sequencing as follows: copper, developer, copper, bleach (brief). If necessary, copper-tone the print again or pass it into blue diluted 1 + 4, which gives a browner result with less red and a hint of blue.

The surface texture of the print often changes and if it is thoroughly copper-toned the darker tones can take on a velvety appearance. The silver ferrocyanide molecule is large — of considerably greater volume than the silver in the untoned paper. This expansion causes it to push up through the emulsion surface, and is particularly noticeable in dark areas and on resin-coated paper.

Pre-colour toning Although the colours of fully toned prints can be attractive, some images benefit from subdued colours or just a hint of tone. This can be most attractive in combination toning. Even more subtle with blue and copper toners is the 'pre-colour' intensifying effect. If the toner is diluted 1 + 1 or 1 + 2, and the time is noted when the colour appears on a test print or test strip, the next print can be lifted 5 seconds before the colour change. This will intensify the print slightly (by half to one grade), separating the tones but without

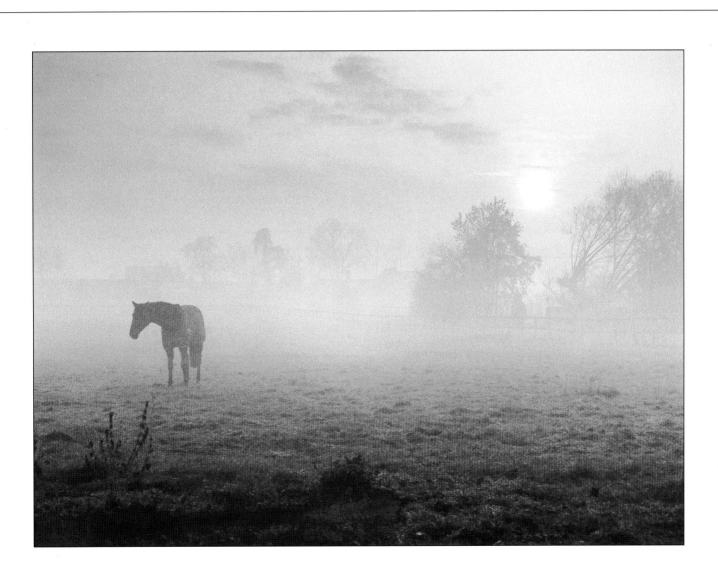

producing any obvious colour — unless it is compared with the original.

The picture's atmosphere may be enhanced by having a colder (blue) or warmer (copper) mood imparted to it without being obviously a toned print. This technique can be very effective when the two are combined, with copper warming the highlights and blue cooling the shadows. These effects are best when subtle. However, a common temptation is to leave the print in the toner(s) just too long.

COMBINATION TONING

Two techniques are used for combination toning: masking and sequential toning. In masking, parts of the print are exposed to one toner while the remainder is protected by a mask. This is usually of peelable varnish, which is painted on to the areas to be protected from the toner and removed afterwards with sticky tape, leaving part of the print untoned, as in the photograph of the donkey below.

This stage can be the end point, but if the toner was an archival one taken to completion, the toned areas will now be impervious to other toners. The previously masked areas will be readily toned by a different toner. The resulting image will show different areas affected by different toners, as in the picture of the stone shelter on the opposite page. More than two toners can be used if desired.

Sequential toning In sequential toning the whole print is toned in two or more toners. Thorough washing between stages is essential, particularly with fibre-based papers, otherwise contamination can occur, producing some very strange results. If this does happen, you may be able to retrieve the print by reimmersing it in developer, depending on which toners were used.

The permutations are many and are affected not only by the toners used but also by the type of paper and the processing chosen for it. You may want to experiment with some of the following techniques.
- Split sepia in light yellow-brown, followed by selenium in chlorobromide papers (or after potassium dichromate bleach in 'cold' papers) gives an attractive duotone.
- Split selenium followed by blue gives blue highlights on brown shadows.
- Any of the above using copper instead of blue.
- Split sepia followed by blue gives blue shadows and brown highlights.
- Depending on the toners chosen, blue on sepia may be used to give a much stronger green than most green toners, which generally produce insipid results. If blue on sepia gives an unintentional green, the print can be brought back to a proper blue by soaking in *very* diluted developer. If the developer bath is too long or too strong, the result will be grey. This can be retoned in blue if required.
- Copper followed by blue gives pink or red highlights and blue shadows.
- Split sepia briefly toned in gold and then in blue, gives pink or orange highlights on green. Be careful not

Sequential toning with dilute baths of copper and blue toners was used to give the gentle pastel colours in the print above. No masking was used.

Combination toning was carried out on the print on the left, with the help of a peelable varnish. This was applied to the donkey alone, allowing the rest of the print to be sepia toned. A little hand colouring was added afterwards.

Laying a blue tone over sepia can produce a strong green, depending on the paper and the formulation of the toners. Here partial gold toning was used to enrich the sepia before blue toning was carried out. When you intend to follow gold with another toner, do not take it to completion, as this prevents any further toning.

In the picture on the next page, dilute split-sepia toning was followed by use of dilute blue on the remaining dark tones.

The picture below reflects how I visualized the print at the taking stage. The colours were obtained by toning a lith print in gold after applying varnish to the shelter and the ground. After the varnish had been removed, the print was toned in selenium. The graffiti was hand coloured.

TONING TIPS

• As different toners affect contrast and density in different ways, it is a good idea to make a set of, say, 20 identical prints with a full range of tones, on resin-coated paper. Process these in batches of ten, constantly rotating them in back-to-back pairs in the developer to prevent them sticking together. Number each print. Keep one for reference and tone one with each new process you try. Keep a record of the details. In this way you will build up a set of reference prints which indicate how to modify exposure and contrast on new pictures to be toned in that process.

• Prints on fibre-based paper may give better results, but need long washing between stages and are more prone to processing marks. Resin-coated paper gives faster results and is ideal for experimentation. Papers with incorporated developer are less predictable.

• Expose for full development. 'Pulled' prints tone weakly. 'Cooked' prints may tone a base fog not previously noticed.

• Use only fresh fixer, to prevent the retention of insoluble fixer products, which spoil the effects of toning.

• Thorough washing after fixing is essential. Residual fixer in the paper will convert the potassium ferricyanide in some toners into Farmer's Reducer, which will irreversibly bleach the print.

• Do not use metal trays and tongs, as these can react with some toners.

• Wear rubber or disposable latex gloves whenever using toners. These protect your skin and prevent toned fingerprints appearing on the print margin.

• Air drying is usually best for toned prints. Gently wipe them with tissues to prevent streaks and puddle marks. However, hot-bed drying may enhance selenium toner on some warm-toned papers.

• Scum marks may be left by selenium toning, but can be removed by soaking the print in 3% acetic acid after the post-toning wash.

• Leave a border by which to handle the print, as some toners, especially blue, mark any handling points.

• Do not allow prints to lie overlapped in the wash, as lines may show up with toning.

• Blotches and uneven toning are usually the result of poor pre-toning processing.

to overdo the gold, because if this archival toner is allowed to work to completion the blue is prevented from taking effect.

• Warm-toned prints and lith prints partially toned in selenium and then in gold give a mixture of blues and browns that blend in the midtones.)

For more on toners see my volume *The Master Photographer's Toning Book* (US: *The Photographer's Toning Book*).

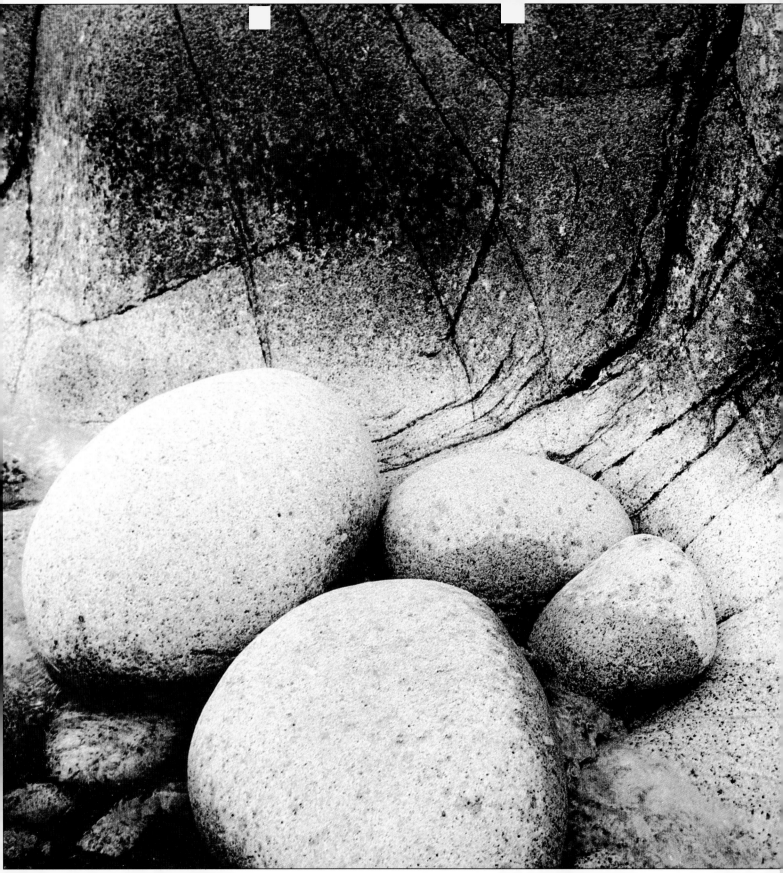

PRESENTATION AND PRESERVATION

Whether you intend to keep, display or sell a print you are pleased with, you will want to protect it and show it to its best advantage. This section brings together the techniques used to preserve prints and give them the finishing touches they deserve.

Chemicals in the darkroom and the environment can attack prints, causing irreversible damage. Archivalling protects them, not only for your enjoyment but for that of your grandchildren. Spotting, knifing and spraying are all important aspects of afterwork, improving or retrieving your prints by removing blemishes and changing emphasis. Borders greatly enhance the appearance of most prints, and can be produced either by printing or non-printing methods, both of which are explained here. Mounting and framing provide the final touches.

Cot Valley *The sea's action has eroded the rocks on this beach to produce a population of smooth, round stones of all sizes. Here a family of these lie, as if sheltering, in the lee of a larger rock. Made on Kentmere Kentona paper, the print was heavily overexposed and under-developed in dilute lith developer. The resulting lith image was split-toned in selenium to tone just the shadows brown, while the remaining tones were gold-toned to produce a gentle blue.*

ARCHIVALLING

It is a mistake to think that the archival permanence of prints is important only to famous photographers. How many thousands of families around the world treasure photographs of, or taken by, their parents and grandparents, or shots of themselves, their children, or close relatives now deceased. Or photographs of their town or village as it used to be, of landscapes or country practices long gone, of a lifestyle they either never knew or recall with nostalgia. Sadly, many such photographs will have faded with age. But this is simply because they were not preserved adequately, if at all, and it need not happen to the prints you produce from now on.

Having gone to the considerable trouble of producing the best prints you can, it makes sense to construct a processing programme that ensures they remain in good condition at least for your own lifetime, if possible for that of your children and grandchildren, and, who knows, perhaps in a permanent collection in years to come. Preparing your print with archival permanence in mind requires an awareness that runs right through the processes of developing, fixing, washing, drying, toning, mounting and storing. This might seem a formidable task, but like most good habits it is quite easy to maintain once started.

Before we look at the techniques, it is worth noting that materials are constantly changing and improving. At the time of writing, the consensus of opinion is that fibre-based papers will have a longer life than resin-coated papers.

Developing Provided you are following the good practice set out in this book and fully developing prints to the optimal degree as explained, no further modification is necessary or helpful.

Fixing Along with washing, fixing is the most important stage in determining the archival safety of your prints. The time allocated to it must be long enough to ensure complete fixing — that is, the complete removal of all the unexposed silver from the paper. Inadequate fixing will allow relatively rapid deterioration of the print. On the other hand, fixing time must not be too long. Not only does overfixing impair the highlight tones, but, more importantly from an archival point of view, it may result in too much fixer being absorbed into the paper to be removed by your washing programme. Even if fixer is successfully removed from the emulsion by washing, if it remains in the paper on which the emulsion is coated, it will eventually leach out into the emulsion and cause damage to it.

Fixing time can be determined, like development time, by either following the manufacturer's instructions or carrying out a test. For film, immerse a cutting of film in the fixer, note the time taken for it to clear, and double it. This will give you a guide to fixer activity.

Paper, however, does not clear and behaves differently to film, so the test has to be modified. In safelight conditions cut a sheet of unexposed paper into four and label them 5, 10, 15 and 20 seconds. Place each piece face down, keep it moving in fixer for its labelled time, and then wash thoroughly. Turn on the lights and in the light develop all four pieces for 2 minutes. Wash and dry them before examining them carefully to see which shows the first sign of darkening. Multiply the 'clear' paper time by four to find the minimum safe fixing time for *that paper/fixer combination*.

The test is only effective with fresh fixer, as fixer weakens with use. This brings us to the next problem in archivalling — unfresh fixer. If prolonged fixing occurs in semi-fresh fixer the result is a build-up in the paper of salts which are *insoluble* in water and which even extended washing cannot remove. They do, however, dissolve in fresh fixer, giving water-soluble salts again.

Two-bath fixing To overcome the problem of insoluble salts, two-bath fixing is recommended for archival processing. The total fixing time is divided between the two baths. The first removes most of the silver and the second acts as a back-up. The first bath exhausts faster, as it does most of the work. As it gradually becomes more exhausted, the insoluble salts are converted in the second bath to soluble salts that can be easily washed out by water. When the first bath has processed the equivalent of 25 sheets of 8in x 10in (20cm x 25cm) paper per litre, it is discarded. (This paper size and number of sheets are an 'average' estimate, and it is probably wise to significantly reduce both.)

The second bath becomes bath 1 and a fresh bath 2 is prepared. A fairly fresh quantity of bath 2 should be stored in a stoppered bottle between infrequent printing sessions, or if baths are left out in dishes, they are both discarded after a maximum of one week. It is not worth bottling tired fixer to squeeze the last possible use out of it. Just compare the cost of a tray of diluted fixer with that of a few packets of paper and many hours of your time.

If you make only dark, low-key prints with no borders, most of the silver in the paper may be exposed

and will stay there, leaving little unexposed silver to be removed by the fixer. However, if you make wide white borders, all that silver is unexposed and must be 'fixed away'. Similarly, light or high-key prints expose only a little of the paper's silver (otherwise they would be black) leaving a huge amount to be fixed. This will drastically reduce the figure of 25 sheets suggested above. You must make allowances for this, and err well on the side of caution. Alternatively you can test how much silver is accumulating with silver-testing paper or a residual fixer test.

Hypo clearing agents Both Kodak and Ilford manufacture agents that speed up the removal of fixer salts from paper efficiently and cut down washing times in the process. Their use is recommended in archival processing sequences, after a first short wash and before a second longer wash. Instructions may vary from product to product.

Toners As has already been explained in greater detail in the section on toning, sepia, selenium and gold are archival toners with a marked protective effect on the print — either singly or in combination sequentially (for example, sepia and selenium).

Sepia cannot be used without a colour shift which may not always be desired. Selenium has been shown by various tests to withstand harmful agents more successfully than sepia and gold and is considerably cheaper than the latter and has a much greater capacity. Gold and dilute selenium toners can have a minimal effect on image colour if so required, although they can be employed for aesthetic reasons too. The role of toning in archival processing can be varied. Some combine it with hypo clearing agent, although the practice is decreasingly popular. Others recommend it after the first (10-15 minutes) wash, *before* hypo clearing. Alternatively it can take place after the 'final' wash. The disadvantage of this is that another long wash is required after toning, giving a very long processing time, using more water and risking emulsion damage.

Washing We have seen how important it is to wash the fixer salts completely out of the paper which bears the emulsion. This may take an hour for fibre-based paper. If you use a washing siphoning tray or sink arrangement, unless you are a very slow worker or are leaving your prints to pile up in the fixer much too long, you will keep introducing new fixer-bearing prints into your washing water. This can make it difficult to know when your washing is complete, as new prints keep contaminating old ones.

It helps to devise a 'holding tank' system to store prints after an initial short wash, which will clear the bulk of the fixer from the surface at least. They can in

due course be passed through a hypo clearing agent and a final wash when the flow of new prints is finished or suspended.

An alternative for the committed printer is an archival washer. These are expensive but efficient and extremely convenient. Each print is held in a separate compartment within a tank and perfused by running water which takes its chemicals away via a 'weir' system without contaminating prints in the other chambers.

Drying Hot-bed driers have the advantage of being quick but also have a number of disadvantages, of which probably the most common is the risk of 'carrying over' contaminants to subsequent prints via the linen apron. It could be argued that if the prints were all adequately washed, there would be nothing to carry over. Even so, it is surprising how discoloured these aprons become, no matter how much care is taken. If used fairly hot, some emulsions do show a tendency to cling to the apron and have to be peeled off, risking damage to the emulsion.

Some fibre bases become distorted or brittle and cannot be mounted or flattened without creasing. Some chlorobromide papers dry with a warmer tone if they are heat-dried, and this can be an advantage or disadvantage, depending on your objective. Note that some toning effects are more pronounced after heat drying and rewashing.

Air drying is generally preferred for both archival and toning purposes. Prints may be dried flat on fibreglass mesh screens after being gently wiped down, or hung from a line. If you are using the second method, you can reduce curl by hanging the prints back to back with clips or clothes pegs on the bottom corners to keep the sheets together. Remember to leave an adequate margin, as clip marks may have to be trimmed off. Resin-coated papers are easily drip-dried on lines, but they should be hung singly rather than back to back, as the plastic backs will not dry if in contact with each other. As they do not curl, the back-to-back method serves no purpose here.

Contamination In time prints are adversely affected by a variety of chemicals found in boards, glues, mounting agents, dyes and boxes, and even in the air. Archivally toned prints will be much more resistant to these and having reached this stage, it seems foolish to use unsafe materials to mount and store your masterpieces. Archival materials are widely advertised and easily available but rather expensive.

In archival processing, efficient washing is essential. Archival washers hold each print in a separate compartment and perfuse it with running water, which escapes via a weir system. New prints can be added without contaminating those already being washed.

BORDERS

After the pains you have taken to produce the best print you can, it is all too easy to consider the job finished. But it is not. Print presentation deserves very careful thought for each picture or series. Although good presentation will not make a jewel out of a bad print, the enhancement it can achieve with a good print should never be underestimated.

Particular attention should be paid to borders, mounting and matting. Few, if any, absolute rights and wrongs exist, although strong opinions are often expressed as such. Borders can be produced photographically, by inks or dyes or by mounting techniques, which in turn may be simple or multiple and complex. Prints destined to remain unmounted look better if any required border is added photographically. On the other hand, there is no point in spending valuable time printing intricate borders, which will ultimately disappear behind a window mount or mat.

Styles of border Borders can be of any size, in any tone and consist of any number of components, but most are simply variations on a small number of options:
• Thin white border on the edge of a print
• Thin black border on the edge of a print.
• Wide white border. This is commonly separated from the picture by a thin black line to prevent light peripheral areas of the print merging with the white border. This black line may vary in thickness but may be so fine as to go unnoticed. It still performs its function.
• Wide black border around the print. This is often separated from the picture by a thin white line, inside which it is common to put a thin black line to stop light areas of a print bleeding into the white line.

Whatever border is used, it should enhance the print. A delicate, high-key study is unlikely to be enhanced by a 2in (5cm) dense black border, but a fine black keyline the same measurement inside the print edge may well set it off beautifully. Low-key pictures can look good with either wide black or white borders, and both have their advocates. However, adding the white line inside a black border does bring out the high lights in a low-key print. Therefore the density to which such a picture is printed may have to be adjusted according to whether a large black or large white border is planned.

Traditionally the bottom edge of the border is the widest, otherwise the print may appear to be too low in the 'frame'. The top and sides may be equal or not, depending on personal preference.

Eccentric mounting is occasionally used, but it is not recommended as a consistent practice. Sometimes a border within the frame (or outer edge) may be used as part of the picture structure, with picture elements spilling over it, holding on to it, or in some other way incorporating it as a pictorial device. This is often considered new, contemporary or original. In fact, the technique was used in photographs in the nineteenth century and in paintings long before that!

With a little practice, printing borders is not difficult. It can enhance the finished print and so is a skill well worth acquiring.

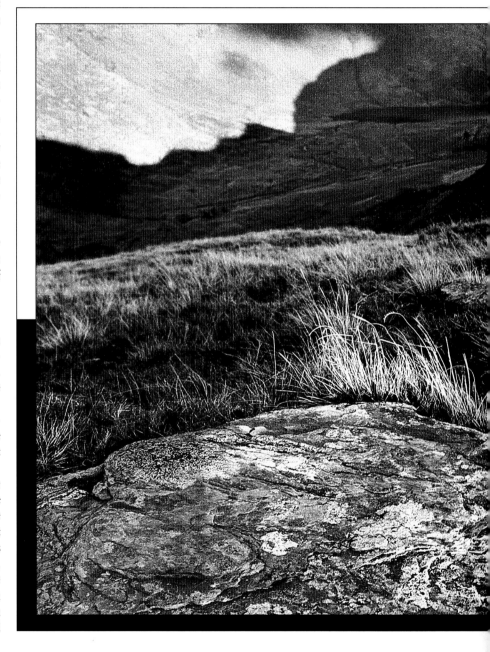

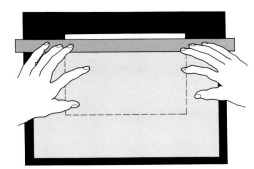

A steel ruler is used to delineate the small strip of paper — the rest is masked by a card — that will form the black border on exposure.

Simple borders White borders are the simplest and are produced by the arms of the masking frame. Some frames allow wider borders (usually up to 2-3in/5-7.5cm), but they tend to be more expensive, as do four- or five-bladed frames, which offer even more versatility.

Black borders There are a number of ways of producing a thin black line around the image area, to separate this from the white border:

I File the edges of the negative carrier to reveal the clear film edges, which print as black. This is only useful if you intend to always print the whole negative, an approach which was discussed in the section on cropping. It is useless, however, if you crop or compose on the baseboard. Ensure that the edges of the negative carrier are filed back so smooth that they cannot possibly damage your irreplaceable negatives.

2 Cut a rectangle of mounting board slightly smaller than the image space inside the arms of the masking frame. Use a guillotine or trimmer for clean edges — not scissors. After exposure, place the board carefully on top of the paper, leaving equal space around the edges. Hold it in place with a paperweight (one on each corner is even better, as this reduces 'light creep' at the corners). Remove the negative carrier and give the minimum exposure needed to produce a full black. The disadvantage of this method is that you may accumulate a collection of many different-sized cards.

3 Use a steel ruler or a suitable straight edge. With the paper still in the easel, lay a card over it to act as a mask. Use a ruler to overlap the card edge, leaving a small strip between the ruler and the easel blade, and expose to black. Repeat for each side in turn. If you have a small masking frame, your ruler will probably not fit within it. In this case, use a straight edge such as a paper packet in good condition.

4 Some expensive easels have a border-making attachment, but I find the above method easier and more reliable. It is also much less expensive.

5 A fine keyline may be added afterwards by using a ruler and a high-quality art pen or fine-line marker. Unless the line is very thin, its characteristic reflectance will give a prismatic effect when seen from certain angles. Furthermore, it will not change colour in response to any subsequent toning, remaining conspicuously black.

Black borders on the edge of the print are most simply made using the ruler technique. In this case remove the paper from the easel first. Placing it on a black card before covering it with the card and ruler, as in the illustration above, aids visibility under the safelight. Ensure first that the ruler is parallel to the paper edge, and secondly that it at least covers the white edge left by the masking frame (unless you want a white inside-edge line). It does not matter if it overlaps the image

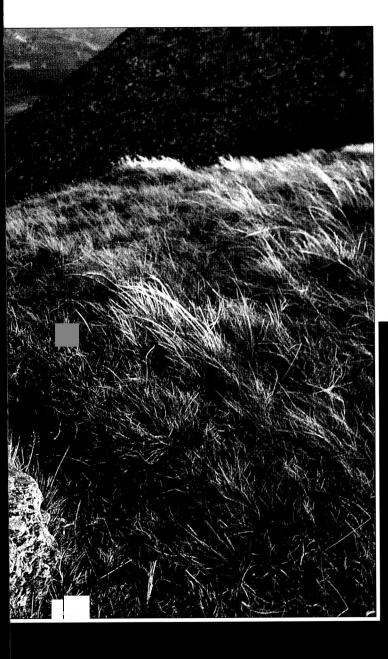

area slightly, as it will be exposed to maximum black and nothing will show through it.

Multiple borders More time is required to make multiple borders than single borders. Multiple borders use a variety of the above techniques, and a style currently popular is: a wide black border + an inside thin white keyline + an inside thin black keyline. The following methods work well.

1 The required arrangement of borders is assembled onto a card around a black central area corresponding in shape to the image area. The arrangement is copied onto high-contrast lith film. Ideally two enlargers are used. The first contains the image negative; the second contains the lith negative of the borders. The border arrangement is projected onto a borderless easel, using edge clips or a sticky board. The arms of the masking frame under the first enlarger are adjusted to give an image area that precisely fits the inside dimensions of the projected border negative. The masking easel arms must allow sufficient space around the edge of the paper to accommodate the borders to be projected onto it. The picture negative is exposed in the usual way and the paper is moved to the second enlarger. Here the whole border arrangement is printed, in one simple exposure, onto the space originally covered by the arms of the masking frame. Because it is black on the lith negative, the area within the borders will be protected from exposure. The advantage of this method is that once set up, the process is quick, simple, accurate and reproducible. The disadvantage is that unless you have a large collection of border negatives, you must always crop the image to the same dimensions.

2 A masking easel with complex border printing facilities is used. Although the concept here appears clever and sound, I find the reality is altogether different, despite the high cost of such easels. For wide borders, where accuracy is relatively unimportant, they are acceptable. For narrow line components I find other cruder methods much simpler and more reliable. A 1mm discrepancy between each end of a 20in x 16in (50cm x 40cm) print may go unnoticed on a 2in (5cm) border, but not on a 1mm keyline, and I always find that despite hours of patient readjustment, this accuracy is lacking.

3 A ruler and a masking card can be used to produce an infinitely variable and, with practice, acceptably accurate multiple border. First, make the inside black line on all four sides of the print, as described above, with the paper still in the masking frame. Make tiny waterproof ink dots in each inside corner before removing the paper from the frame. (These show black on white paper but will be on the inside black keyline after development.) The next step takes place with the paper on the baseboard, out of the frame. Line up the ruler on

each pair of dots in turn, and advance it 1-2mm to cover what will be the white line, before exposing the remaining visible border to black. If you cannot judge this distance by eye, use tiny guide marks on the edge of the paper, which can later be trimmed off. (If you prefer not to mark the paper with dots, use registration marks on the undersheet, measuring back from the edge of the paper.)

Other border permutations can be made by using variants of the above methods.

For mounted prints, rather than printing complex borders it is easier to produce them by multiple mounting onto white and black card or paper, trimming each in daylight to the exact dimensions required.

BORDER TIPS

• A foot-switch is invaluable, as it leaves both hands free.

• The border exposure should be enough to produce maximum black, but not much more, otherwise the black will creep into the white as a grey fringe.

• If you are using variable-contrast paper, use grade 5 to maximize whites and blacks. Readjust the contrast before you make the next print.

• If you are using a masking card, a black underside will help to prevent light 'creep'.

• To aid accurate positioning of the masking card, draw a thick line around the top edge with a black felt-tip pen. Under the safelight the printing paper will show up as a white strip between the black line and the black masking-frame arm.

• Before making the exposure, check that the components of narrow borders will be of equal width on all sides of the print, by measuring them with the edge of one or more coins.

AFTERWORK

Two patterns of blade commonly used for 'knifing' prints. A pointed blade is more accurate for scraping off tiny spots and scratches. A round-tipped blade is slightly less precise but easier to handle without damaging the print.

An adjustable illuminated lens is useful for all retouching work.

Most prints will require some afterwork — the finishing touches. Small blemishes on the dry print are common and should be removed. White spots from dust on the negative and white scratch marks require spotting. Black marks need to be removed either by bleaching or by knifing.

Knifing Like all the procedures in printing, knifing requires practice but is a skill worth acquiring. It is used mostly to remove small, dark blemishes resulting from emulsion holes or scratches that cannot be avoided by treating the negative. Once perfected, it can give very precise and controllable results without the 'creep' effect of a bleach on a wet print.

The best tool for knifing is a scalpel with a small blade. A round-tipped blade is less likely to dig into the emulsion; a pointed blade can be more accurate for tiny spots and thin scratches but is slightly more difficult to use. Hold the blade nearly perpendicular to the print at a similar angle to that used for a pencil, although the angle may vary according to the blade used. The blade should be stroked gently and repeatedly over the emulsion, but should never dig or cut. Almost imperceptibly the layers are scraped away to achieve a gradual lightening. Matt surfaces are easier to treat than stipple or glossy, and fibre-based paper easier than resin-coated. In any event an altered surface texture will be apparent. Extensive knifing is usually obvious, but can be camou-

flaged in two ways:

1 A neutral wax polish is applied by vigorous rubbing. Repeated applications may be necessary. This is best done on a mounted print to avoid buckling the paper. If the print is to be framed behind glass, a window mount (a mat) should be used to keep the polished surface and the glass apart. In any case the blemishes from knifing are less visible behind glass.

2 Spray varnishes are easy to use and cover a multitude of sins. They can be either glossy or matt, and do not have to match the original print surface, as they impart their own. A matt spray will make further afterwork with pencil or graphite much easier and a second coat will make the use of either undetectable.

The archival effects of both these treatments are questionable and this should be borne in mind if prints are to be sold. I possess polished and sprayed prints which show no adverse effects after 20 years, but I do not know what the next 50 will show.

Spotting Small white spots on the print can be disguised by applying small spots of dye with a good-quality spotting brush of size 0, 1 or 2. *Never* use a brush previously used to apply potassium ferricyanide or any other bleach.

As a spotting medium, watercolours have the advantage of being removable with a damp cloth. However, they do leave matt spots, which are particularly noticeable on glossy prints. Although this problem can be limited by using a little gum on the brush, it may still be detectable. Emulsion dyes are undetectable but more permanent and require more care in matching.

The most widely used spotting dye is probably Spotone, available in a range of colours with mixing instructions to match different papers. This chart is a good starting point, but image colour varies with many factors, so use a reject print or test strip to test for accurate matching. In the case of mistakes, light tones may be removed quickly by rubbing with a damp cloth, while darker tones may need an ammonia solution.

Mix and match the dye and test it on a reject print, which can be any print on the same paper. Do *not* test it on resin-coated paper when you intend to work on a fibre-based print, as the effect is likely to be different. The brush should be fairly dry, but not too dry, as the dye needs some water to take it into the emulsion. Nor must it be too wet, as a drop of dye on the print will dry to form a ring. Practice on a reject print until you get a feel for the right degree of dampness. If you use a hardener with your fixer (and why are you using one?) you will find the dye is less easily accepted by the emulsion. Dampening the area to be spotted may help.

Lay the print on a smooth, well-illuminated surface, and use a magnifier if you need one. In addition to the illuminating type, various models exist which fit on the

Knifing and spotting are important retouching skills. Protect the print during all retouching procedures. A reject print can be used to test the effect of spotting dye before it is applied to the finished print.

head or glasses. Make sure the print does not overlap the working surface under your arm, or it will crease as you lean on it. I lay a reject print over the print I am working on, exposing the area to be spotted, as in the illustration above. This protects the print and allows me to test the brush for colour, density and wetness each time I pick up dye and before I apply it to the print. Giving one or two dabs to the test print takes only a second but avoids many mistakes.

Apply the dye in a series of little dots to match the grain pattern on the print. Ultra-fine grain prints are much more difficult than grainy ones. Do not try to brush the dye on in a painting action. Scratch lines are best treated in small sections, building up each section and returning in random order until they all blend together. Sometimes a dye can be applied as a wash to add density to a tone. This is a different technique from spotting and often more difficult as colour mismatches are much more apparent. The colours in some dyes tend to separate when used this way, so make tests first.

Building up tones I start on dark areas and move to lighter spots where the tone on the print matches the dye on the brush. This is much quicker than matching the dye to each spot. Build up the tone by reapplying several lighter spots rather than matching the dye's density exactly. As the dye darkens on drying, I leave each spot slightly light and move on. I return to add another spot, if I can find it. Often I cannot. If you try to match each spot exactly before moving on, you are in danger of ending up with dark spots on the print.

For toned prints, colour-print dyes may be necessary, but the blue, grey, olive, sepia, selenium and brown in the Spotone sets will serve to match most, unless large blemishes have to be treated.

Soft pencil and graphite applied with a fingertip can be useful touching-up agents, especially when used on matt paper or paper sprayed with matt lacquer. Rubbing a pencil lead or a graphite stick on fine emery paper will produce a fine graphite dust for this purpose. These effects can be particularly attractive in high-key work, where pencil and print tones can be combined to produce a result that looks part print and part sketch. Matt lacquer hides the evidence and stops it smudging or being rubbed off.

Print presentation Like the personal interpretation that goes into making the print, presentation is a matter of preference, although it is undeniably influenced by fashion. Over the years I have seen large cream mounts give way to flush mounts (where the edge of the print is the edge of the mount). These gave way to small and then large black mounts which now have mostly been replaced by large white mounts. All were *de rigueur* in their day.

Once the print is finished, the next steps are dictated largely by its intended destination. If you are really dissatisfied with a 'near miss', store it in a box marked 'Rejects' rather than the wastebin. These prints will be useful for experimenting with toners, dyes, hand colouring, spotting and many other procedures. If you are only slightly disappointed, put it to one side and review it in a week, for you may change your mind. As Salvador Dali said, 'Don't be afraid of perfection. You'll never reach it.' All the same, you should still strive for it. If you are thrilled with the print, put it to one side and review it in a month — you may still change your mind about it.

If the print is for reproduction, there is nothing more to do to it once it has been spotted. Certainly do not mount it, as this may cause scanning problems. Removable mounts are merely a frustration to a busy picture editor. If it is being submitted for consideration, it may be worth enclosing it in a clear polyester archival sleeve. This may give the print an air of authority (to which, however, most editors will be immune), but it will certainly give it protection, as it will not always receive the reverential handling you would wish for.

MOUNTING

Prints for display should be mounted if they are to be shown to their best advantage. This can be done by sticking them on mounting board, behind a window mount (also known as a 'mat') or between the two. Each method of mounting has advantages and disadvantages.

Mounting boards The boards used for mounting come in various materials, sizes, colours, surface textures, thicknesses and standards of archival quality. Many are double-sided, offering the choice of two colours. Standard mounting board is quite suitable for many exhibitions or display purposes for most amateur photographers. This is not archival board, however, and consequently is not free of potentially harmful substances. If you prepare prints to archival standards, it makes sense to use archival materials for mounting and storing them.

Surface mounting The advantages of surface mounting are that it is easy to do and it holds the print extremely flat, bonded onto the mounting material. The disadvantage is that usually it cannot be removed and therefore prints of nostalgic or monetary value are best mounted differently. The mounting board may be cardboard of various thicknesses, foam board (which is thick and lightweight), plastic (which is thin but rigid) or even hardboard, chipboard or wood. If you are using mounting board, thin board is suitable for insertion into frames, but thick board is needed if the print is to be hung unframed, as variations in heat and humidity will cause the thinner boards to curl. If you plan to use glass-fronted frames, window mounts are advisable.
Prints may be stuck onto their mounts by using either wet or dry mounting techniques.

Wet mounting The wet or sticky methods require the use of either brushed-on or spray adhesives. The first type are cheap but messy and have a tendency to 'lift' if the print is displayed in warm conditions. Spray adhesives are extremely easy to use and are available in permanent and temporary versions. Some are quick-drying, others slow-drying to permit small adjustments after the print has been positioned. In either case, it is wise to measure and position the dry print precisely on the board before mounting and to make some removable registration marks to enable swift and accurate positioning once the print has been sprayed.

To apply the adhesive, place the print face down on a much larger area of paper such as a newspaper. Spray in even sweeps across and progressively down the print. At the end of each pass, overshoot onto the newspaper before returning across the print in the opposite direction. Adhesive is applied extra thickly at the end of each sweep and if this is allowed to fall on the print rather than the newspaper, excess adhesive is likely to be squeezed out around the edges of the print onto the mounting card, giving a messy finish. The amount of adhesive needed is a matter of trial and error, and provides another good use for your reject prints.

When the adhesive is tacky all over, apply the print to the board at one edge, lining it up with the registration marks. Holding the print so that the sticky side is a convex curve, lower it slowly and lightly across the board. Minor adjustments should now be possible (depending on the adhesive). When its position is correct, systematically smooth down the print from the centre outwards in all directions, to remove all air bubbles. Inspect the result in oblique light. Use a clean cloth or a rubber roller, taking care not to leave roller marks on the print by pressing too hard, and not to pick up adhesive from the edges and track it across the print.

If you are using thin board, you may find that it curls or warps as the adhesive dries. This can be minimized by mounting a sheet of paper on the back of the mounting board in exactly the same way as you mounted the print. The adhesive drying effect then occurs on both sides of the board simultaneously, reducing warp.

Finally, once you are satisfied that there is no excess edge glue, place the mounted print under a sheet of weighted-down glass and leave it to dry.

Dry mounting The most effective and cleanest way to attach a print to mounting board is dry mounting. A sheet of dry-mounting tissue is placed between the print and the board and the whole assembly is pressed together under heat, whereupon the tissue bonds the print and board together.

For dry mounting you will need a trimmer — either a sharp craft knife and a ruler, or a rotary trimmer or guillotine. Also required is a domestic iron or a dry mounting press with a separate tacking iron. A domestic iron is usually readily available but some practice is required to achieve really good results. A dry mounting press is expensive, but invaluable if you mount a lot of prints as it is easy to use and gives perfect results every time.

The procedure for dry mounting a print is shown in the series of illustrations on the next page. Place the print face down on a clean surface and position a sheet

of mounting tissue of at least equal size on the back. With the domestic or tacking iron, touch the central area in several spots, making sure there are no wrinkles between them. This action sticks the mounting tissue to the centre of the print.

Turn the print and tissue over. Trim the edges to give the border size you want and to remove excess mounting tissue. Position the print exactly on the mounting board. It is not sticky and so you have time to be accurate. Holding the print in place, lift each corner, exposing the mounting tissue lying on the board. Touch this with the iron to stick it down at each corner in turn. Everything is now held securely in place by a few contact points.

Cover the print with clean, uncreased paper. Silicone-release paper is best, or the tissue used to separate the dry-mounting sheets in the box. Both have one smooth side. Present this side to the print. Either insert the print into the mounting press at the temperature recommended for that tissue and printing paper, or use a domestic iron with a steady pressure, systematically moving slowly out from the centre in all directions. Take great care if mounting resin-coated paper in this way, as the heat may melt your print. Overmats are available to prevent this.

It is easy to create elaborate borders by mounting the print onto several layers of black, white, cream or coloured paper of different sizes before finally mounting it on a board. All these materials are available from artists' suppliers.

Window mounting The print can be either attached to the back of a window mount or sandwiched between the window mount and a back board. This has a number of advantages:
• Arguably it is aesthetically more pleasing.
• The print is not permanently fixed and can be removed or replaced without damage to the print.
• If the mount is damaged, it can be replaced. The print will probably not have been damaged.
• If you print always to the same format, the mounts are interchangeable. Once you have a collection of mats, arranging a new display of prints is quick and easy.
• Because the print is recessed, it is protected from some surface damage and also from contact with glass if

framed behind glass. Moisture can collect behind glass from condensation and this will eventually mark or damage the surface of a print at points of contact.
• Archival mounting boards are generally used this way, as minimal quantities of adhesive are needed.

Cutting the window mount You will need either a bevelled cutting tool mounted on a straight edge, with a ruler and a self-healing cutting mat, or a purpose-made window cutter. Like the dry-mounting press, a window cutter is the expensive option but a joy to use, as it makes a tedious job simple and gives perfect results time after time. The mount is cut to give a 45-degree slope to the cut edge when viewed from the front.

If the print is sandwiched between boards, it can either be fixed by triangular corners or lightly taped at one or two points. This leaves the print room to expand or contract without buckling. A fibre-based print can expand by a surprising amount by absorbing moisture while still apparently dry. I recently matted a set of prints for exhibition. The windows bore a precise relationship to the printed border lines on the prints. I subsequently decided to remove one print for toning. After drying the print— apparently completely — I was surprised to find that it had expanded to the extent that the borders were concealed behind the window edges. This raises an important point about borders. Pictures for window mounting must be printed with borders of at least 1/2in (1.25cm) behind the edges of the window. It is a common practice to leave a small border inside the window as well, in which case a fine black keyline may be helpful.

Multiple windows Small prints often benefit from the company of other pictures. Multiple window mounting can stretch your imagination and design skills, allowing you to combine windows of different size and shape in a single large mount. First, carefully select your prints, which may be similar in style or subject matter — a set of sepia-toned prints, for example — or strikingly different. You will need two sheets of card of the same size. Giving careful thought to the relationship of the picture elements, find the best arrangement for the group. After taking precise measurements, fix the pictures to one card, cover them with

To dry mount a print, tack the dry-mounting tissue to the centre of the back of the print. Then trim the edges to remove any excess tissue. Position the print (with tissue attached) face up on the mount. Lift up the edges of the print and tack the tissue to the mount at each corner with a hot iron or a tacking iron. Cover the print with a clean sheet of paper and iron the print smoothly onto the mount, working out from the centre.

a sheet of tracing paper and trace their outlines. Transfer the tracing paper to the second sheet and cut out windows, as decribed above, 2mm smaller on each side. Join the two cards.

Framing The craft of framing falls outside the scope of this book, but it is worth mentioning briefly a few points to consider when making your prints for framing.

Frames may be either glassless or contain glass or plastic. Glassless frames are lighter and less easily damaged in transport. They expose your print to the viewer with no 'barrier'. This allows appreciation of surface texture and avoids troublesome reflections which may make viewing extremely difficult in some environments. However, they offer the print no protection.

Plastic-fronted frames may not shatter, but they scratch easily and may become slightly milky, hiding that beau-tiful quality you have striven so hard to achieve.

Glass-fronted frames are the most commonly used. Glass can enhance a print, restoring some of that elu-sive quality seen in a wet print. However, reflections can be troublesome. Non-reflective glass can solve this problem, but your heart may sink as your prints lose contrast and sparkle when placed behind it. Soft, gentle pictures may not suffer so much in this respect, but if you are using non-reflective glass, the prints will have to be made specifically with this in mind.

Not all glass has the same colour. It can be infuriat-ing in a framing session to find that some of the replacement glass has a strong green tint, which you notice for the first time when laying it on newspaper for cleaning. This cast may obscure the more subtle seleni-um tones — another factor to be aware of at the print-making stage.

In combination with the print's light distant tones and strong perspective lines, the black mount heightens the illusion of depth. The white keyline separates the dark tones of the sky from the mount and emphasizes the highlights within the print.

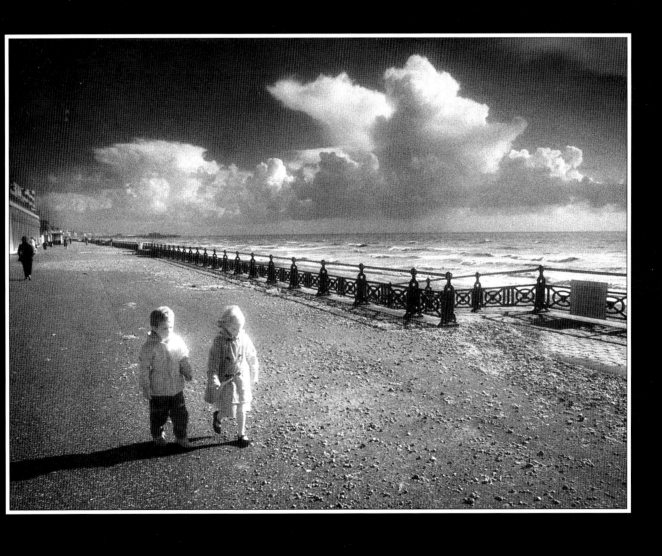

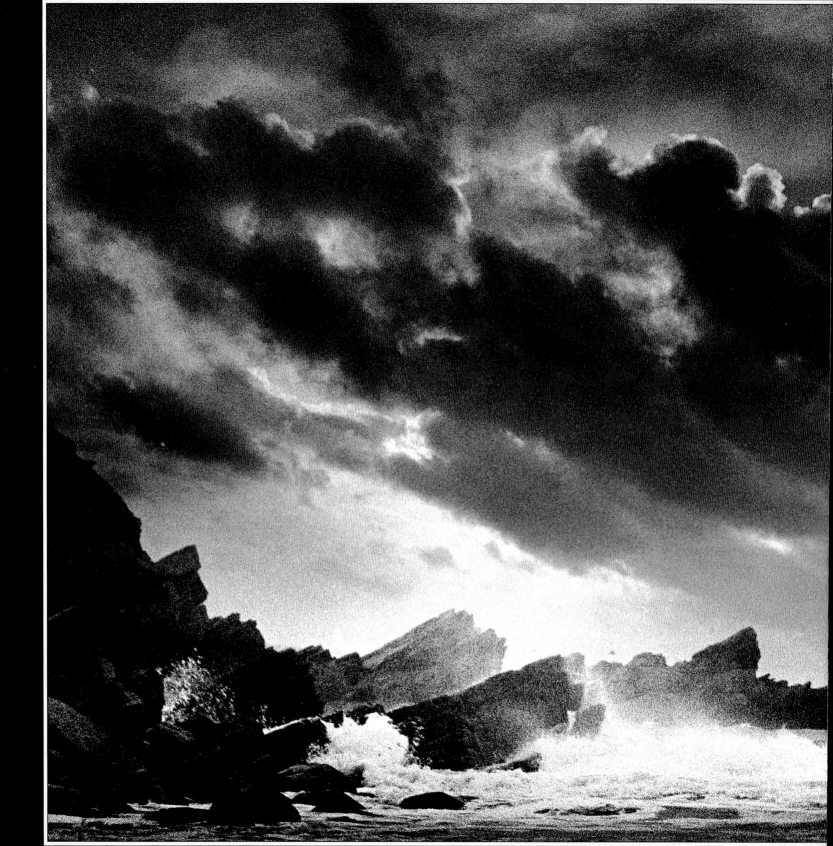

You can take good photographs without relying on technical tables and charts, but unless you have a prodigious memory you will not get far in the darkroom without the help of reference data. This invaluable resource includes money-saving formulae and instructions for mixing bleaches, intensifiers, toners and the other chemical preparations you will want to make up from time to time. Important advice on safety is also given.

Equally indispensable is the selection of quick-reference tables given here. With these you can convert quantities from imperial to metric and vice versa, calculate enlargements and reductions with ease, work out dilutions and convert *f*-stops into exposure times. Also included is a table of exposure conversion factors for use when changing from one paper size to another.

Lee Valley *Even with careful printing the negative of this scene lacked the information necessary to convey my experience of the storm. The rain flattened contrast to minor variations of mid-grey, while the sky was featureless and without atmosphere. Grades 4 and 5 were used throughout the image to give tonal separation. Dodging and burning-in made the rocks advance or recede. Ferri was used to lighten the spray. But it was an imported sky which most effectively conveyed the mood of the storm. Its shape and direction were chosen both to balance the land mass and suggest movement in the clouds.*

FORMULARY

Important: Many chemicals are toxic, corrosive or irritant. Others that are not may produce by-products that are, when mixed with other chemicals.

ALWAYS:
• Wear gloves (rubber or latex), protective clothes and use eye protection.
• Wash spillages to skin and eyes quickly with copious water.
• Keep a tap hose attached for this purpose.
• Clearly label and date everything.
• Be meticulously clean.
• Provide good 'through' ventilation.
• Dispose of solutions safely. Seek advice if necessary.
• add chemicals slowly and in the sequence indicated.
• Filter tap water and all home-made solutions to remove insoluble particles, especially if it is to be used for film.
• *Keep all chemicals away from children.*

NEVER:
• Eat, drink or smoke while mixing chemicals.
• inhale dust from powders.
• Fail to read instructions and warnings *first*.
• Use the kitchen scales for chemicals.
• Use metal containers, mixers, trays.
• Add chemicals without knowing the outcome is safe.
• Add waters to strong acids or alkalis (e.g. caustic soda — NaOH). Always add them to water — slowly.
• Keep large glass bottles on a high shelf.

CHEMICALS CHECKLIST
The following are some of the commonest darkroom chemicals and their dangers:

Acetic acid Burns, especially glacial acetic acid. Avoid contact with skin, eyes, clothes.
Ammonium persulphate Irritant to skin and eyes. If heated gives toxic sulphur dioxide gas.
Chromium Toxic to skin and very toxic to lungs. May cause cancer.
Ferric chloride Corrosive when moist.
Hydrochloric acid Corrosive (especially concentrated) — burns skin, eyes and clothes.

Iodine Stains. Avoid contact with skin, eyes and clothes. Good ventilation.
Mercury Extremely toxic alone or in compounds. Very dangerous if ingested. Toxic through skin.
Methyl alcohol Highly flammable — never use near flame. Avoid prolonged breathing (e.g. during 'dry' thiocarbamide reduction).
Metol Irritant. Causes allergic dermatitis. Avoid breathing dust.
Potassium dichromate Corrosive. Causes skin ulceration, damages eyes. Avoid inhaling dust.
Potassium ferricyanide Slightly toxic. *But,* if exposed to strong heat, hot acid or strong ultraviolet light, can release deadly hydrogen cyanide gas.
Potassium iodide Irritant to skin. Do not inhale or ingest.
Potassium permanganate Toxic. Wear gloves. Do not inhale (includes fumes from any reactions).
Silver nitrate Corrosive. Stains skin. Supports combustion.
Selenium powder Toxic, especially to eyes or if inhaled. Avoid contact or inhalation.
Sodium hydroxide Caustic, corrosive, burns. May splatter when added to water. Use gloves or spatula.
Sodium sulphide Contact with acids liberates hydrogen sulphide. Foul smell, and fogs film and paper.
Sodium thyocyanate Irritant. Avoid contact with skin.
Sodium thiosulphate (hypo) Can be toxic if inhaled. Can decompose to toxic sulphur dioxide gas.
Sulphuric acid Corrosive (especially concentrated). Burns skin, eyes and clothes.
Thiocarbamide Toxic if inhaled, ingested or through the skin. May cause cancer through repeated skin exposure.

Treat all the above chemicals with care and respect.

MIXING SOLUTIONS
'Anhydrous' forms of chemicals are those without water. 'Crystal' forms contain a lot of water in the crystals. This affects the weight. It is important to know which form you have and how to convert the weight if it is the wrong one. Anhydrous chemicals are increasingly common and are more economical and reliable.

The following data will allow you to calculate the conversion of commonly used chemicals that come in both forms:

> **Sodium thiosulphate (hypo)**
> 100g anhydrous = 160g crystals
> *or*
> 62.5g anhydrous = 100g crystals
> i.e. Anhydrous x 1.57 = crystals;
> anhydrous = crystals x 0.7.

Sodium sulphite

100g anhydrous = 200g crystals

or

50g anhydrous = 100g crystals

i.e. Anhydrous x 2 = crystals;
 anhydrous = crystals x 0.5.

Sodium carbonate

100g anhydrous = 270g crystals

or

37g anhydrous =100g crystals.

i.e. Anhydrous x 2.7 = crystal;
 anhydrous = crystals x 0.37.

All mixing should be done in *clean* glass or plastic/Perspex containers. Do not use metal trays, mixing rods or tongs. Mix chemicals in the prescribed order ensuring that they are completely dissolved before adding the next agent. Warm water helps, but do not use very hot water unless instructed to.

Percentage solutions When a very small quantity of a chemical is needed, it is best taken from a stock solution made up as percentages. To prepare a 10% stock solution, dissolve 100g in 750ml warm water, then top up to 1000ml (1 litre) when dissolved. Alternatively, 10g in 100ml or 1g in 10ml are also 10% solutions. Therefore each 10ml contains 1g. If your formula requires 0.5g, use 5ml, as 0.5g in 5ml is still a 10% solution. If you require 0.25g, use 2.5ml, and so on.

There is a table on page 156 to help you work out how much dilution you need to go from one percentage to another (e.g. to get 3% acetic acid from 28% stock). It also tells you how much of each solution you need to get a litre from X parts of A + Y parts of B (for those instructions that tell you to mix 1 + 7, for example).

FORMULAE

This is not intended to be a comprehensive photographic formulary. It is a useful guide to formulae relevant to procedures outlined in this book and to some allied techniques. Many alternative formulae exist.

Beers developer

Low contrast (solution A):

Metol	8g
Anhydrous sodium sulphite	23g
Anhydrous potassium carbonate	20g
Potassium bromide	1.1g
in water (50° C/122°F) to	750 ml
Make up to 1 litre.	

High contrast(solution B):

Hydroquinone	8g
Anhydrous sodium sulphite	23g
Anhydrous potassium carbonate	27g
Potassium bromide	2.2g
in water (50°C/122°F) to	750ml
Make up to 1 litre.	

Low Contrast ⬅➡ High Contrast

	1	2	3	4	5	6	7
A:	8	7	6	5	4	3	2
B:	0	1	2	3	4	5	14
Water:	8	8	8	8	8	8	0

Developer additives

For cold tones:

Anhydrous sodium carbonate	10g
Benzotriazole	10g
in water to	1 litre

Add 10ml to 1 litre developer.
Increase gradually if necessary.

For warm tones:

1.
Ammonium bromide	50g
Ammonium carbonate	50g
in water to	1 litre

Add 20ml to 1 litre developer.
Increase gradually if necessary.

2. 'Old Brown'

Use old exhausted developer 1 to 2 with new developer.
Increasing to 1 to 1 if necessary.

For old paper (develop for 1 minute) use :

1. Potassium bromide 10%:10ml per litre developer.
Use precise amounts.
NB: tends to warm tones.

2. Benzotriazole 1%:5ml per litre developer.
Use precise amounts.
NB: tends to cool tones.

Reducers

Subtractive reducers

1. Farmer's Reducer

A: Potassium ferricyanide	10g
in water to	100ml
B: Sodium thiosulphate anhydrous	100g
in water to	1 litre

Add 10ml *A* to 100ml *B* immediately before use. Discard when turns green. Vary strength if required (see page 111).

2. Alkaline Farmer's Reducer

A: Sodium thiosulphate crystals	1000g
in water to	500ml

(start at 30°C/86°F and rewarm repeatedly until dissolved)

B: Sodium hydroxide (caustic soda) — 30g
in water to — 300ml
C: Potassium ferricyanide — 90g
in water to — 300ml

Add 300ml *A* to 22.5ml *B*, add 75ml *C* (repeat if required)

3. 'Stainless'
A. Potassium iodide — 3g
B. Sodium thiosulphate crystals — 200g
in water to — 1 litre
Use as for Farmer's Reducer.

Proportional reducers

1. 'Stainless'
Iodine — 2g
Thiocarbamide — 4g
in water to — 100ml
Use immediately as has short life.

2. A. Concentrated sulphuric acid — 1 or 1½ ml
Potassium permanganate — 0.25g
in distilled water to — 1 litre
B. Ammonium persulphate — 200g
in distilled water to — 1 litre

A 1 part + B 3 parts. Transfer to fresh 1% sodium metabisulphite to clear colour.

3. Ammonium persulphate — 25g
Sodium chloride (common salt) 1% solution — 25ml
Sulphuric acid 1% solution — 30ml
in water to — 1 litre

Reducers for local use

1. Dry local 'reducer'
A Iodine — 2.3g
Methyl alcohol — 50ml
B Thiocarbamide — 4.6g
in warm water to — 50ml
C Methyl alcohol (see page 148)

2. Wet local 'reducer'
A Potassium iodide — 15g
Iodine — 5g
in water to — 100ml
B Sodium thiosulphate crystals (hypo) — 200g
in water to — 1 litre
A 1 part + B 5 parts

3. Wet local 'reducer'
A Potassium iodide — 30g
Iodine — 10g
in water to — 500ml
B Sodium thiosulphate crystals — 200g
in water to — 1 litre

A 1 part + B 4 parts (variable) or A 1 part + water 4 parts; fix in B.
Many variations are possible.

Selected bleach baths

For redevelopment and toning techniques:

1. A Potassium dichromate — 5%
(e.g. 50g in 1 litre)
B Hydrochloric acid — 10%
A 1 part + B 1 part + water 6 parts.
Useful as print intensifier; to give cold blue/blacks in metol redevelopment, including with warm-toned papers; for facilitating selenium split toning with some papers.

2. Potassium dichromate — 20g
Concentrated sulphuric acid — 50ml
Sodium chloride (common salt) — 100g
in water to — 1 litre
Produces various light or deep, rich browns on redevelopment, depending on developer used. Experiment with subsequent toning.

3. Cupric sulphate — 50g
Concentrated sulphuric acid — 6.5ml
Sodium chloride (common salt) — 50g
in water to — 1 litre
Useful for blue-blacks in metol redevelopment. Purple-blue blacks obtainable in strong selenium.

4. Potassium ferricyanide — 100g
Potassium bromide — 100g
in water to — 1 litre
Standard bleach for thiocarbamide-type sepia toning. Can be used much diluted for slower action if required. Using potassium ferricyanide alone will give warmer tones.

5. Potassium ferricyanide — 33g
Ammonium bromide — 40g
in water to — 1 litre
An alternative bleach to 4, giving a colour shift on redevelopment to purple/brown — this varies with developer. Try metol hydroquinone.

Toners

Thiocarbamide toner
A Bleach
Potassium ferricyanide — 100g
Potassium bromide — 100g
in water to — 1 litre
B Toner
Thiocarbamide — 100g
in water to — 1 litre
C. Activator
Sodium hydroxide — 100g
in water to — 1 litre
Add sodium hydroxide to water — not vice versa. Mix B and C according to colour required e.g.

Deep brown ← Mid brown → Yellow brown

B	1	1	5
C	5	1	1

Use any in-between stages as required. The deeper the brown, the quicker the toner is used up and needs replacing.

Sulphide toner
A Bleach as above		
B Sodium sulphide (flake)		35g
in water to		1 litre

Copper toner
A Copper sulphate		15g
Potassium citrate		100g
in water to		1 litre
B Potassium ferricyanide		10%

Add B to A 1+1 immediately before use.
There are many variations on this formula.

Blue toner
A Potassium ferricyanide		3g
Sulphuric acid 10%		50ml
in water to		1 litre
B Ferric ammonium citrate		3g
(or ammonium ferric citrate)		
Sulphuric acid 10%		50 ml
in water to		1 litre

A 1 part + B.1 part immediately before use.
Many variations and alterations exist for blue toners with different characteristics.

Gold toner (single bath)
Ammonium thiocyanate		105g
Gold chloride 1% solution		60ml
dissolve in warm water (50°C/ 122°F)		750ml
in water to		1 litre

Selenium toner
Sodium sulphite anhydrous		150g
Selenium powder		6g
Ammonium chloride		190g
in water to		1 litre

Dissolve sodium sulphite in 750ml hot water. Add selenium and boil for 30 minutes. Filter. Add ammonium chloride when cool. Dilute to 1 litre. *Warning:* Selenium is toxic through skin or eye contact and if inhaled. Good ventilation is essential. This can be a dangerous process and it should be borne in mind that this toner is now widely available ready-made.

Selenium sulphide Toner
A Potassium ferricyanide		50g
Potassium bromide		50g
in water to		1 litre
B Sodium sulphide (pure)		250g
Selenium powder		5.7g
in water to		1 litre

Dissolve sodium sulphide first. Heat to 40°C (104°F) and slowly stir in selenium. Bleach in A. Wash. Dilute B 1+19 before use (can be varied). Discard after use.

Note: If print shows surface scum after toning, soak in 3% acetic acid solution until cleared.(see page 156 for dilution to 3%).

Negative intensifiers see page 72 for various proprietary products not included here. Some toners, notably selenium, produce a degree of intensification in prints, and 5% potassium dichromate in 10% hydrochloric acid can be used as a print intensifier.

Mercury intensifier
Mercuric chloride powder		13.g
Magnesium sulphate purified powder		60.g
Potassium iodide granular		30.g
Sodium sulphite anhydrous		15.g
in water at 21°C (70°F) to		1 litre

Allow sediment to settle and filter. Store in dark bottle.
Warning: Mercuric chloride is exceptionally toxic even in tiny quantities. It is also environmentally dangerous on disposal. Its distribution is subject to official restrictions which differ from country to country.

Chromium intensifier
Potassium dichromate anhydrous		90g
Concentrated hydrochloric acid		64ml
in water to		1 litre

Use 1 + 10 parts water on hardened negative. When bleached, redevelop in artificial light (*not* sunlight) in any quick-acting, non-staining low-sulphite developer. Re-fix. Wash.

Silver intensifier
This is a 'proportional' intensifier particularly suitable for fine-grain materials. Protect it from sunlight.
A Silver nitrate crystals		60g
in distilled water to		1 litre
Store in brown bottle.		
B Sodium sulphite anhydrous		60g
in water to		1 litre
C Sodium thiosulphate (hypo) crystals		105g
in water to		1 litre
D Sodium sulphite anhydrous		15g
Metol		25g
in water to		3 litres

A 1 part + B 1 part (a white precipitate appears).
Add C 1 part (precipitate disappears slowly). Stir in D 3 parts. Immerse negative and agitate continuously. Intensification is proportional to the length of time in the solution. *Do not exceed 25 minutes.* The solution is stable for 30 minutes at 20°C (68°F). Fix briefly in hypo and wash.

QUICK REFERENCE ENLARGING/REDUCING TABLE (FOR STANDARD PAPER SIZES)

IF ENLARGING FROM	MULTIPLY T1 BY
8 x 10 to 10 x 12	1.44
8 x 10 to 12 x 16	2.56
8 x 10 to 16 x 20	4.0
8 x 10 to 20 x 24	5.76
10 x 12 to 12 x 16	1.78
10 x 12 to 16 x 20	2.78
10 x 12 to 20 x 24	4.0
12 x 16 to 16 x 20	1.56
12 x 16 to 20 x 24	2.25
16 x 20 to 20 x 24	1.44

IF REDUCING TO	MULTIPLY T1 BY
8 x 10 from 10 x 12	0.69
8 x 10 from 12 x 16	0.39
8 x 10 from 16 x 20	0.25
8 x 10 from 20 x 24	0.17
10 x 12 from 12 x 16	0.56
10 x 12 from 16 x 20	0.36
10 x 12 from 20 x 24	0.25
12 x 16 from 16 x 20	0.64
12 x 16 from 20 x 24	0.44
16 x 20 from 20 x 24	0.69

Conversion factors are based on the formula:

$$T2 = \left(\frac{L2}{L1}\right)^2 \times T1$$

where T1 = exposure time for the first print, L1 = length of first print, L2 = length of new print and T2 = exposure time for new print. Use this formula to calculate other sizes e.g. 5in x 7in to 13.75in x19.25in at a first exposure of 6.5 seconds:

$$T2 = \left(\frac{19.25}{7}\right)^2 \times 6.5$$

$T2 = (2.75)^2 \times 6.5$

$T2 = 7.56 \times 6.5$

$T2 = 49$ seconds

The above sizes are in inches. The precise metric equivalents are:

8 x 10 = 20.3 x 25.4cm 10 x 12 = 25.4 x 30.5cm
12 x 16 = 30.5 x 40.6cm 16 x 20 = 40.6 x 50.8cm
20 x 24 = 50.8 x 61cm

-1 stop	-¾ stop	-½ stop	-¼ stop	BASIC EXPOSURE IN SECONDS
0.5	0.6	0.7	0.8	1
1.0	1.2	1.4	1.7	2
1.5	1.8	2.1	2.5	3
2.0	2.4	2.8	3.4	4
2.5	2.9	3.5	4.2	5
3.0	3.5	4.3	5.0	6
3.5	4.1	5.0	5.9	7
4.0	4.7	5.7	6.7	8
4.5	5.3	6.4	7.6	9
5.0	5.9	7.1	8.4	10
5.5	6.5	7.8	9.2	11
6.0	7.1	8.5	10.1	12
6.5	7.7	9.2	10.9	13
7.0	8.3	9.9	11.8	14
7.5	8.8	10.6	12.6	15
8.0	9.4	11.4	13.4	16
8.5	10.0	12.1	14.3	17
9.0	10.6	12.8	15.1	18
9.5	11.2	13.5	16.0	19
10.0	11.8	14.2	16.8	20
10.5	12.4	14.9	17.6	21
11.0	13.0	15.6	18.5	22
11.5	13.6	16.3	19.3	23
12.0	14.2	17.0	20.2	24
12.5	14.7	17.7	21.0	25
13.0	15.3	18.5	21.8	26
13.5	15.9	19.2	22.7	27
14.0	16.5	19.9	23.5	28
14.5	17.1	20.6	24.4	29
15.0	17.7	21.3	25.2	30
16.0	18.9	22.7	26.9	32
17.0	20.1	24.1	28.6	34
18.0	21.2	25.6	30.2	36
19.0	22.4	27.0	31.9	38
20.0	23.6	28.4	33.6	40
21.0	24.8	29.8	35.3	42
22.0	26.0	31.2	37.0	44
23.0	27.1	32.7	38.6	46
24.0	28.3	34.1	40.3	48
25.0	29.5	35.5	42.0	50
26.0	30.7	36.9	43.7	52
27.0	31.8	38.3	45.4	54
28.0	33.0	39.7	47.0	56
29.0	34.2	41.2	48.7	58
30.0	35.4	42.6	50.4	60

f - STOP CALCULATION TABLE

+¼ stop	+½ stop	+¾ stop	+1 stop	+1½ stop	+2 stops	+2½ stops	+3 stops	+3½ stops
1.2	1.4	1.7	2.0	2.8	4.0	5.7	8.0	11.3
2.4	2.8	3.4	4.0	5.7	8.0	11.3	16.0	22.6
3.6	4.2	5.0	6.0	8.5	12.0	17.0	24.0	33.9
4.8	5.6	6.7	8.0	11.3	16.0	22.6	32.0	45.3
5.9	7.1	8.4	10.0	14.2	20.0	28.3	40.0	56.6
7.1	8.5	10.1	12.0	17.0	24.0	33.9	48.0	68.0
8.3	9.9	11.8	14.0	19.8	28.0	39.6	56.0	79.2
9.5	11.3	13.4	16.0	22.6	32.0	45.3	64.0	90.5
10.7	12.7	15.1	18.0	25.5	36.0	50.9	72.0	101.8
11.9	14.1	16.8	20.0	28.3	40.0	56.6	80.0	113.1
13.1	15.5	18.5	22.0	31.1	44.0	62.2	88.0	124.4
14.3	16.9	20.2	24.0	34.0	48.0	67.9	96.0	135.8
15.5	18.3	21.8	26.0	36.8	52.0	73.5	104.0	147.1
16.7	19.7	23.5	28.0	39.6	56.0	79.2	112.0	158.4
17.8	21.2	25.2	30.0	42.4	60.0	84.9	120.0	169.7
19.0	22.6	26.9	32.0	45.3	64.0	90.5	128.0	181.0
20.2	24.0	28.6	34.0	48.1	68.0	96.2	136.0	192.3
21.4	25.4	30.2	36.0	50.9	72.0	101.8	144.0	203.6
22.6	26.8	31.9	38.0	53.8	76.0	107.5	152.0	214.9
23.8	28.2	33.6	40.0	56.6	80.0	113.1	160.0	226.3
25.0	29.6	35.3	42.0	59.4	84.0	118.8	168.0	237.6
26.2	31.0	37.0	44.0	62.3	88.0	124.5	176.0	248.9
27.4	32.4	38.6	46.0	65.1	92.0	130.1	184.0	260.2
28.6	33.8	40.3	48.0	67.9	96.0	135.8	192.0	271.5
29.7	35.3	42.0	50.0	70.8	100.0	141.4	200.0	282.8
30.9	36.7	43.7	52.0	73.6	104.0	147.1	208.0	294.1
32.1	38.1	45.4	54.0	76.4	108.0	152.7	216.0	305.5
33.3	39.5	47.0	56.0	79.2	112.0	158.4	224.0	316.8
34.5	40.9	48.7	58.0	82.1	116.0	164.1	232.0	328.1
35.7	42.3	50.4	60.0	84.9	120.0	169.7	240.0	339.4
38.1	45.1	53.8	64.0	90.6	128.0	181.0	256.0	362.0
40.5	47.9	57.1	68.0	96.2	136.0	192.3	272.0	384.6
42.8	50.8	60.5	72.0	101.9	144.0	203.7	288.0	407.3
45.2	53.6	63.8	76.0	107.5	152.0	215.0	304.0	430.0
47.6	56.4	67.2	80.0	113.2	160.0	226.3	320.0	452.5
50.0	59.2	70.6	84.0	118.9	168.0	237.3	336.0	475.2
52.4	62.0	73.9	88.0	124.5	176.0	248.6	352.0	497.8
54.7	64.9	77.3	92.0	130.2	184.0	259.9	368.0	520.4
57.1	67.7	80.6	96.0	135.8	192.0	271.2	384.0	543.0
59.5	70.5	84.0	100.0	141.5	200.0	282.5	400.0	565.6
61.9	73.3	87.4	104.0	147.2	208.0	293.8	416.0	588.2
64.2	76.1	90.7	108.0	152.8	216.0	305.1	432.0	611.0
66.6	79.0	94.1	112.0	158.5	224.0	316.4	448.0	633.6
69.0	81.8	97.4	116.0	164.2	232.0	327.7	464.0	656.2
71.4	84.6	100.8	120.0	169.8	240.0	339.0	480.0	678.8

MILLI-LITRES	UK FL.OZ	US FL.OZ
1.00	0.035	0.034
2.00	0.070	0.068
3.00	0.106	0.101
4.00	0.141	0.135
5.00	0.176	0.169
6.00	0.211	0.203
7.00	0.246	0.237
8.00	0.282	0.271
9.00	0.317	0.304
10.00	0.352	0.338
15.00	0.528	0.507
20.00	0.704	0.676
25.00	0.881	0.845
50.00	1.76	1.69
75.00	2.64	2.54
100.00	3.52	3.38
250.00	8.80	8.45
500.00	17.60	16.90
750.00	26.40	25.40
1000.00	35.20	33.80

* To convert millilitres into fluid ounces multiply the volume in millilitres by 0.0352 for UK fl.oz and by 0.0338 for US fl.oz.
* To convert UK fl. oz and US fl. oz into millilitres multiply by 28.4 and 29.6 respectively.

LITRES	UK GALLS	US GALLS
1.00	0.22	0.264
2.00	0.44	0.528
3.00	0.66	0.793
4.00	0.88	1.06
5.00	1.10	1.32
6.00	1.32	1.59
7.00	1.54	1.85
8.00	1.76	2.11
9.00	1.98	2.38
10.0	2.20	2.64
15.00	3.30	3.96
20.00	4.40	5.28
25.00	5.50	6.60
50.00	11.00	13.20
75.00	16.50	19.80
100.00	22.00	26.40
250.00	55.00	66.00
500.00	110.00	132.00
750.00	165.00	198.00
1000.00	220.00	264.00

* To convert litres into gallons multiply the volume in litres by 0.22 for UK gallons and by 0.264 for US gallons.
* To convert gallons into litres multiply the volume in gallons by 4.55 for UK gallons and by 3.79 for US gallons.

GRAMS	GRAINS	OUNCES
1.00	15.4	0.035
2.00	30.9	0.071
3.00	46.3	0.106
4.00	61.7	0.141
5.00	77.2	0.176
6.00	92.6	0.212
7.00	108.0	0.247
8.00	123.0	0.282
9.00	139.0	0.317
10.00	154.0	0.353
15.00	231.0	0.53
20.00	309.0	0.71
25.00	386.0	0.88
50.00	772.0	1.76
75.00	1157.0	2.65
100.00	1543.0	3.54
250.00	3858.0	8.85
500.00	7716.0	17.60
750.00	11574.0	26.55
1000.00	15432.0	35.40

* To convert grams into grains multiply the amount in grams by 15.432. To convert ounces into grams multiply the amount in ounces by 0.0354.
* To convert grains into grams multiply the amount in grains by 0.0685. To convert ounces into grams multiply the amount in ounces by 28.35.

VARIABLE-CONTRAST PAPERS – FILTER SETTINGS

ILFORD

Grade	A Y	A M	B Y	B M	C Y	C M	D Y	D M
0	150	25	92	16	75	12	110	16
0.5	110	33	74	22	55	16	73	22
1	85	42	56	28	42	21	57	28
1.5	70	55	46	37	35	27	46	36
2	55	70	36	46	27	35	36	46
2.5	42	80	28	53	21	40	28	53
3	30	90	26	60	15	45	20	60
3.5	18	112	12	75	9	56	12	74
4	6	135	4	90	3	67	4	90
4.5	0	195	0	130	0	97	0	130
5	0	200+	0	130+	0	97+	0	130+

A = DUNCO, DEVERE, CHROMEGA, BESELER, JOBO, KAISER, OMEGA, PATERSON, SIMMARD, LPL, KODAK B = DURST C = MEOPTA D = LEITZ.

KODAK

Grade	A Y	A M	B Y	B M
0	130	0	130	0
1	75	10	65	15
2	50	20	40	35
3	30	35	20	60
4	10	100	10	100
5	0	200	0	180

A = KODAK B = DURST

TEMPERATURE CONVERSION TABLE

Find the temperature you wish to convert in the central column. If the temperature is in degrees Fahrenheit, read the Celsius equivalent in the left-hand column. If the temperature is in degrees Celsius, read the Fahrenheit equivalent in the right-hand column. For example, to convert 18°C to Fahrenheit, find 18 in the central column and read the value on the right: 64.4°F. Alternatively use the formula °F = (°C × 9/5) + 32 or °C = (°F - 32) × 5/9.

°C		°F	°C		°F	°C		°F	°C		°F	°C		°F
-17.8	0	32.0	6.7	44	111.2	31.1	88	190.4	55.6	132	269.6	80.0	176	348.8
-17.2	1	33.8	7.2	45	113.0	31.7	89	192.2	56.1	133	271.4	80.6	177	350.6
-16.7	2	35.6	7.8	46	114.8	32.2	90	194.0	56.7	134	273.2	81.1	178	352.4
-16.1	3	37.4	8.3	47	116.6	32.8	91	195.8	57.2	135	275.0	81.7	179	354.2
-15.6	4	39.2	8.9	48	118.4	33.3	92	197.6	57.8	136	276.8	82.2	180	356.0
-15.0	5	41.0	9.4	49	120.2	33.9	93	199.4	58.3	137	278.6	82.8	181	357.8
-14.4	6	42.8	10.0	50	122.0	34.4	94	201.2	58.9	138	280.4	83.3	182	359.6
-13.9	7	44.6	10.6	51	123.8	35.0	95	203.0	59.4	139	282.2	83.0	183	361.4
-13.3	8	46.4	11.1	52	125.6	35.6	96	204.8	60.0	140	284.0	84.4	184	363.2
-12.8	9	48.2	11.7	53	127.4	36.1	97	206.6	60.6	141	285.8	85.0	185	365.0
-12.2	10	50.0	12.2	54	129.2	36.7	98	208.4	61.1	142	287.6	85.6	186	366.8
-11.7	11	51.8	12.8	55	131.0	37.2	99	210.2	61.7	143	289.4	86.1	187	368.6
-11.1	12	53.6	13.3	56	132.8	37.8	100	212.0	62.2	144	291.2	86.7	188	370.4
-10.6	13	55.4	13.9	57	134.6	38.3	101	213.8	62.8	145	293.0	87.2	189	372.2
-10.0	14	57.2	14.4	58	136.4	38.9	102	215.6	63.3	146	294.8	87.8	190	374.0
-9.4	15	59.0	15.0	59	138.2	39.4	103	217.4	63.9	147	296.6	88.3	191	375.8
-8.9	16	60.8	15.6	60	140.0	40.0	104	219.2	64.4	148	298.4	88.9	192	377.6
-8.3	17	62.6	16.1	61	141.8	40.6	105	221.0	65.0	149	300.2	89.4	193	379.4
-7.8	18	64.4	16.7	62	143.6	41.1	106	222.8	65.6	150	302.0	90.0	194	381.2
-7.2	19	66.2	17.2	63	145.4	41.7	107	224.6	66.1	151	303.8	90.6	195	383.0
-6.7	20	68.0	17.8	64	147.2	42.2	108	226.4	66.7	152	305.6	91.1	196	384.8
-6.1	21	69.8	18.3	65	149.0	42.8	109	228.2	67.2	153	307.4	91.7	197	386.6
-5.6	22	71.6	18.9	66	150.8	43.3	110	230.0	67.8	154	309.2	92.2	198	388.4
-5.0	23	73.4	19.4	67	152.6	43.9	111	231.8	68.3	155	311.0	92.8	199	390.2
-4.4	24	75.2	20.0	68	154.4	44.4	112	233.6	68.9	156	312.8	93.3	200	392.0
-3.9	25	77.0	20.6	69	156.2	45.0	113	235.4	69.4	157	314.6	93.9	201	393.8
-3.3	26	78.8	21.1	70	158.0	45.6	114	237.2	70.0	158	316.4	94.4	202	395.6
-2.8	27	80.6	21.7	71	159.8	46.1	115	239.0	70.6	159	318.2	95.0	203	397.4
-2.2	28	82.4	22.2	72	161.6	46.7	116	240.8	71.1	160	320.0	95.6	204	399.2
-1.7	29	84.2	22.8	73	163.4	47.2	117	242.6	71.7	161	321.8	96.1	205	401.0
-1.1	30	86.0	23.3	74	165.2	47.8	118	244.4	72.2	162	323.6	96.7	206	402.8
-0.6	31	87.8	23.9	75	167.0	48.3	119	246.2	72.8	163	325.4	97.2	207	404.6
0.0	32	89.6	24.4	76	168.8	48.9	120	248.0	73.3	164	327.2	97.8	208	406.4
0.6	33	91.4	25.0	77	170.6	49.4	121	249.8	73.9	165	329.0	98.3	209	408.2
1.1	34	93.2	25.6	78	172.4	50.0	122	251.6	74.4	166	330.8	98.9	210	410.0
1.7	35	95.0	26.1	79	174.2	50.6	123	253.4	75.0	167	332.6	99.4	211	411.8
2.2	36	96.8	26.7	80	176.0	51.1	124	255.2	75.6	168	334.4	100.0	212	413.6
2.8	37	98.6	27.2	81	177.8	51.7	125	257.0	76.1	169	336.2			
3.3	38	100.4	27.8	82	179.6	52.2	126	258.8	76.7	170	338.0			
3.9	39	102.2	28.3	83	181.4	52.8	127	260.6	77.2	171	339.8			
4.4	40	104.0	28.9	84	183.2	53.3	128	262.4	77.8	172	341.6			
5.0	41	105.8	29.4	85	185.0	53.9	129	264.2	78.3	173	333.4			
5.6	42	107.6	30.0	86	186.8	54.4	130	266.0	78.9	174	345.2			
6.1	43	109.4	30.6	87	188.6	55.0	131	267.8	79.4	175	347.0			

MAKING UP WORKING STRENGTH SOLUTIONS

DILUTION RATIO	FINAL VOLUME (ml)	VOLUME (ml) OF STOCK SOL	VOLUME (ml) WATER
1+0	1000.00	0.00	0.00
1+1	1000.00	500.00	500.00
1+2	1000.00	333.33	666.66
1+3	1000.00	250.00	750.00
1+4	1000.00	200.00	800.00
1+5	1000.00	166.67	833.33
1+6	1000.00	142.86	857.14
1+7	1000.00	125.00	875.00
1+8	1000.00	111.11	888.89
1+9	1000.00	100.00	900.00
1+10	1000.00	90.91	909.09
1+11	1000.00	83.33	916.67
1+12	1000.00	76.92	923.00
1+13	1000.00	71.43	928.57
1+14	1000.00	66.67	933.33
1+15	1000.00	62.50	937.50
1+16	1000.00	58.82	941.18
1+17	1000.00	55.56	944.44
1+18	1000.00	52.63	947.37
1+19	1000.00	50.00	950.00
1+20	1000.00	47.62	952.38
1+25	1000.00	38.46	961.54
1+30	1000.00	32.26	967.74
1+40	1000.00	24.39	975.61
1+50	1000.00	19.61	980.39
1+75	1000.00	13.16	986.84
1+100	1000.00	9.90	990.10
1+125	1000.00	7.94	992.06
1+150	1000.00	6.62	993.38
1+175	1000.00	5.68	994.32
1+200	1000.00	4.98	995.02
1+250	1000.00	3.98	996.02
1+300	1000.00	3.32	996.68
1+400	1000.00	2.49	997.51
1+500	1000.00	2.00	998.00
1+600	1000.00	1.66	998.34
1+700	1000.00	1.43	998.57

PERCENTAGE SOLUTION CONVERSIONS

To get a working strength dilution from a higher percentage dilution:

1. Put the % of the stock solution at A, e.g. 28% acetic acid.
2. Put the % of the solution you are going to use to make the final solution at W. Normally this is water so the figure is 0.
3. At R put the % you require, e.g. 3% to make a working strength stop bath.
4. Subtract R from A (28-3=25) and put the figure at Y.
5. Subtract W from R (3-0=3) and put the figure at X.
6. Mix X parts of A with Y parts of W, i.e. 3 parts of the 28% acetic acid solution with 25 parts water, to get the working solution.

DARKROOM SUPPLIERS

UK

Agfa Gevaert Ltd
Tel 01582 473690
www.agfa.co.uk

Fotospeed
Tel 01225 742486
www.fotospeed.com

Ilford Imaging UK Ltd
Tel 01565 684005
www.ilford.com

Jessops Ltd
Tel 0116 232 0432 (mail order)
www.jessops.com

Kentmere Photographic
Tel 01539 822322
www.kentmere.co.uk

Kodak Ltd
Tel 01442 61122
www.kodak.co.uk

Nova Darkroom Equipment Ltd
Tel 01926 403090
www.novadarkroom.com

Paterson Photographic Ltd
Tel 0121 520 4830
www.patersonphotographic.com

RH Designs
(f-stop timers, darkroom products)
Tel 01442 258111
www.rhdesigns.co.uk

Silverprint Ltd
(papers, all darkroom equipment)
Tel 020 7620 0844
www.silverprint.co.uk

Tetenal Ltd
Tel 01533 630306
www.tetenal.com

US
Adorama
www.adorama.com

B&H
(paper, chemistry, equipment)
Tel 800 947 9981
www.bhphotovideo.com

Cachet
(fine art photographic products)
Tel 714 432 7070
www.onecachet.com

Freestyle Photographic Supplies
Tel 800 292 6137
www.freestylephoto.biz

Paterson Photographic Inc
Tel 770 947 9796
www.patersonphotographic.com

Photographer's Formulary
(great toner kits, chemicals, etc.)
Tel 800 922 5255
www.photoformulary.com

Advice on processing and toning on www.kodak.com

GLOSSARY

Acetate mask A clear acetate sheet marked with photo-opaque paint and used for masking and dodging purposes.

Anhydrous Without water. Refers to dry form of chemicals.

Archivalling
The preservation of prints by protecting them from chemical attack by materials or the environment.

Baryta Barium-based substance which stops the emulsion sinking into the paper of fibre-based photographic papers.

Bleaching Lightening the image by bleaches or 'reducers'. Can be used to lighten selected areas permanently if used with fixer, or to bleach away the image before redevelopment in another developer or a toner.

Burn-in To give additional exposure to an area of printing paper in order to produce a darker tone locally when developed. Other areas of the print are shaded at this time

Cold-cathode enlarger A cool-running enlarger which uses fluorescent tubes to give diffuse light which is rich in blue or blue-green, to which graded paper is most sensitive, giving short exposure times.

Cold tone Print tone tending towards blue or black.

Condenser enlarger An enlarger which uses condensers to focus light through the negative into the lens. Produces higher-contrast prints than other types of enlarger.

Contact printing
Printing 'actual size' by exposing paper with the negative in contact with it.

Contrast mask A thin contact negative or positive placed in register with a negative before printing, as a method of controlling contrast.

Contrawise bleaching Primarily, bleaching lower tones on the latent image before development.

Converging verticals Distortion effect, commonest with wide-angle lenses and typically seen in photographs of buildings shot from ground level.

Cropping Removing part of the image for compositional reasons.

Crystalline Containing water and forming characteristic crystal shape.

D-max Maximum density — the deepest black available.

D-min Minimum density — the lightest tone available.

Density range The difference between D-max and D-min.

Developer Chemical solution used to convert the invisible silver halide in film emulsion into visible metallic silver.

Developer additive Preparation added to developer for use with old papers, to vary tones or for other purposes.

Diffuser enlarger An enlarger which passes diffused light through the negative. Produces lower-contrast prints than other types of enlarger. Also minimizes negative blemishes.

Dodger Tool used for dodging.

Dodging Preventing exposure from local areas of printing paper in order to produce lighter tones on the print. Also known as holding back.

Dry bench Surface area of darkroom reserved strictly for 'dry' procedures.

Dry down The darkening of a print on drying. Applies mostly to fibre-based prints. The effect appears greater if the inspection light is too bright.

Emulsion The light-sensitive surface layer of film and paper. Usually consists of silver halides in gelatin.

Enlarging table Table used to support the enlarger and allow the height of the baseboard to be adjusted vertically.

Factorial development A method of consistently determining full development time for prints, taking into account the gradual exhaustion of the developer.

Farmer's Reducer A bleach for permanently lightening print tones.

Fibre-based paper Photographic paper not employing resin-coated technology. Handling characteristics are those of paper rather than plastic. Processing times are long. Probably more archivally permanent than resin-coated paper.

Ferri See Potassium ferricyanide

Fixer A processing solution used to remove unexposed silver halides from the emulsion, so making the image permanent. Also known as fix.

Flashing Exposing the paper to 'white light' to a degree below D-min — i.e. producing no tone (or fog) itself on the paper. Reduces contrast and extends tonal range.

Flash strip Test strip used in flashing to determine point of maximum flash, or 'max flash'.

Fogging Producing an overall tone or 'veil', either by exposing to white unsafe light past D-min or by chemical action.

f-stop Unit of measurement of the difference between lens aperture settings. The difference between two consecutive f-numbers — e.g. f2.0 and f2.8 — is one f stop.

f-stop timer Enlarger time calibrated to convert f-stop instructions into real time.

Gamma A measurement of contrast usually

quoted in film-developer instructions on development for contrast levels suitable for condenser or diffuser enlargers. Also applies to papers.

Grain Clumping of the silver-halide grains in film and paper that make up the image. Unlike film, the grain size on paper is largely responsible for the image tone (colour) after development.

Hardener A chemical preparation used to harden the print (or film) surface after processing. This is not advisable if toning or processing for archival permanence. Useful for glazing fibre-based papers or enhancing gloss on resin-coated glossy papers.

High-key image Image consisting mainly of light tones.

Hypo Sodium thiosulphate, a fixer.

Hypo clearing agents
Chemical agents used to speed the efficient removal of hypo or fixer from prints in subsequent washing.

Infectious development
Rapidly accelerating development seen in lith printing.

Intensification
Increasing density and/or contrast chemically.

Latent image
An invisible image on paper or film, which development will render visible.

Lith paper
Specialist paper used with dilute lith developer to produce lith prints by infectious development when overexposed and not fully developed.

Low-key image Image consisting mainly of dark tones.

Mat A mounting board with a cut-out window that is laid on top of a print, providing a form of mounting and storage.

Newton's rings Ring patterns caused by moisture on opposing shiny surfaces — e.g. glass-glass or glass-film.

Old Brown Old, thoroughly exhausted developer. May be added to developer when developing for warm tones.

Oxidation Process by which a chemical compound combines with oxygen to form an oxide. Occurs with the development of silver emulsions and is the opposite of reduction.

Paper base The base tone of unexposed paper after developing and fixing, seen, for example, in unexposed borders.

Perfect print Like the Holy Grail, a mythological entity quested after by many, but found by few if any.

Potassium ferricyanide A bleach used in Farmer's Reducer and other bleaching solutions. Also known as 'ferri' and 'liquid sunshine'.

Pre-development bleaching A technique of lowering contrast by immersing the exposed paper in very dilute bleach before development — i.e. bleaching the latent image as opposed to the visible image.

Printing map A visual plan of the dodging and burning-in used on a print.

Redevelopment Bringing back an image that has been bleached away, by placing it in a developer with similar or different characteristics to that which first developed it.

Reduction The process by which a chemical compound loses oxygen. To reduce a print or negative is to lighten it by chemical means, either all over or in selected areas.

Resin-coated paper Photographic emulsion coated onto plastic or resin-coated paper. Chemicals do not penetrate resin-coated paper fibres and so processing times are short.

Safelight Light which does not sensitize photographic materials. Refers also to the darkroom lamps which give this light.

Silver halides Generic name for a group of light-sensitive compounds of silver with a halogen (bromines, chlorines, iodines, fluorines). Hence bromide, chlorobromide and bromochloride papers.

Split filtration A technique used with variable-contrast papers in which different contrasts are used on the same print, allowing subtle tonal control. Also used in dodging and burning-in.

Split toning Toning only part of the density range of a print — variously the light, light and mid, mid and dark, or dark tones.

Still development Development without agitation, similar but less marked in effect to water bathing, and used to control contrast.

Stop bath Acid solution used after developer to instantly arrest development before paper is transferred to fixer.

Test strip A paper given a test series of incremental exposures in order to determine the desired exposure.

Toning Processes used either to alter the colour of a print chemically or to produce archival permanence of the image, with or without significant colour change.

Variable-contrast filters Filters used with variable-contrast paper to achieve different contrast grades.

Variable-contrast paper Prinitng paper containing two emulsion layers of different contrast, allowing a range of contrasts to be obtained from a single packet, or even on a single print, by exposing through appropriate filters.

Warm tone Print tone tending to brown or red.

Water bathing A method of controlling print contrast.

Wet bench Area of darkroom reserved for 'wet' procedures.

White light 'Unsafe' light of uniform density, not projected through a negative, and used in fogging and flashing.

INDEX

159